The Renaissance
in Rome
1400–1600

The Renaissance
in Rome
1400–1600

Loren Partridge

The Everyman Art Library

Acknowledgements

I would like to thank Leslie Martin, Wendy Partridge, and Regina Stefaniak who have
read the manuscript and made many suggestions for improvement.
It has also been a pleasure to work with Jacky Colliss Harvey, series editor,
and Susan Bolsom-Morris, picture editor.
This book is dedicated to Leslie Martin with love.

First published in Great Britain in 1996 by
George Weidenfeld & Nicolson Ltd
The Orion Publishing Group, Orion House
5 Upper St Martin's Lane
London WC2H 9EA

A catalogue-in-publication record for this book is available from the
British Library

ISBN 0297 83367 7

Copyright © 1996 Calmann & King Ltd
This book was produced by Calmann & King Ltd, London

Series Consultant Tim Barringer (Birkbeck College, London)
Senior Editor Jacky Colliss Harvey
Designer Karen Stafford, DQP, London
Picture Editor Susan Bolsom-Morris
Printed in Hong Kong

Frontispiece View of Rome with the urban plan of Sixtus V, page 34 (detail)

Contents

N

RENAISSANCE ROME

Vatican

Tiber

Gianicolo

Campo Marzio

Trastevere

Tiber

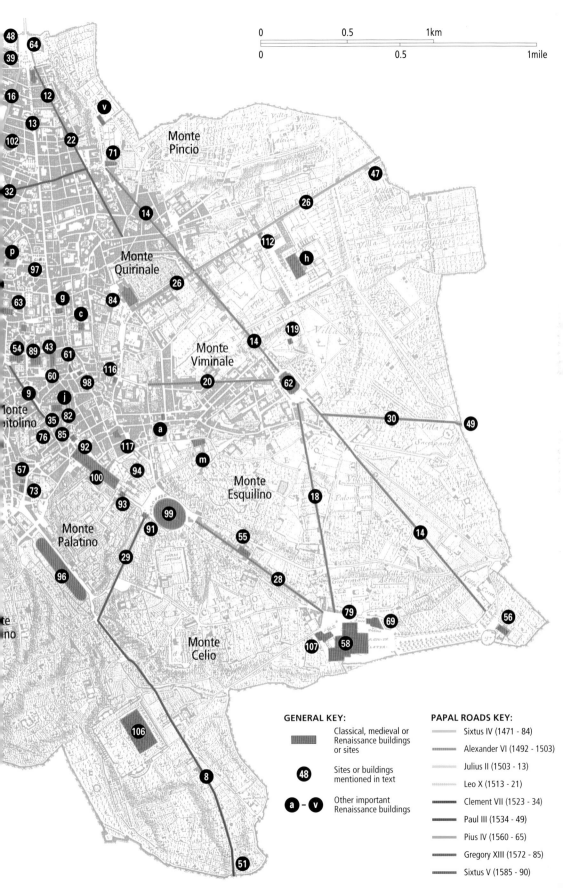

Monte
Pincio

Monte
Quirinale

Monte
Viminale

Monte
Esquilino

Monte
Capitolino

Monte
Palatino

Monte
Celio

0 0.5 1km

0 0.5 1mile

GENERAL KEY:

Classical, medieval or
Renaissance buildings
or sites

48 Sites or buildings
mentioned in text

a - v Other important
Renaissance buildings

PAPAL ROADS KEY:

Sixtus IV (1471 - 84)

Alexander VI (1492 - 1503)

Julius II (1503 - 13)

Leo X (1513 - 21)

Clement VII (1523 - 34)

Paul III (1534 - 49)

Pius IV (1560 - 65)

Gregory XIII (1572 - 85)

Sixtus V (1585 - 90)

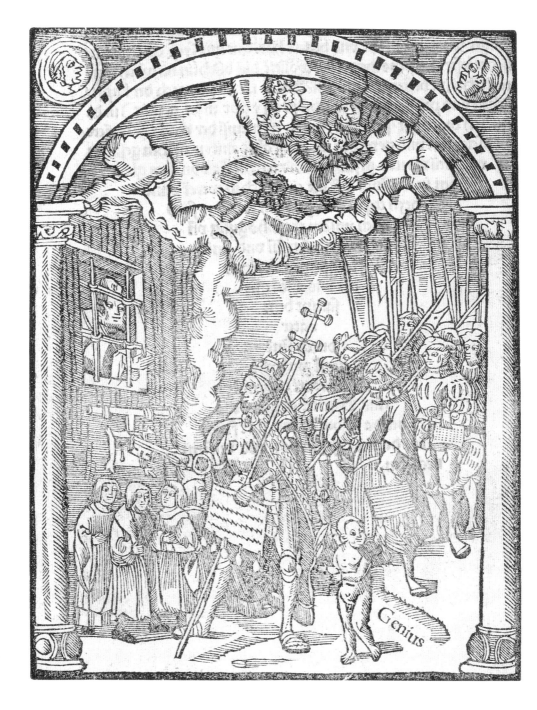

Genius

Patronage and Popes: Saints or Sinners?

1. Frontispiece to the German edition of Desiderius Erasmus's *Julius exclusus* (1st Latin edn. 1517), 1523. Woodcut, 5³/₄ x 4¹/₂" (14.7 x 12.3 cm). Bayer Staatsbibliothek, Munich.

Julius II – accompanied by young clerics, his evil genius, and his army – is dressed in armor and holds a key, processional cross, and papal bull (official document) with numerous seals. The letters P M inscribed on Julius's breastplate are abbreviations for "Pontifex Maximus" (supreme priest). St. Peter, who looks out from behind the locked door to paradise, suggests in the dialogue, however, that they stand for "Pestilential Maximum!"

T he woodcut in FIG. 1 represents the pope as a sinner, the fresco of FIG. 2 as a saint. Such radically different perceptions of a Renaissance pope speak worlds about the papacy and papal patronage in the Roman Renaissance.

In the fresco, Sixtus IV (r. 1471–84), wearing a tiara and his official robes, is led by St. Peter toward a tower inscribed PAR-ADISVS. The original Latin inscription under the fresco reads: "As a reward for his piety St. Peter leads Sixtus IV into the possession of paradise [saying], 'Christ, for whom you prepared a home for the poor on earth [the Ospedale di Santo Spirito], gives you this [home] in heaven.' "

Thirty-seven scenes chronicling the life of Sixtus IV, which precede this climactic one in the Ospedale di Santo Spirito, support his claim to heavenly reward. His mother's prophetic visions of a religious vocation for her son and his miraculous recoveries from illnesses and accidents show Sixtus IV to have been divinely favored as a child. Other scenes depict his entry into the Franciscan order, his popular preaching, his success in theological debate, and his climb up the ecclesiastical hierarchy with successive appointments as general of the Franciscans, cardinal, and pope. As pope, he is depicted canonizing St. Bonaventura (1221-74), receiving homage-paying sovereigns from all over the world, and supporting a crusade against the Turks. His most meritorious deeds, judged by the large number of scenes (twelve) devoted to them, are urbanistic projects in Rome: improving the streets, squares, walls, water supply, and river port; building a bridge across the Tiber;

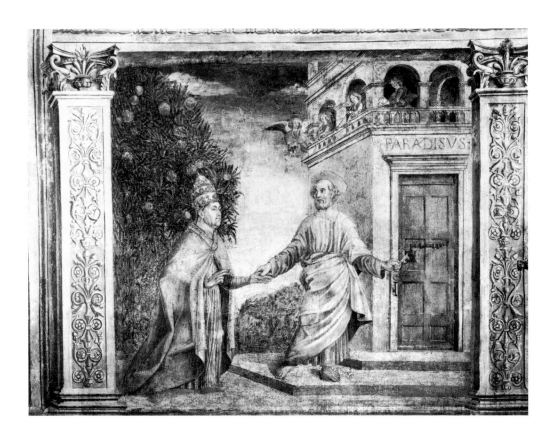

2. ANONYMOUS
Sixtus IV led to Paradise by St. Peter, 1473–83. Fresco. Ospedale di Santo Spirito, Rome.

The orange tree behind Sixtus IV , which bears its fruits in the dead of winter, symbolizes salvation. From an open loggia above the door to paradise, angels offer Sixtus a musical fanfare.

restoring and constructing numerous churches, including S. Maria del Popolo; rebuilding the Ospedale di Santo Spirito for foundlings, the poor, and infirm; and founding the Vatican Library.

The woodcut from *Julius exclusus* by the Dutch theologian Desiderius Erasmus (c. 1469–1536) shows a dialogue between St. Peter and Pope Julius II (r. 1503–13) at the door to paradise:

> Peter: ...immortal God, what a sewer I smell here! Who are you?...
>
> Julius: ...so you'll know what sort of a prince you're insulting, listen a bit...I neglected nothing in accumulating money; when Bologna had been occupied by the Bentivogli, I restored it to the Roman See. The Venetians, previously not conquered by anyone, I crushed in battle... I neatly disposed of a schismatic council by faking a counter-council, and...I drove the French, who were then the terror of the whole world, completely out of Italy...even though I supported such a great army, celebrated so many splendid triumphs, erected buildings in so many places, still, when I died I left five million ducats...

Peter: Madman!...all I hear about is a leader not of the church but of this world, more wicked than the pagans...tell me, who was the very first to...burden, with those adornments of yours, the church which Christ intended to be...unencumbered?

Julius: ...they say that somebody or other named Constantine unloaded the entire majesty of his empire on Sylvester, the Roman Pope...

Peter: It could be a legend.

Julius: Actually, I've suspected that myself...But, nonetheless it is greatly to my advantage to believe it...

Peter: Well—I still don't hear anything that isn't worldly...

Julius: Perhaps you are still dreaming of that old church, in which you...were pope in name and title only. What if you could see today so many sacred buildings erected by kingly wealth, so many thousands of priests everywhere (many of them very rich), so many bishops equal to the greatest kings in military power and in wealth, so many splendid palaces belonging to priests ...what would you say?

Peter: That I was looking at a tyrant worse than worldly, an enemy of Christ, the bane of the church.

Julius: You would say otherwise if you had witnessed even one of my triumphs...the horses, the parade of armed soldiers, the adornments of the commanders...the lavishness of the displays that were carried by, the procession of bishops, the proud cardinals, the trophies, the booty, the shouts of the people and the soldiers resounding to heaven, everything ringing with applause, the music of trumpets, the blast of horns, the flashing of cannon, the coins scattered among the people, and myself carried aloft like some divine thing...they thundered in celebration of me; they proclaimed me Jupiter who shakes everything with his thunderbolt...[and] the salvation of the people of the earth...So you won't open, then?

Peter: To any sooner than to such a pestilence...you yourself are a great builder: build yourself a new Paradise...

Common to both of these images is the pope as a great builder and patron of the arts, and, indeed, a high percentage of the art discussed in this book was commissioned either by popes or by high church officials following their lead. Otherwise, these images could not be more different.

3. MELOZZO DA FORLI
*Pope Sixtus IV nominates
Platina Prefect of the
Vatican Library,* 1476-77.
Fresco. Pinacoteca, Vatican.

Originally painted for the
Vatican Library founded by
Sixtus IV, the scene shows
from right to left: Sixtus IV;
Raffaele Riario, Apostolic
Protonotary, cardinal in
1477 and builder of the
Palazzo della Cancelleria;
Cardinal Giuliano della
Rovere, the future Pope
Julius II; Platina, the papal
librarian; Girolamo Riario,
Count of Imola and Forli;
and Giovanni della Rovere,
Prefect of Rome. Except for
Platina, all are papal
"nephews" or relatives. The
inscription translates:
"Rome, once full of squalor,
owes to you, Sixtus, its
temples, foundling hospital,
street squares, walks,
bridges, the restoration of
the Acqua Vergine at the
Trevi fountain, the port for
sailors, the fortifications on
the Vatican Hill, and now
this celebrated library."

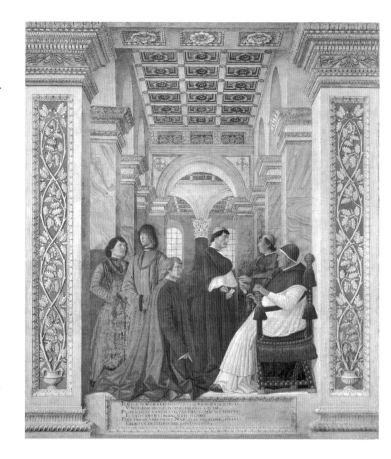

In the Ospedale di Santo Spirito the pope was portrayed as a wise preacher, learned theologian, inspired leader, and able administrator. He exercised his spiritual power by saving the just (Bonaventura) and damning the infidel (Turks). The nations of the world bowed down in recognition of his universal temporal power. He piously cared for the poor and needy, and above all, glorified the church by the renovation of Rome. The inscription on a fresco of the founding of the Vatican Library also trumpeted Sixtus IV's renewal of the city (FIG. 3).

Using the early Christian ideals of piety, humility, poverty, and self-sacrifice as the standard against which to measure Julius II, Erasmus characterized the pontiff as the embodiment of impious and brazen worldliness, arrogant and egotistical tyranny, paganlike love of wealth and military might, and self-aggrandizing and grasping greed.

Erasmus was right when he saw the Renaissance papacy as worldly (FIG. 4). Running the largest, most complex international institution in Europe, supporting the curia or papal court numbering

in the thousands, and maintaining and expanding facilities required large sums of money. The breakaway of the Protestants from the church in the first half of the sixteenth century and the confiscation of church lands and revenues by the rising transalpine nation-states resulted in less revenue being directed to Rome from northern Europe, forcing the papacy to depend financially more on the Papal State in central Italy as its tax base. In fact, most of the military activity of the papacy, such as Julius II's campaigns against the Bentivogli in Bologna or the French and Venetians in northern Italy, was directed largely toward expanding and consolidating the Papal State. As a result popes increasingly played the roles of secular prince, autocratic warlord, and hated tax collector. In order to make the popes' authority stronger, the bureaucracy and diplomatic corps more efficient, and the papal army more effective, the church was also gradually transformed during the Renaissance from an international institution to one more purely Italian in personnel and outlook. Overshadowed by the growing power of the Valois in France and the Habsburgs in Austria, Germany, and Spain, simultaneously the papacy became an ever less important player on the European stage. The brutal Sack of Rome in 1527 by the troops of the Habsburg Holy Roman Emperor, Charles V (1500–58) made a mockery of papal claims to world dominion. So did repeated raids in Italy and eastern Europe by the Turks, and their increasing domination of the Mediterranean after the fall of Constantinople in 1453.

4. Papal tiara designed by Caradosso (Cristoforo Foppa; 1452–1526/27) for Pope Julius II.

The Renaissance church was not only worldly, it was also corrupt. Popes generally appointed family members to high office regardless of merit (nepotism) and often carved dynastic family states out of church lands (alienation). Clerics were often poorly educated, lax in their vows, and undisciplined. Offices were routinely bought and sold (simony), and a single church official could draw income from many offices and benefices (pluralism) without attending to the duties of any (absenteeism). A ground swell of European popular piety was paid little attention by an often elitist church, and – for a price – any sin could be remitted through the purchase of indulgences which were believed to lighten the punishment of Purgatory. No wonder that to many reformers, such as Martin Luther (1483–1546), the pope truly seemed to be the Antichrist, and Rome a Babylon. Even a select committee of cardinals and high prelates appointed by Pope Paul III (r. 1534–49) reported in 1537 that the church seemed to be "tottering, and, in truth, about to collapse headlong into ruin." For the committee, as for Erasmus, the principal source of abuse was the pope and his exaggerated claims to power.

Popes mostly viewed the church as monarchical, and papal power – both spiritual and temporal – as supreme, universal, and absolute. They believed themselves to be new Christ figures on earth; just as Christ had consigned his full authority to Peter, so (and this "so," lacking biblical authority, forged a weak link susceptible to attack) each successive pope became Christ's vicar, according to the doctrine of the Petrine Succession.

Conciliarism, a competing model of church governance, held that church power resided in frequently convened councils of bishops and that popes were subject to their mandates. Because of the urgent need for church reform, Renaissance popes could not avoid convening a number of councils. But by controlling council representation they were able to fend off the most serious challenges to their primacy.

The Roman nobles, merchants, and communal officials who resented papal meddling in the social, economic, and political life of the city also challenged papal authority. In the earlier Renaissance the Romans often boldly tried to try to knock the pope off his horse during his ritual post-coronation procession across the city from St. Peter's to the Lateran Palace (the *possesso*), or to force him into exile once enthroned, or, all else failing, to attempt his assassination. At the death of a pope, the populace often desecrated his images, ransacked his property, and took control of the city until a new pope was elected. Even in the later Renaissance when the pope completely dominated Rome, discontented nobles often turned up as brigands in the Roman countryside harassing travel, trade, and agriculture.

However, the Protestants in northern Europe posed by far the greatest challenge to papal primacy, eventually completely rejecting the church. Since they believed that humankind was essentially sinful and "justified by faith alone," contrition, confession, penance, good works, and even the Mass itself were for them unnecessary for salvation. They rejected the entire hierarchy of the priesthood, from the pope down, substituting the universal priesthood of all believers. Many Protestants also believed in the bread and wine of the Mass (the Eucharist) as simply symbolic of the sacrificial Christ – and not, as the Catholics believed, as intrinsically salvific by the priest's mystical transformation of them into the body and blood of Christ (Transubstantiation). Finally, since they considered the Bible as their only authority, Protestants rejected all subsequent church history and tradition upon which many Catholic beliefs and doctrines were based.

In this climate of challenge and change the papacy aggressively reaffirmed the history and traditions of the church. Popes also

encouraged the pan-Italian revival of classical culture, called by contemporaries a *rinascita* (rebirth) – source of our word "renaissance." They did so in part because the abundant ruins in Rome brought antiquity vividly to life, but more particularly because the literary and artistic forms of ancient (especially imperial) Rome being recovered by humanists (scholars and teachers of the classical world) could support papal claims to universal authority. Fundamental to this ideological use of the Roman past was the belief that the *pax romana* or world peace of Emperor Augustus (63 BC–AD 14) was prepared by God in order to establish the *pax Christi*, the spiritual empire of Christ born in Augustus's reign. When Emperor Constantine (c. 285–337) converted to Christianity in the early fourth century, the church united with the Roman Empire. In transferring his capital to Constantinople, it was believed that Constantine donated the city of Rome, the western empire, and the imperial regalia to the pope, although already in 1440 Lorenzo Valla (1407–57) had demonstrated the document recording this famous donation to be an eighth-century forgery. But, as Erasmus's Julius observes with Machiavellian cynicism, it was to his advantage to believe in Constantine's bequest, because it justified his claim to be a new emperor. Similarly, when Julius II took on the persona of Julius Caesar parading in imperial triumph, or was called a new Jupiter, as Erasmus describes, he marshaled the authority of classical history and myth to claim by association supreme temporal and spiritual power. Since Erasmus did not subscribe to this ideology, he saw only paganism. But when popes and high church officials had the streets and squares of Rome renovated according to ancient principles of design, and churches and palaces built and decorated using classical motifs, they did so largely to make ideological claims in the face of strong challenges to their power.

Rome had a well-developed agricultural sector, but, unlike Florence, Venice, or Milan, was not a center of banking, manufacturing, trade, or transportation. Rather Rome thrived on papal bureaucrats and pilgrims, and without their income there was little to sustain it. Thus, during the so-called Babylonian Captivity (1309–77) – when the papacy was in Avignon, a client of French kings – and the Great Schism (1378–1417) – when different conclaves and councils elected a series of eight popes, at least two or three at any moment simultaneously claiming authority from residences mostly outside of Rome – the population of Rome declined from about 35,000 to 17,000, much smaller than Florence, Venice, Milan, or even Siena.

5. RAPHAEL
Portrait of Julius II,
c.1511–12. Oil on panel,
42½ x 31″ (108 x 80 cm).
National Gallery, London.

When the popes returned permanently to Rome in the early fifteenth century, however, the city began to grow and prosper. A large service sector catered to pilgrims, who once again flocked to the city seeking indulgences and spiritual nourishment – about 30,000 in normal years and over 100,000 during Jubilees or Holy Years held once every twenty-five years. The expanding papal court fostered a building boom of churches, palaces, and villas. By 1600 Rome's population had increased to 100,000, larger than any city in Europe except for London and Paris.

Scholarship and the arts had been moribund at the beginning of the fifteenth century, but during the Renaissance Rome emerged as one of the great cultural centers of Europe, largely because opportunities afforded by church patronage attracted some of the brightest minds and best artists from all over Italy (FIG. 5). It was the papacy that led the church through the slow and painful process of reform. The canons and decrees of the Council of Trent (1545–63) and subsequent papal commissions clarified doctrines, standardized liturgy and scriptures, and corrected the worst abuses of nepotism, alienation of church lands, simony, pluralism, absenteeism, and the sale of indulgences. The Inquisition, reestablished in 1542, enforced orthodoxy, and the Index, founded in 1571, suppressed Protestant ideas by banning heretical books. The proper education of priests and effective ministering to the laity became high papal priorities. Many new lay confraternities (groups devoted to religious and charitable causes) and religious orders, such as the Jesuits, were founded by papal charter. The older orders were reformed to require strict obedience, discipline, and observance of vows. The papacy pursued with renewed vigor its mission to pacify, civilize, and Christianize the entire world in preparation for the Second Coming of Christ. It did so by actively promoting peace between the Valois and Habsburgs, who had turned Italy into a battleground over conflicting dynastic claims, because without peace (finally achieved by the Treaty of Cateau-Cambrésis in 1559) most European regimes were reluctant to support the papacy in its campaigns against Protestants and Turks (FIG. 6). The papacy also renewed its missionary activity all over the world, especially in the recently discovered New World. Occasional military victories – the navy of the Holy League defeating the Turks at Lepanto in 1571, the massacre by French troops of thousands of Huguenots on St. Bartholomew's Day in 1572 – as well as a wave of new converts and martyrs for the faith encouraged many to believe

6. FRANCESCO SALVIATI
Charles V and Francis I Make Peace at Nice in 1538, c.1552–55 (detail of south-east wall). Fresco. Sala dei Fasti Farnese, Palazzo Farnese, Rome.

To the left of the figure of Paul III are these portraits of both Francis I of France and the Habsburg Emperor, Charles V.

that the enemies of the papacy would finally be conquered and that the church would once again live up to Erasmian early Christian ideals and soon become truly universal and triumphant.

A church under constant attack yet steadily renewing itself produced great contradictions and tensions. These were often accommodated within the tradition of millenarian prophecy, in which it was believed that the Second Coming and Last Judgment would be preceded both by a time of troubles and by a time of the renewal of religion, learning, peace, and prosperity. Since both troubles and renewal were everywhere evident during the Roman Renaissance, it was not difficult for contemporaries to feel a sense of living at the edge of space and time with damnation or salvation imminent. The art of the Roman Renaissance both reflected and constructed this conflicted world of the best of times and the worst of times.

Rome has more noteworthy monuments from more periods – antiquity to the present – than any other city in Europe. Urban patterns and monuments of one era impinge on those of another, and most have been altered (often drastically) due to neglect, vandalism, or changes in taste and function. As a result, in the first three chapters on the urbanism, churches, and palaces of Renaissance Rome, I have often resorted to maps, diagrams, reconstructions, and prints to recapture original intentions. Many of the altarpieces I discuss in chapter four are no longer over their intended altars, and, while the fresco decorations I treat in chapters five and six are by their very nature still *in situ*, most of the chapels and halls of state themselves have undergone various degrees of change.

For each chapter I have selected a broad range of works to give a sense of developments across two centuries, but in a book of this limited scope I had to omit many important examples. Similarly, and regrettably, I have either not covered or merely mentioned whole categories – villas and villa decoration, gardens, tomb sculpture, portraiture, and decorative arts.

While the usual designations of artistic styles are used – early Renaissance, High Renaissance, Mannerist, and late Renaissance or Counter-Reformation art – I have emphasized a close reading of a few works in terms of function, patronage, symbolism, and papal ideology, and explored how the art shaped, and was shaped by, the cultural circumstances sketched above.

ONE

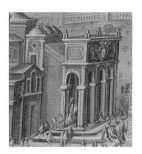

Urbanism: Rotting Cadavers and the New Jerusalem

The election in 1417 of Pope Martin V (r. 1417–31) ended the Great Schism. When Martin returned to Rome in 1420, "he found it so dilapidated and deserted," according to Platina (1421–81) in his *Lives of Popes*, "that it bore hardly any resemblance to a city. Houses had fallen into ruins, churches had collapsed, whole quarters were abandoned; and the town was neglected and oppressed by famine and poverty." The ancient aqueducts that brought water to the hills of Rome (the *monti*) had long ago collapsed, and most of the inhabitants of this economically depressed city had to live on the flood plain between the three bends of the River Tiber (the *abitato*; FIG. 8). In a bull (or official document) of 1425 Martin V further noted that within the *abitato*

> many inhabitants of Rome...have been throwing and illicitly hiding entrails, viscera, heads, feet, bones, blood, and skins, besides rotten meat and fish, refuse, excrement, and other fetid and rotting cadavers into the streets...and have dared boldly and sacrilegiously to usurp, ruin, and reduce to their own use streets, alleys, piazzas, public and private places both ecclesiastical and profane.

Preparing for the Restoration

To correct these conditions the papacy had to establish a legal framework within which to operate urbanistically. Under Martin V the two communal overseers of the streets were brought

7. ANTONIO DA SANGALLO
THE YOUNGER
Zecca (Papal Mint), Rome,
c. 1525.

Marking the junction between the Via Papale and the Via del Pellegrino, the concavity of the facade seems almost to respond to the pressure of approaching papal processions. Based on the motif of a classical triumphal arch, the facade also signaled the triumph of Clement VII, whose coat of arms was once prominently featured on it.

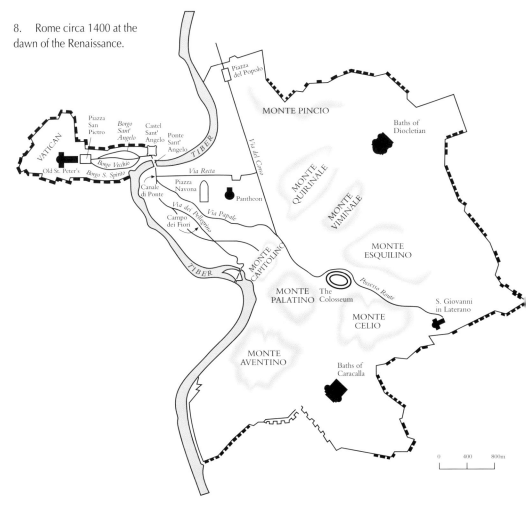

8. Rome circa 1400 at the dawn of the Renaissance.

under papal authority. Nicholas V (r. 1447–55) made them papal appointees and strengthened their jurisdiction. In bulls of 1475 and 1480 Sixtus IV gave them a salary, the power to expropriate private property with compensation, and a mandate to give priority to the circulation of pilgrims. By the sixteenth century the overseers' tenure in office was extended from a few months to life and they had to work ever more closely with papal architects. Finally, in 1587 Pope Sixtus V (r. 1585–90) increased the number of overseers to twelve (while strictly limiting their duties to street maintenance), strengthened the laws of expropriation, and placed the design and execution of papal projects entirely in the hands of his architect and engineer, Domenico Fontana (1543–1607). As effective as papal control became, it was never absolute. The rights and interests of property owners – large and small, lay and ecclesiastical, local and foreign – often changed or stopped papal plans.

A major motive underlying the restoration and development

of Rome was first articulated by Nicholas V in his 1455 deathbed speech to the cardinals. His urban program, he said, was "for the exaltation of the power of the Holy See throughout Christendom," because "great buildings, which are perpetual monuments and eternal testimonies seemingly made by the hand of God," demonstrate that "the authority of the Roman Church is the greatest and highest." Thus, the unlettered, whose faith "is on a weak foundation" unless "moved by certain extraordinary sights," will find their "belief continually confirmed and daily corroborated by great buildings . . ." Nicholas V's ideal, then, was to transform Rome into an image of the celestial Jerusalem with "great buildings seemingly made by the hand of God."

Sixtus IV had an image of imperial Rome in mind when he called the city the "capital of the world [*caput mundi*]," which held "primacy among all others because of the throne of St. Peter." And, indeed, for the curialist (member of the curia or papal court) Raffaello Maffei (1451–1537) the urbanism of Sixtus IV did recall the classical city, as Sixtus had "made Rome from a city of brick into a city of stone just as Augustus of old had turned the stone city into marble." An inscription of 1512 on the Via Papale commemorating the urbanism of Julius II implied that he had gone one better than his uncle, almost literally becoming a new Augustus: "To Julius II, Pontifex Optimus Maximus, who...beautified the city of Rome...by opening up and measuring out streets in accordance with the dignity of the empire." The language explicitly refers to the same passage that Maffei had in mind from Suetonius's *Lives of the Twelve Caesars*: "Since the city was not adorned as the dignity of the empire demanded...he [Augustus] so beautified it that he could justly boast that he had found it built of brick and left it marble."

Restoring the grandeur of ancient Rome and constructing an image of celestial Jerusalem supported papal claims to universal temporal and spiritual power. Although urban and political realities always fell short of this grand vision, to see the city ideologically was to see it as a whole, as a work of art. And this led, as we shall see, to urban schemes ever more spatially unified and visually integrated.

Utility also motivated the building and rebuilding of fortifications, streets, squares, and fountains: better security against outsiders; better policing and political control of insiders; more expeditious movement of people and goods; expanded commerce and taxes by more settlement and building; and improved hygiene. A strong, safe, efficient, prosperous, and healthy Rome was also a microcosmic image of a harmonious and peaceful Christendom.

The First Projects: Nicholas V–Paul III

Rome's development was increasingly based on the aesthetic principles revived or reinterpreted from classical antiquity, but its general shape owed most to Nicholas V's move from the Lateran Palace, the permanent papal residence for over a thousand years, to the Vatican Palace, an occasional temporary papal abode. (See the map of Rome on pages 6 and 7 for all streets, squares, and monuments mentioned in the text.) The Lateran Palace in the east of the city was in bad repair, isolated, and insecure, while the Vatican Palace in the west was closer to the *abitato* and protected by the Tiber, the Vatican walls built by Leo IV (r. 847–55), and the fortified Castel Sant'Angelo, originally the tomb of the Emperor Hadrian (AD 76–138). Living near St. Peter's, site of papal coronations and the tomb of Peter, also reinforced papal claims to legitimacy. But S. Giovanni in Laterano remained the cathedral of Rome, so the move to the Vatican required the pope, as Rome's bishop, to travel frequently with his retinue back and forth between the two along the Via Papale.

The first and most important such procession of every pope, which took place after his coronation, was the *possesso*, by which he claimed possession of his bishopric (FIG. 9). The position of priests, diplomats, nobles, and laity in this ritual displayed to the city the papal ideal of ecclesiastical and social hierarchy. By traversing the territory of the nobles and urban patriciate, accepting obeisance from communal officials, rejecting the sacred

9. ANONYMOUS
Possesso of Sixtus IV in 1471, 1473–83. Fresco. Ospedale di Santo Spirito, Rome.

The procession includes armed guards, Sixtus IV blessing the populace while transported on a litter under a canopy by noble youths, mounted bishops with a processional cross, and Roman nobles and communal officials carrying banners adorned with the coat of arms of Sixtus's della Rovere family, the papal insignia of tiara and crossed keys, and the communal motto SPQR (*senatus populusque Romanus*: the Senate and people of Rome).

books of the Jews, riding through triumphal arches, and throwing coins to the populace, the pope also claimed to unify and dominate the city – often provoking stoning and rioting in the process. This major east–west urban corridor was enhanced by the Capitoline Hill – the *caput mundi* of the ancient world and seat of the secular communal government – the Roman Forum, and the Colosseum. Given its symbolic, ceremonial, and interconnective importance, a high percentage of Renaissance urban and architectural projects were either placed along the Via Papale or were related to the three major centers that were at its middle and ends.

Once moved to the Vatican, the popes required the overseers of the streets to pay special attention to the three major east–west medieval streets giving access to and from the Vatican by way of the Canale di Ponte and the Ponte Sant'Angelo. In the center was the Via Papale. To the north was the Via Recta, an ancient Roman road that led to the Via del Corso by way of the Piazza Navona (after 1477 the food market). To the south was the Via del Pellegrino, which went to the Campo dei Fiori (the livestock market) and on to the Capitoline or to Trastevere.

Nicholas V planned to match these streets with three new straight streets in the Vatican connecting the Castel Sant'Angelo with St. Peter's and the Vatican Palace. The plan was not carried out, but three existing irregular medieval east–west streets fulfilled the same purpose: the Borgo Vecchio (or Via Sacra) in the center, the Borgo Santo Spirito to the south, and the Borgo Sant'Angelo to the north, the last two rebuilt by Sixtus IV. It was at the Ponte Sant'Angelo, where these streets joined, that the first important project of Renaissance urbanism was carried out.

During the 1450 Jubilee or Holy Year, when pilgrims jammed the Ponte Sant'Angelo, a bucking mule provoked a panic and over two hundred pilgrims fell into the Tiber and drowned. To expiate their deaths, Nicholas V renovated the area from 1450 to 1453, making it safer, stimulating commerce, and creating an ordered entrance to the Vatican (FIG. 10). The bridge was cleared of shops; the Piazza S. Celso was enlarged; two octagonal chapels were built to mark the entrance to the bridge and to commemorate the deaths of the pilgrims; three round bastions, a two-towered gatehouse, and a papal apartment were added to the Castel Sant'Angelo; and a bronze statue of St. Michael sheathing his sword was placed on top of the papal apartment to recall the apparition in 590 of the archangel to Pope Gregory the Great (r. 590–604) as a sign that a devastating plague had ended.

Nicholas V intended the collaboration between the papacy, commune, and residents to demonstrate his desire to work har-

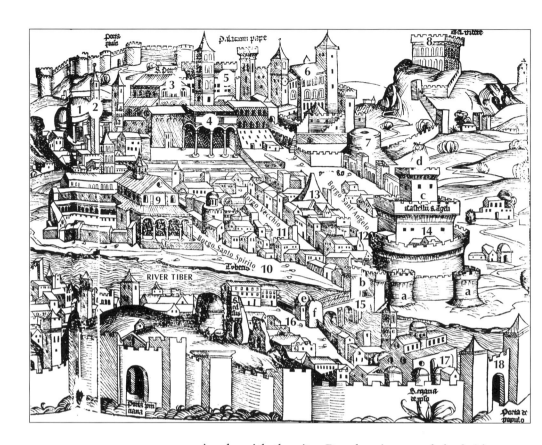

moniously with the city. But the piazza and the bridge were also dominated by signs of papal supremacy: St. Michael, an image of divine punishment and mercy, symbolized the pope's spiritual power to save and damn; the Castel Sant'Angelo, transformed from a stronghold of the powerful Orsini family into a papal bastion and apartment, was an emblem of the pope's temporal power. This power was associated with imperial Rome, because the classical design principles that characterized the original urban scenography of the site of the tomb of the Emperor Hadrian were here revived for the first time in Renaissance Rome. These included *axiality* (the connecting of piazza and fortress by the bridge's axis), *symmetry* (the balancing of chapels and gatehouse towers on either side of the central axis), *focus* (the emphasizing of entrance into, versus exit from, the Vatican by the fortress's massive presence at the north end of the central axis), *hierarchy* (the arranging of piazza, chapels, bastions, papal apartment, and divine apparition in an ordered crescendo of importance), and *unity* (the visual coalescing of all elements along the central axis).

Most pilgrims entered Rome from the north at the Porta del Popolo and continued south along the Via del Corso – an ancient

Roman street running to the Capitoline. To make a more direct pilgrimage route between the Piazza del Popolo and the Ponte Sant'Angelo – as well as to stimulate trade and commerce around the Porto di Ripetta, Rome's smaller upstream port – Sixtus IV constructed the Via Sistina. To prevent a recurrence of the 1450 disaster on the Ponte Sant'Angelo, he also built for the Jubilee of 1475 the Ponte Sisto, the first Tiber bridge since antiquity, which provided a southern route in and out of the Vatican by way of the Via della Lungara.

For the Jubilee of 1500 Alexander VI (r. 1492–1503) destroyed the ancient Vatican pyramid, the so-called Tomb of Romulus, to build the Via Alexandrina (the first straight street in Rome since antiquity) leading from the Vatican Palace to the Castel Sant'Angelo. It created a grand triumphal way for the *possesso*, other important papal processions, and pilgrims.

Julius II did his part for pilgrims by having his architect, Donato Bramante (c. 1444–1514), widen and straighten the Via della Lungara, and construct a parallel street on the other side of the Tiber, the Via Giulia (the longest straight street since antiquity), which connected at one end with the Ponte Sisto and at the other with a planned but unexecuted bridge, the Ponte Triumphale.

Leo X (r. 1513–21) improved communication between the Piazza del Popolo, the Porto di Ripetta, the Via Recta, and the Vatican by the construction of the Via Leonina, although his concern was less for pilgrims than for a triumphal approach to his (never completed) family palace near the Piazza Navona.

The pattern of three streets in the *abitato* and the Vatican converging on the Ponte Sant'Angelo probably led Pope Clement VII (r. 1523–34) to commission Antonio da Sangallo the Younger (1485–1546) to construct a third street to meet the Piazza del Popolo, the Via Clementia. Inspired by the precision of classical planning, Sangallo laid out the Via Clementia at the same angle to the Via del Corso as the Via Leonina. The geometrically precise convergence of these three streets constituted the first *trivium* or trident, a planning scheme with important implications for subsequent developments in Rome.

It was also Clement VII who commissioned from Sangallo for the Jubilee of 1525 one of the more impressive of many Renaissance embellishments of the Via Papale – the facade of the papal mint established by Julius II (see FIG. 7, page 19).

Paul III extended the Via Clementia and changed its name to Via Paolina Trifaria. He connected this street to the Via del Corso, the Via Leonina, and the Via Sistina by the Via Trinitatis focused on Trinità dei Monti toward the east.

Opposite

10. WOLGEMUT
View of the Vatican from Hartmann Schedel's *Liber Chronicarum*, Nuremberg, 1493. Woodcut.

1) S. Petronilla
2) Obelisk
3) St. Peter's
4) Benediction Loggia
5) Sistine Chapel
6) Papal Palace
7) Tower of Nicholas V
8) Villa of Innocent VIII
9) Ospedale di Santo Spirito
10) Borgo Santo Spirito
11) Borgo Vecchio (Via Sacra)
12) Borgo Sant'Angelo
13) Pyramid (so-called Tomb of Romulus)
14) Castel Sant'Angelo:
 a) bastions,
 b) gate house,
 c) papal apartment,
 d) Archangel Michael
15) Ponte Sant'Angelo
16) Piazza S. Celso:
 e) Chapel of the Holy Innocents
 f) Chapel of Mary Magdalene
17) S. Maria del Popolo
18) Porta del Popolo

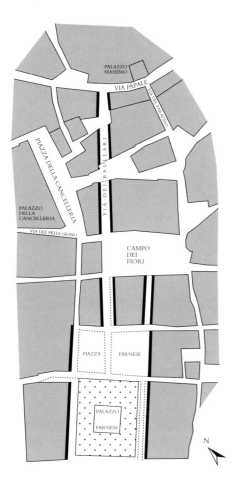

He also commissioned the Via Paolo and Via di Panico as short links between the Ponte Sant'Angelo and the Via Giulia and the Via Papale respectively. Together with the Canale di Ponte these streets formed a second Roman *trivium*. Since it was best appreciated by the pope from his newly decorated apartment in the Castel Sant'Angelo (discussed in chapter six), the order and harmony of the new trident mirrored back to the pope's gaze an image of imperial Rome and heavenly Jerusalem.

In 1514, while still a cardinal, Alessandro Farnese (1468–1549) had begun to build a palace designed by Antonio da Sangallo the Younger. After becoming Pope Paul III in 1534, he greatly enlarged the palace to suit his enhanced status (discussed in chapter three). The new plans included the destruction of two blocks of houses to form the nearly regular Piazza Farnese as well as the partial destruction of three more blocks to create the Via dei Baullari, a street focused on the center of the Farnese Palace (FIG. 11). More aesthetic than utilitarian, the primary purpose of the new street and piazza was to show off the palace and create a commanding view for, and of, the Farnese. Based on the design norms of antiquity the Piazza Farnese and the Via dei Baullari thus associated the *nouveau riche* Farnese with the rationality and regularity of a grand cultural tradition. They also bore witness to the ruthless power of an imperial papacy to dispossess its citizens and impose its will on the congested city center.

11. Map of the Piazza Farnese and the Via dei Baullari, developed by Paul III in the 1530s and 1540s in conjunction with the Palazzo Farnese.

Dotted lines indicate areas destroyed to make the new square and street; the dark lines indicate new facades. The map also shows the urban situation of the Palazzo Massimo delle Colonne.

The Triumph of Emperor Charles V

In 1536, after defeating the Turks in Tunisia the year before, Emperor Charles V marched up through Italy demonstrating his domination of the peninsula and provoking great fear in Rome as he was perfectly capable of again sacking the city. Paul III tried to manipulate the situation to his advantage by staging a triumphal entry in the antique manner for Charles V, beginning at S. Paolo fuori le mura. Although the *possesso* and the processions of Julius II mentioned by Erasmus imitated Roman triumphs, this was the first time since antiquity that the victor was an emperor of worldwide power. Paul III cleared the ancient Via Appia from the

Porta S. Sebastiano in the southeast to beyond the ruins of the Baths of Caracalla. The route then turned north along a new street – the Via di S. Gregorio – which led through the Arch of Constantine to the Colosseum. Over two hundred houses were cleared out of the Roman Forum allowing the procession to then travel along the ancient Via Sacra through the arches of Titus and Septimius Severus. It is uncertain whether or not the procession was intended to go up to the Capitoline, the goal of all ancient Roman triumphs. But in the end this route was avoided as was the suggestion that the triumphal emperor would here, as in antiquity, take on the favor and power of the gods. Going around the Capitoline, past the Column of Trajan, through a temporary arch near S. Marco, the procession continued to St. Peter's by way of the Via del Pellegrino.

To suggest a clear distinction between the empire and the church, Charles was led through or past the largest number of ancient monuments possible. His procession was framed at its beginning and end by memorials to the founders of the church, Paul and Peter, however, and made to circumvent the *possesso* route as far as was possible. Whether amused or flattered by the honor shown him as a new Roman emperor, Charles V evidently felt it was to his advantage to appear to be the defender of the church and at St. Peter's he dutifully performed the ritual of obeisance par excellence – kissing the pope's foot.

It was probably Paul III's humiliating show of weakness before the power of Charles V that prompted him to commission Michelangelo (1475–1564) to renovate the Capitoline as a sign of the pope's claim to dominate the city and the world. The project was far enough along by 1566 that the papal *possesso* could henceforth regularly turn at the Gesù (discussed in chapter two), follow Paul III's new Via d'Aracoeli to the Capitoline, go through Michelangelo's new Capitoline "forum," and then proceed down the hill and along the Via Sacra cleared for Charles V. Now more than ever, the pope could ritualistically enact the roles of high priest and emperor.

The renovation of the Capitoline began in 1538 when Paul III ordered the second-century bronze equestrian statue of the Roman emperor Marcus Aurelius to be placed in the center of the hill on an oval base designed by Michelangelo. The shape of the base implies that Michelangelo already had an oval pavement in mind (FIG. 12). Because the statue had stood for centuries near the Lateran Palace, marking the site where papal judicial punishment was administered, *Marcus Aurelius* was intended to serve as an emblem of papal authority displacing the old communal symbol of justice, a classical sculpture of a lion attacking a horse.

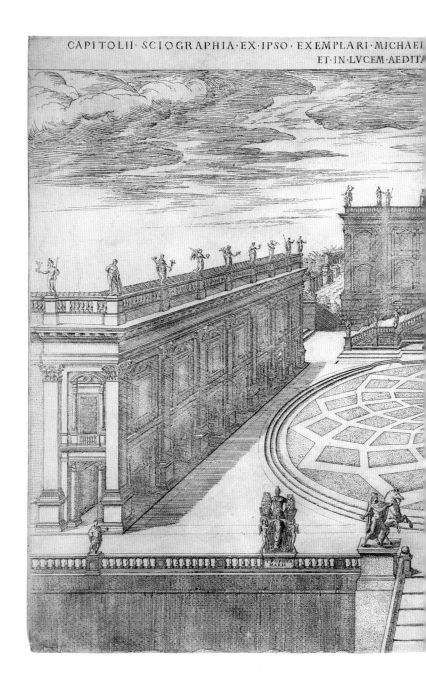

12. ETIENNE DUPÉRAC

Michelangelo's design for the Capitoline, from the *Speculum romanae Magnificientiae* (edited by Antonio Lafréry), Rome, 1569. Engraving. British Museum, London.

In this first full record of Michelangelo's intentions, the Palazzo Senatorio built in the Middle Ages dominates the center; to the right is the Palazzo dei Conservatori dating from the fifteenth century. Together they housed the administrative, judicial, legislative, and commercial functions of the commune. Michelangelo simply added new facades (built 1545–1605) and planned the Palazzo Nuovo on the left (built 1603–55) to balance the design.

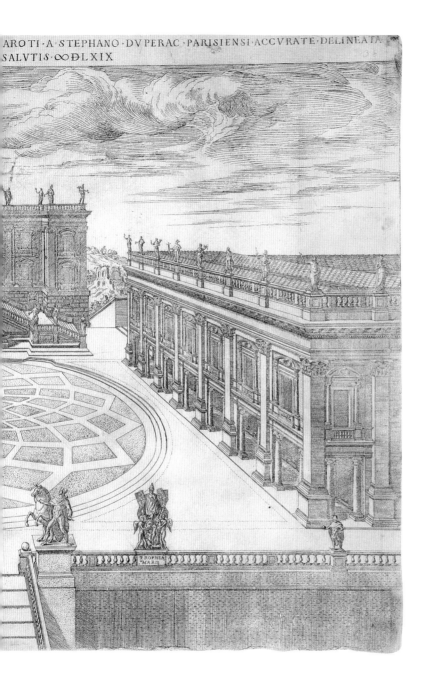

ARO TI · A · STEPHANO · DVPERAC · PARISIENSI · ACCVRATE · DELINEATA
SALVTIS · ∞ꓷLXIX

TROPHEA
MARII

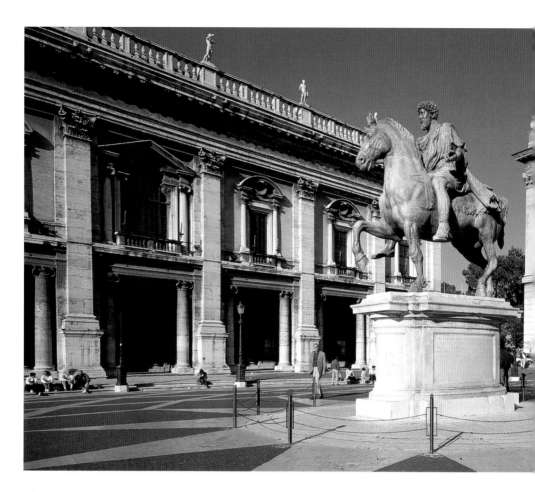

13. MICHELANGELO
Capitoline hill, designed
between 1538 and 1564,
Rome.

Michelangelo united the
three-storey Palazzo
Senatorio, office of the
highest ranking civic official,
with the two-storey flanking
facades by using the same
giant order of two-storey
pilasters carrying entablatures
with statue-lined balustrades.
The stellate pavement pattern
was executed only in 1940
under Mussolini. *Marcus
Aurelius* has recently been
restored and placed in the
Palazzo Nuovo.

Michelangelo placed *Marcus Aurelius* on a domed oval pavement with a twelve-pointed stellate pattern radiating out from a sunburst (FIG. 13). The mounded pavement evokes the earthly sphere, appropriate for the Roman *caput mundi*, while its stellate pattern – according to the Roman architect Marcus Vitruvius (active 46–30 BC), whose treatise *On Architecture* was well known to Michelangelo – alludes to the heavenly sphere with its signs of the zodiac. The sunburst was a classical sign of Apollo, and since Apollo was often understood in the Renaissance as a metaphor for Christ, the pavement pattern and *Marcus Aurelius* together suggested the temporal and spiritual universality of Paul III, a new Roman emperor and the vicar of Christ.

The *Horsetamers* from the Quirinal Baths of Constantine planned for the top of the horse ramp, as shown on Dupérac's engraving (but not installed), were believed in the Renaissance to represent Alexander the Great with his horse Bucephalus and to have been carved as a contest between the famous Greek sculptors Phidias

and Praxitiles. They would have recalled Paul III's given name, Alessandro, just as Paul III was compared to Alexander the Great in the Sala Paolina in the Castel Sant'Angelo (discussed in chapter six). Classical river gods representing the Nile and the Tiber (placed in front of the double-ramp stairs in 1548–52) reinforced the claims of the new Alexander and new Marcus Aurelius to universal temporal power, east and west.

Michelangelo applied the design principles of antiquity on the Capitoline more rigorously than ever before, especially compared to the Piazza S. Celso or the Piazza Farnese. In the massing of forms – lower flanking buildings with colonnades, larger central building approached by a ramp, and a central statue – he was also inspired by classical examples. The Capitoline was truly a new communal Roman forum by and under papal authority.

Michelangelo's design, however, is unique for its imaginative, unclassical dynamism. The design of the Palazzo dei Conservatori (1563–84), for example, dramatizes and exaggerates the play of load and support (FIG. 14). The relatively thin and tall Corinthian pilasters create the illusion of supporting the extremely heavy and strongly projecting crowning cornice. Michelangelo deliberately masked the massive piers that actually carry the cornice (of which the pilasters are only a part) by incorporating them into the lower entablature so that they appear to be non-supporting frames surrounding the bays. In a contrasting illusion the lower portico's relatively thick and massively strong free-standing Ionic columns seem to support an impossibly wide stone entablature. Were it

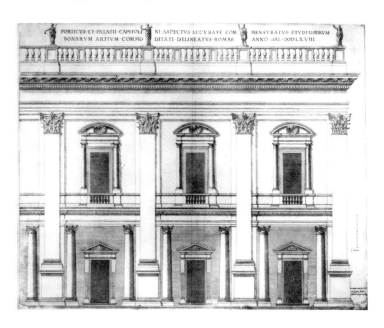

14. BARTOLOMEO FALETI Michelangelo's design for the facade of the Palazzo dei Conservatori, 1568. Engraving.

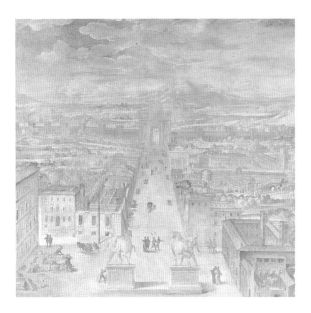

not for Michelangelo's ingenious use of disguised arches, vaults, and iron tie rods, the entablature would, in fact, collapse.

The spatial illusion is equally dynamic. The original two palaces were set at a slightly oblique angle to each other. Michelangelo placed the Palazzo Nuovo at the same angle, creating a trapezoidal space larger at the back than the front. The optical effect is one of spatial expansion toward the back and past the sides of the Palazzo Senatorio, evocative of the *possesso* processing over the hill and down into the Roman Forum.

15. View of the Via Pia, c. 1588. Fresco, Salone dei Papi, Lateran Palace, Rome.

At the far end is Michelangelo's unfinished Porta Pia of 1561–65. At the near end are the *Horsetamers* (thought to be Alexander the Great and his horse Bucephalus), moved from the nearby Baths of Constantine by Sixtus V in 1586–87. In between is Sixtus V's Moses Fountain of 1585–88. In the left foreground Sixtus V's Quirinal Palace is under construction.

Pius IV

One sign of an increasingly autocratic papacy was an expanding bureaucracy, and Pius IV (1559–65) almost doubled the size of the Vatican to accommodate the administrative staff. He constructed a wall with bastions connecting the north end of the Cortile del Belvedere to the Castel Sant'Angelo, and strengthened the latter by new arrow-head bastions in a pentagonal plan. Within this fortified *civitas pius* between the old and new north walls, Pius IV encouraged the building of churches, convents, and monasteries for religious houses, and palaces for curial officials and cardinals, especially along the principal cross streets – the Borgo Pio and the Via Angelica.

Pius IV also made one of the first efforts to stimulate development in the *monti* by building the straight and wide Via Pia on the Quirinal Hill, an area of curial villas (FIG. 15). As a focus for the northeast end Pius commissioned Michelangelo to design the Porta Pia, which surprisingly was turned inward toward the street and not defensively outward (FIG. 16). When Sixtus V moved the Quirinal *Horsetamers* to the southwest end in 1586–87, the Via Pia became a unified work of art with monumental foci at both ends, a first in the Roman Renaissance.

The New Jerusalem of Sixtus V

In a bull of 1586 Sixtus V for the first time brought the pilgrimage route under strict and systematic papal control. He required

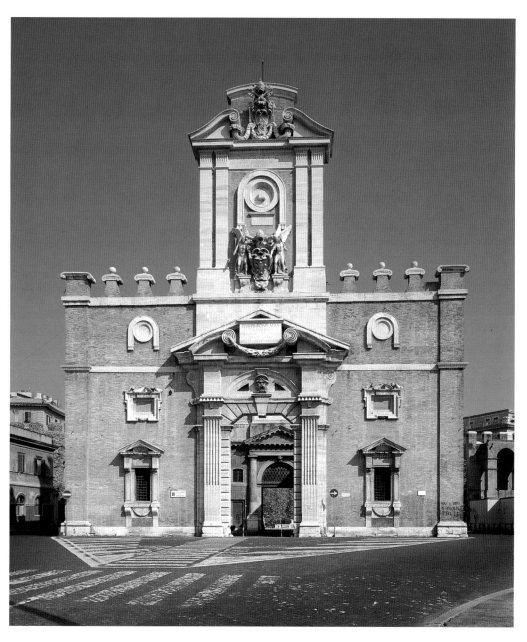

16. MICHELANGELO
Porta Pia, Rome, 1561–65.

Michelangelo capriciously designed the lower segment with blunt juxtapositions of, and unexpected contrasts between, unconventional classical motifs to suggest contradiction, conflict, and change. By contrast he intended the upper section to culminate in a classical temple front motif with a triangular pediment (the present pediment dates from the mid-nineteenth century), which would have been canonical, stable, and ordered. Here he placed two angels – evoking Pius IV's Christian name, Angelo – carrying the papal coat of arms in triumph, flanked by the six *palle* (balls) of the pope's Medici family crest silhouetted against the sky on drooping, non-aggressive battlements.

17. View of Rome with the urban plan of Sixtus V, c. 1588. Fresco, Salone Sistino, Library, Vatican.

1) Porta del Popolo
2) S. Maria del Popolo
3) **Obelisk in Piazza del Popolo**
4) Via Leonina
5) Via del Corso
6) Via Clementia/Paolina Trifaria
7) **Via Felice**
8) Mausoleum of Augustus
9) Via Trinitatis
10) Trinità dei Monti
11) Via Pia
12) **Quirinal Palace**
13) **Moses Fountain**
14) Porta Pia
15) **Villa Montalto**
16) **Obelisk of S. Maria Maggiore**
17) **S. Maria Maggiore**
18) **Via Panisperna**
19) **Via S. Lorenzo**
20) S. Croce in Gerusalemme
21) Via Merulana
22) **Lateran Obelisk**
23) **Lateran Palace**
24) **Benediction Loggia of S. Giovanni in Laterano**
25) **Via S. Giovanni in Laterano**
26) Colosseum
27) Arch of Constantine
28) Basilica of Maxentius and Constantine (so-called Temp of Peace)
29) Arch of Titus
30) Roman Forum
31) Arch of Septimius Severus
32) Via d'Aracoeli
33) Il Gesù
34) Palazzo Venezia
35) S. Maria di Loreto
36) **Column of Trajan**
37) **Column of Marcus Aurelius**
38) Torre delle Milizie
39) Torre dei Conti

The composition has been organized around S. Maria Maggiore and the projects of Sixtus V (here in bold type) have been exaggerated in size.

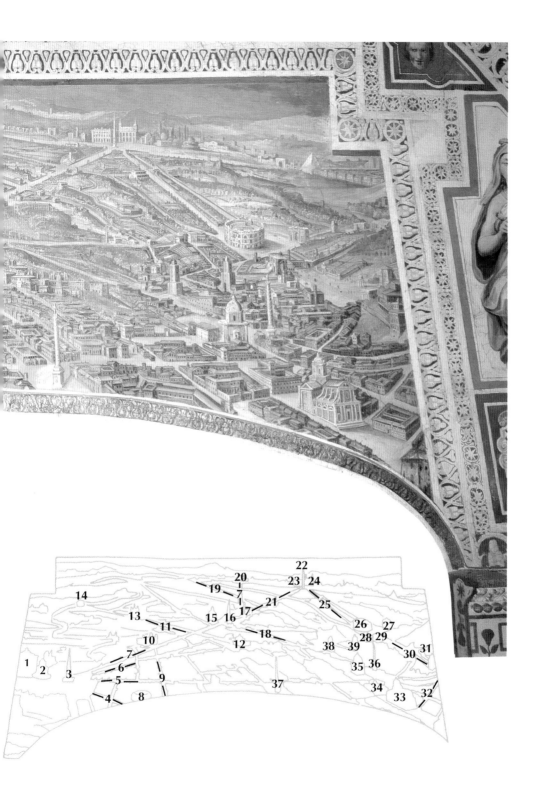

virtually all Romans, but especially popes and the curia, to make pilgrimages every year during prescribed periods and to celebrate some thirty masses. Rome was to become a "hospice of religion" pulsating with spiritual life, demonstrating to pilgrims its spiritual centrality, the capital of prayer, penance, and good works, the living new Jerusalem and not just its image. For the crowds of thousands to move freely in these processions, Sixtus V created a new network of straight and wide roads between the pilgrimage churches, also useful for the hundreds of new carriages that had become the most recent Roman status symbol. The hub was at the center of Marian devotion in Rome, S. Maria Maggiore, Sixtus V's own burial church and conveniently near his Villa Montalto (FIG. 17).

To mark the pilgrims' goal most of these streets ended with an obelisk which for the Egyptians had been symbolic sun rays, and for the emperors who transported them to Rome, victory trophies. In the mid-fifteenth century Nicholas V had planned to move the Vatican obelisk to the center of the Piazza S. Pietro, and under Leo X, Raphael (1483–1520) had proposed an obelisk for the center of the Piazza del Popolo. But it was only with the strong-willed determination of Sixtus V and the superior engineering of his architect, Domenico Fontana, that the forty-ton Vatican obelisk was finally moved in 1586 (FIG. 18). This successful experience revealed the possibility of repairing and resiting three fallen obelisks: one from the Tomb of Augustus was placed behind S. Maria Maggiore in 1587; two from the Circus Maximus – one Constantinian, the other Augustan – were erected at the Lateran in 1588 (FIG. 19) and at S. Maria del Popolo in 1589. All were topped with devices of Sixtus V and a cross, and rededicated with inscriptions which alluded to Sixtus V as a new Christ, Augustus, and Constantine, victoriously unifying Christendom and establishing universal peace.

The second-century columns of Trajan and Marcus Aurelius, recording victories in Dacia, Germany, and Sarmatia (on the middle plain of the Danube) were also subordinated to the Church Triumphant when Sixtus V had them capped in 1587 with bronze statues of saints Peter and Paul.

Now Christianized, these phallic beacons added a historical dimension to the urban landscape, broadcasting the message that even in ancient Egypt and Rome the victory of the church had been divinely preordained. The domes and bell towers of the city signaled the final triumph at the end of time, at the Second Coming.

The urban development of Rome under Sixtus V was accomplished in only five years – an extraordinary achievement, possible

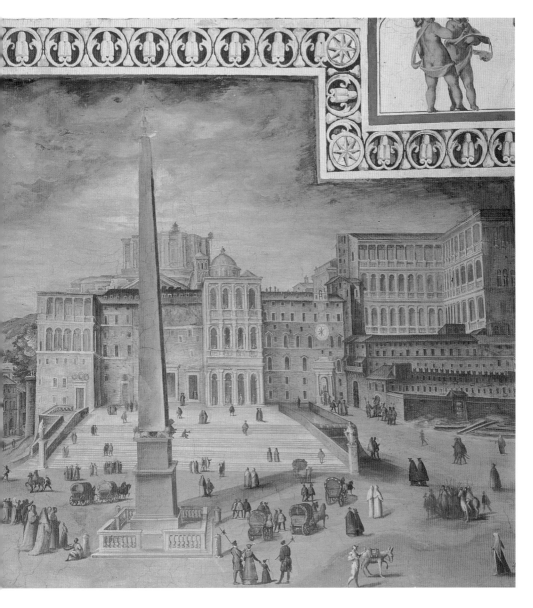

18. View of Piazza S. Pietro, c. 1588. Fresco, Salone Sistino, Library, Vatican.

The Vatican obelisk was moved by Domenico Fontana in 1586 for Sixtus V. Behind the obelisk is Michelangelo's drum for the still uncompleted dome of St. Peter's. To the right of the obelisk is the fifteenth-century Benediction Loggia. To the extreme right are Bramante and Raphael's Papal Palace Logge, commissioned by Julius II, with an extension at right angles added by Gregory XIII.

only because of the sparse population on the hills. But from the beginning Sixtus V planned to settle the hills and establish among other things a silk industry, a livestock market, and a public laundry. To provide the necessary water he built at a huge cost, from 1585 to 1587, the Acqua Felice, the first aqueduct since the Roman era. The terminus was just off of the Via Pia at the Moses Fountain (FIG. 20 and see FIG. 15), and from here nearly thirty additional fountains, including those on the Capitoline, were eventually fed.

A gigantic figure of Moses, a standard Christ type, dominates the center of the Moses Fountain. His upward glance and the horns on his head (symbolic rays of light) reveal Moses in the presence of God having received the tablets of law, now held under his left arm. Moses thus signifies papal justice, alluding to the legal reforms of Sixtus V and his ruthless enforcement of the law. The commanding gesture of his outstretched right arm recalls Moses striking water from the rock. The water suggests the traditional reference to Baptism and the fissure in the rock, the wound in Christ's side. The energy and purpose of this figure with the power to save and damn aptly symbolizes Sixtus V. But the bombastic overemphasis equally accents the frustration and weakness of the papacy in the new world order of the Counter-Reformation.

When Sixtus V died in 1590, Pompeo Ugonio (d. 1614), curialist, scholar, and professor of Greek and Latin, rhetorically praised the order and prosperity of the pope's new Rome and new Jerusalem. Rome, he says, is

> weighted down by the load of his good works. Now it is liberated from the fear of cut-throats, permeated with the light of peace, augmented with wider streets, adorned with buildings, refreshed by fountains, implanted with massive obelisks reaching to the very heavens...Wheresoever Rome turns, she sees herself restored to a new golden age abounding with justice, fortitude, vigilance, liberality, magnificence, and the piety of this greatest prince...She fears, however, to appear ungrateful, because in no way can she repay the immensity of such great benefits.

Rome had come a long way from the rotting cadavers of Martin V. For the first time since antiquity the entire city was functionally integrated and aesthetically unified into a work of art. But Ugonio's oration barely suppressed its excessive cost: the "weighty load" of Sixtus V's autocratic rule demanded strict obedience and rigid conformity, provoking a terrorized "fear of appearing ungrateful."

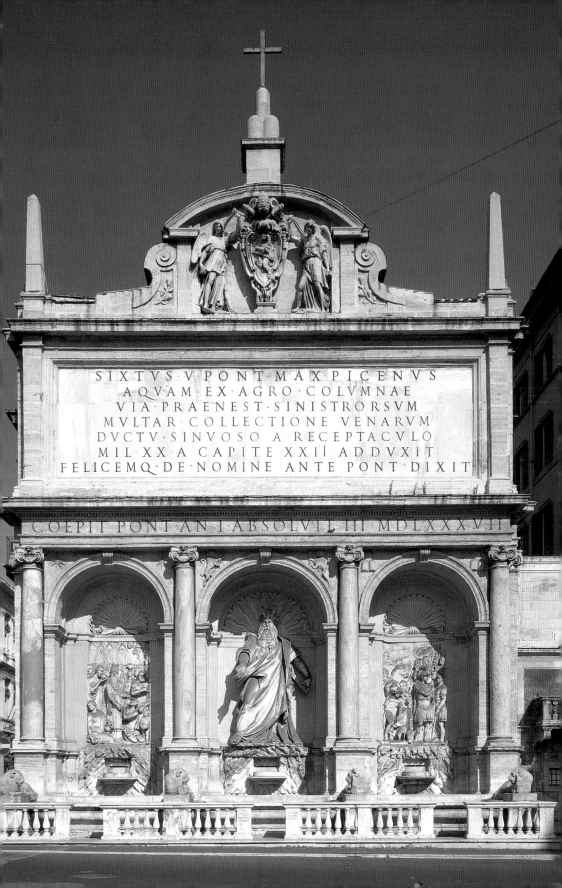

SIXTVS·V·PONT·MAX·PICENVS
AQVAM·EX·AGRO·COLVMNAE
VIA·PRAENEST·SINISTRORSVM
MVLTAR·COLLECTIONE·VENARVM
DVCTV·SINVOSO·A·RECEPTACVLO
MIL·XX·A·CAPITE·XXII·ADDVXIT
FELICEMQ·DE·NOMINE·ANTE·PONT·DIXIT

COEPIT·PONT·AN·I·ABSOLVIT·III·MDLXXXVII

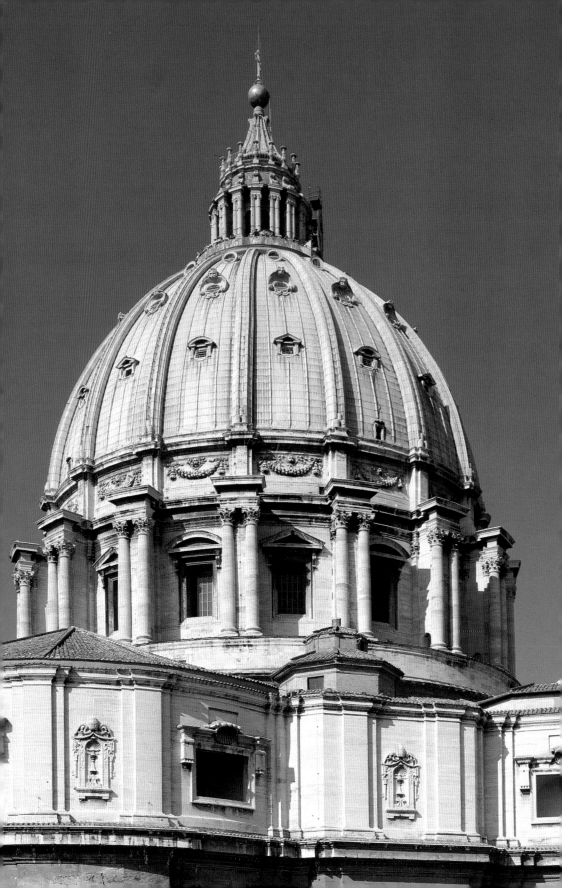

TWO

Churches: Harmony of the Spheres and Construction Chaos

R enaissance Rome had more early Christian and medieval churches per head than any other city in Europe. Just to maintain this legacy was such a drain on papal resources that few new churches were built in the first three-quarters of the fifteenth century. But with the revival of classical culture, new ideas of church design emerged, making earlier churches appear to be inadequate expressions of both Christian doctrine and papal ideology.

21. Drum, dome and lantern of St. Peter's, Vatican, 1546–93.

Michelangelo designed the dome as a hemisphere, but Giacomo della Porta (c. 1537-1602) raised its profile to make it more visible from a distance. Even so, when Carlo Maderno (1556–1629) turned St. Peter's into a Latin-cross church by extending the nave three bays eastward under Paul V (r. 1605–21), the dome was still wholly or partially obscured from Piazza S. Pietro.

The Renovation of St. Peter's by Nicholas V

The mid-fifteenth-century renovation of St. Peter's by Pope Nicholas V was the first important Roman Renaissance church designed with reference to classical architecture and was almost certainly influenced by the classically inspired *On the Art of Building* (1452) by the great Renaissance humanist Leon Battista Alberti (1404–72).

Although never completed, the St. Peter's project can be partially reconstructed by a contemporary written description and later representations of its massive foundations. The object was to provide more space for pilgrims to circulate and priests to officiate around the high altar and the tomb of St. Peter. The design was probably modeled on Rome's two most influential buildings of antiquity, the Basilica of Maxentius and Constantine (c. AD 310–320), known in the Renaissance as the Temple of Peace, and the Pantheon (AD 118–125).

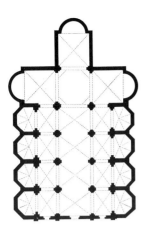

22. Ground plan, S. Maria del Popolo, Rome, 1472–78.

Nicholas V planned a monumental new west end with groin vaulted transepts and choir of about equal length (probably initially each terminating in an apse) buttressing a hemispherical dome over the crossing, the high altar, and the tomb of St. Peter. The centralized and canopylike space would have exalted St. Peter and his successors in a new imperial mode.

It also seems that the design was proportional and modular, deriving from classical ideas about musical and cosmic harmony. Pythagoras (6th century BC) had discovered that musical harmonies were produced by simple mathematical ratios based on small whole numbers, such that two taut vibrating strings of unequal length, related to each other in a ratio of 1:2, create a musical octave; in a ratio of 3:4, a fourth; 2:3, a fifth; and so on. Plato (c. 429–347 BC) believed that, since the cosmos must be perfect, it had to be constructed according to these same mathematical ratios, hence his famous "harmony of the spheres." Neoplatonists also conceived of God and his creation in geometrical terms: the circle – without beginning or end, every point equidistant from its center – was a symbol of godhead and spirit; the stable and solid square, earth and matter. Drawing on these ideas, transmitted in part by Vitruvius, Renaissance theorists such as Alberti advocated that the dimensions and plan of any church, a symbolic evocation of the heavenly Jerusalem, be conceived according to simple mathematical ratios and clear geometrical forms in tune with the cosmos.

23. Interior, S. Maria del Popolo, Rome, 1472–78.

The five groin vaults of equal height over the nave create a strong visual drive toward the light-filled crossing and the high altar. The aisle bays, half as wide as those of the nave, form separate units of space relating both to the half-octagonal side chapels covered with umbrella vaults and to the nave. In the seventeenth century the windows in the nave were modified and the sculptural decoration added above the arches.

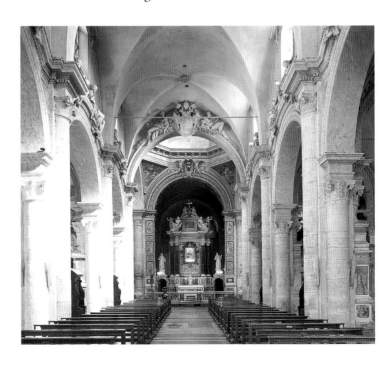

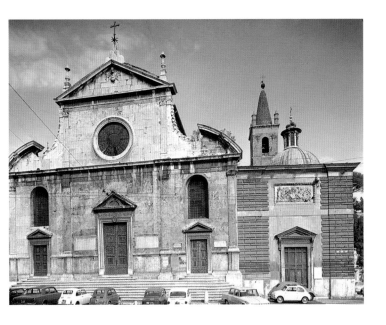

24. Facade, S. Maria del Popolo, Rome, 1472–78.

Originally the lower temple front was defined by triangular half-pediments over the side aisles (the rounded partial-pediments and volute-shaped wall segments date to the seventeenth century). Four pilasters, vertically continuous from top to bottom, interlock the upper and lower temple fronts, representing the nave within, while the side aisles are mirrored by the outside bays of the lower temple front.

S. Maria del Popolo and S. Pietro in Montorio

The first new fifteenth-century church inspired by Nicholas V's St. Peter's plan was Sixtus IV's S. Maria del Popolo of 1472–78 in the Piazza del Popolo. The altar end features the Nicholine centralized three-apsed plan (FIG. 22). The plan of the domed crossing, the groin vaulted transepts, and the choir are all based on a square. The dome, the first of the Roman Renaissance, is octagonal, symbolizing the resurrection of Christ on the eighth day after his entry into Jerusalem. The proportional and modular design of the vaulted interior captures the austere power and grandeur of ancient Roman architecture more convincingly than any previous Roman Renaissance church – an impressive "imperial" Pantheon for the burial of the members of Sixtus's family – the della Rovere clan – and their supporters (FIG. 23).

Dedicated to the Virgin, embodiment of the church itself, S. Maria del Popolo had to have a striking facade at this crucially important northern gateway to the city (FIG. 24). Because of the classicizing interior, the traditional Roman-style projecting porch of early Christian design was rejected in favor of a flat, travertine stone facade based on ancient Roman temple fronts. A row of columns carrying a pediment in front of an enclosed chamber epitomized a Roman temple facade. This design, however, awkwardly introduced the spaces of a Christian church with high central nave and lower side aisles. The ingenious solution here was to superimpose and interlock two temple fronts. In terms of

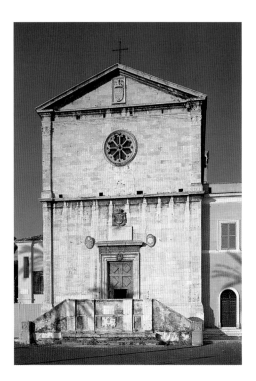

25. Facade, S. Pietro in Montorio, Rome, 1482–1500.

classical architectural practice, the problems with this design are many: the pilasters are thin and unevenly spaced; the upper pilasters are too short; and the span of the central entablature is too wide. Yet as a tentative experiment in adapting a motif designed for one situation to a very different one, it pointed the way toward solving a problem that would challenge architects throughout the entire Renaissance.

Lacking side aisles, the towering travertine stone facade of S. Pietro in Montorio of 1482–1500 is a variation on just the central section of S. Maria del Popolo's facade – taller, more solid and massive, but still somewhat awkwardly proportioned (FIG. 25). Behind that facade, however, is a variation on the plan for St. Peter's that is one of the most exciting of the early Renaissance with its combination of groin, pendentive, and umbrella vaults as well as its semi-circular and polygonal chapels, transepts and apse (FIG. 26).

For the first time in the Roman Renaissance the architect, who was perhaps Baccio Pontelli (c. 1450–92/5), has captured something of the full complexity of ancient Roman architecture: sculptural and malleable walls, pilasters that express structural forces, and a varied but unified sequence of interior and exterior volumes (FIG. 27).

The church was commissioned by Sixtus IV and his friend and confessor Amadeo Meñez de Silva (1431–82), who had been given an earlier church on this site in 1472 for his Spanish order of reformed Franciscans, the Amadeistas. They were motivated to build such an impressive church by the writings of the humanist and curialist Maffeo Vegio (1407–58), who had recently argued that here on the Janiculum (Hill of Janus) – halfway between the two pyramids believed to be the tombs of Romulus and Remus, the legendary founders of Rome – St. Peter had been crucified upside down, as described in early chronicles. The medieval pilgrims' guide, *The Marvels of Rome*, and other sources claimed that Noah's ark landed on the Janiculum after the flood to refound the human race, and identified the Roman god Janus as Noah's son or grandson. According to Roman myth, Janus inherited his authority from Saturn on the Janiculum, and established a golden age of peace in central Italy. Janus's attribute was a key: the door to his temple (*janus* is Latin for door) signified peace when closed and war when open. After the age of Janus, the door remained open until

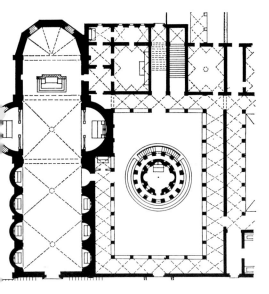

Left

26. Ground plan, S. Pietro in Montorio, Rome, 1482–1500.

Over the nave are two groin vaults; a pendentive vault covers the crossing. The choir has a single groin vault over the high altar and terminates in a polygonal apse with an umbrella vault. Smaller semi-circular chapels punctuate the walls of the nave, larger ones form transepts.

Below

27. Interior, S. Pietro in Montorio, Rome, 1482–1500.

The continuous, encircling entablature carried on pilasters unites the rich variety of vaulted spaces.

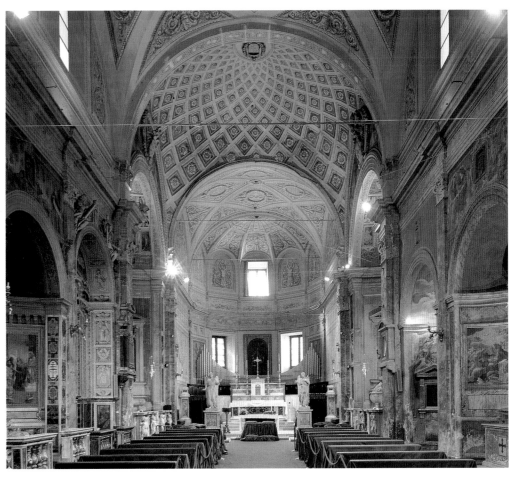

Churches: Harmony of the Spheres and Construction Chaos 47

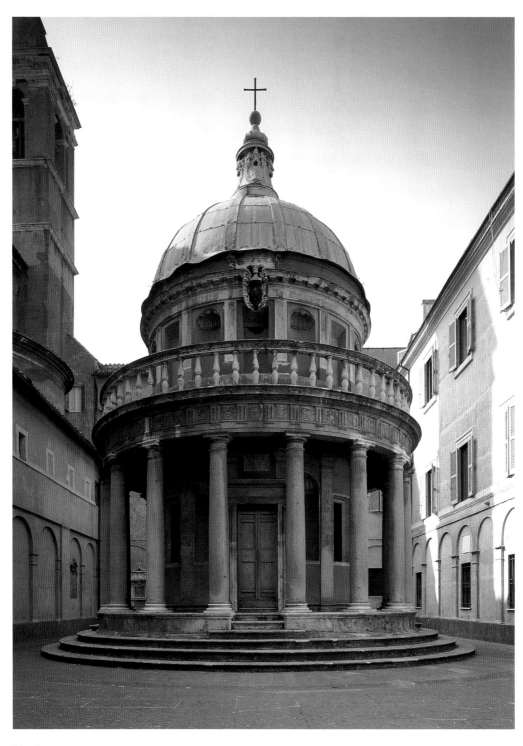

28. BRAMANTE
Tempietto, S. Pietro in Montorio, Rome, c. 1502–10.

Augustus's *pax romana*, which in turn prepared for the coming of Christ. Thus the site of S. Pietro in Montorio, dedicated to St. Peter, the new key-bearer and new carrier of religion and peace to Rome, suggested that the founding of the Roman Church had been prefigured across time by Janus, Romulus and Remus, and Augustus.

The Tempietto of about 1502–10 was commissioned for the cloister of S. Pietro in Montorio by Ferdinand and Isabella, the monarchs of Spain, with the support of the Spanish pope, Alexander VI (FIG. 28). Here Bramante used classical architecture more convincingly than ever before, but also brilliantly demonstrated how ancient art could be imaginatively adapted to serve papal ideology.

Bramante chose as his model the classical temple of Hercules Victor, excavated in Rome during the reign of Sixtus IV. This was the only known round temple with a colonnade of sixteen Doric columns on a base, as here. Bramante's choice was logical: a centrally planned church was a traditional memorial to a martyr; Vitruvius had written that the Doric order was especially appropriate for male deities; Hercules, the mortal who achieved immortality through his self-sacrificing labors, was often allegorized in the Renaissance as a Christ type.

Bramante had at his disposal sixteen ancient Roman granite columns, and, following classical practice, used their diameter as the design module. For example, he spaced the columns four diameters apart and set them two diameters from the walls. These harmonic ratios joined with the circular and hemispherical forms to express the perfection and centrality of St. Peter.

The geometrical regularity of Bramante's design would have been greatly accentuated had his plan for a circular portico been executed (FIG. 29). It would also have created a visual tension between expanding space and compacting form, resolved only in the hemispherical dome, symbol of heaven, capped by an over-scaled and solid "lantern." The contraction to a rocklike core was an apt architectural expression of *Petrus* (Peter), the *petra* (rock) upon which the church was founded (Matt. 16:18–19); the expansion outward, its proselytizing mission; the concentric design, its unity and universality. The 48 metopes (carved reliefs) of the Doric frieze with papal regalia and sacramental implements of the Eucharist signaled that Christ and his vicars were the agents of mediation between the terrestrial and celestial church.

29. BRAMANTE
Plan of the Tempietto, from Sebastiano Serlio, *Regole generali d'architettura*, Venice, 1540. Woodcut.

Bramante planned a circular portico with sixteen columns larger than, but proportional to, the sixteen columns of the shrine. Walking around the concentric circles would have created the illusion of continuous spatial expansion, drawing worshipers centrifugally forward in a perpetual pilgrimage. Simultaneously, the portico would have centripetally concentrated the worshipers' attention on the compact forms of the Tempietto.

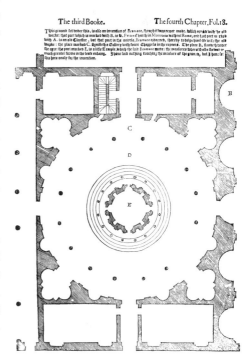

Bramante and Michelangelo: Designs for the New St. Peter's

On 18 April 1506 Julius II laid the cornerstone for new St. Peter's. The spiritual and pilgrimage center of the church was thus transformed into a chaotic construction site and would remain so for the next hundred and fifty years. More than a thousand years old, St. Peter's was in bad repair and cluttered with nearly a hundred tombs, altars, and chapels added over the centuries. At first Julius considered continuing the plan of Nicholas V, but instead boldly decided to destroy old St. Peter's, the most revered church in Christendom, and to build a colossal new centralized church designed according to the latest Renaissance architectural ideals with St. Peter's tomb as its focus. Besides addressing the problem of insufficient room for the papal court and pilgrims around the high altar, he also wanted to place his own huge tomb, commissioned from Michelangelo, near Peter's tomb in the grand new choir.

The most influential of Bramante's several plans was a Greek cross within a square (FIG. 30), the cross sybolizing the sacrificial Christ; the encompassing square, the perfection of the Church Militant. The massive dome, a temple in the sky, symbolized the Church Triumphant. The lantern on the dome, a beacon of divine illumination, created a symbolic focal point of the Christian world conjoining spirit and matter, mediating between the celestial Jerusalem and the bodies of Christ, Peter, and Julius II.

Sigismondo dei Conti (c. 1440–1512), Julius II's secretary and historian, recorded that Bramante wished "to place the dome of the Pantheon over the vaults of the Temple of Peace." Indeed, the dome's stepped exterior and the 131-foot (40 m) interior diameter were reminiscent of the stepped, 137-foot (42 m) dome of the Pantheon, architectural symbol of the Roman cosmos and now of an imperial papacy. The body of St. Peter's was probably modeled on the so-called Temple of Peace to suggest the shift of the center of Christianity from East to West, because the Basilica of Maxentius and Constantine was incorrectly believed to have been built to celebrate the conquest of Jerusalem (c. AD 70) by the Emperors Vespasian and Titus. Because it derived from the plan of Byzantine or Byzantinizing churches in Constantinople and northern Italy, the arrangement of four minor domes building hierarchically to the spatial climax of the central dome also served as a metaphor of the church's universality.

The symbolism was fairly conventional, but the design was revolutionary. For the first time in the Roman Renaissance piers were

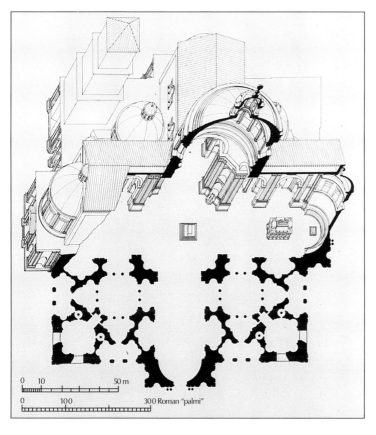

30. BRAMANTE
St. Peter's, axonometric
reconstruction.

At the corners of the square
were four towers, perhaps
symbolic of the four
evangelists and the four
gospels; the towers framed
three entrances, making
twelve in total, perhaps
symbolic of the twelve
apostles and the twelve
tribes of Israel. In the center
of each flank was a temple
front motif and a semi-
dome. These reflected on
the exterior the form of the
interior nave, transepts, and
choir – a cross with equal
arms terminating in apses.
The colonnaded drum over
the crossing raised the
dome to make it visible
from the exterior.
Underneath the dome was
the high altar over Peter's
tomb; in the choir to the
west, Michelangelo's tomb
for Julius II.

turned at angles, and walls were sculptured and molded. In a
way only hinted at in S. Pietro in Montorio, irregular and malleable
walls did not just delimit volume, they actively shaped it; space was
not just what was left over between the walls, but interacted
with them. Pure geometrical forms were evident only in the ground
plan or at the roof line; in between were dynamic solids and spaces
expanding, swelling, and rising. Given this inventive deploy-
ment of classical forms and its suitability for papal ideology, nearly
every subsequent church built or planned in Rome until the Sack
of the city was centrally planned on the model of new St. Peter's.

Underlying Bramante's achievement was the recent recovery
of the Roman technique of poured concrete, formed and cast on
site, faced with cut masonry or stucco, a process that required a
large, highly skilled, and specialized workforce carefully controlled
from the top by a supervising architect. This new bureaucra-
tized architecture mirrored in its making the increasingly bureau-
cratic papacy that called it into being.

After the death of Julius in 1513 and Bramante in 1514, work
on new St. Peter's continued intermittently under the direction

of Raphael, Baldassare Peruzzi (1481–1536), and Antonio da Sangallo the Younger, each of whom prepared alternatives with stronger walls and piers to support the huge central dome – mostly Latin-cross plans better suited to liturgical needs. Work stopped completely after the Sack and did not resume again until 1538 under the supervision of Sangallo, who built a huge and costly wooden model to guide the construction to its completion.

Appointed supervising architect after Sangallo's death in 1546, Michelangelo immediately rejected Sangallo's model, however, mocking its "dark hiding places above and below [which are] perfect lairs for crime, for forging money, raping nuns and other such roguery." Destroying part of what Sangallo had already built and redesigning the whole, Michelangelo created a remarkably lucid barrel-vaulted Greek cross with terminating apses (FIG. 31). It was surrounded by a barrel-vaulted square ambulatory (or passageway) surmounted by four minor domes at the corners and a hemispherical dome over the crossing, all supported by massively thick walls and piers.

Aerial and exterior views of the rear of St. Peter's (FIGS 32 and 33) reveal how the low peaked roof and the apses reflect the interior volume of the Greek cross; the square corners, the ambulatory; the dome, the hemispherical space over the crossing. Exterior angled piers between the apses and the corners supply more masonry to buttress the dome and reflect the interior angled piers that carry it. Never before had interior volumes been so clearly expressed by the exterior. Never before had the divine majesty

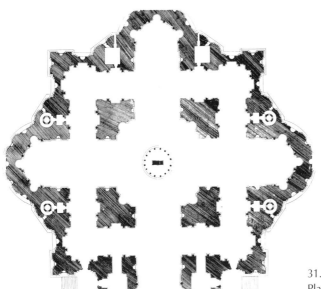

31. ETIENNE DUPÉRAC AFTER MICHELANGELO
Plan of St. Peter's, 1569. Engraving.

32. Aerial view of the rear of St. Peter's and the Vatican before the building of the Via della Conciliazione in 1929.

Between the Castel and Ponte Sant'Angelo (10–11), and the 1656–67 oval colonnade (3) by Gianlorenzo Bernini (1598–1680) surrounding the Vatican obelisk (2) can be seen (from right to left): the Borgo Santo Spirito (4), the Borgo Vecchio or Via Sacra (5), the Via Alexandrina (6), and the Borgo Sant'Angelo (7). To the left of the curving corridor linking the Papal Palace and the Castel Sant'Angelo (8) is the Borgo Pio (9) within the *civitas pius*. The Sistine Chapel (12), Papal Palace (13), and Cortile del Belvedere (14) are to the left of St. Peter's. Beginning in 1929 the area between Borgo Vecchio and Via Alexandrina was razed for the present 160-foot (50 m) wide Via della Conciliazioni, made to allow visibility of St. Peter's dome from afar. This inhuman and sterile urban design, scaled for armies on parade and armies of tour buses, succeeded in destroying the effect of surprise produced by suddenly coming upon the vast embrace of the colonnade, symbolic of the universal church.

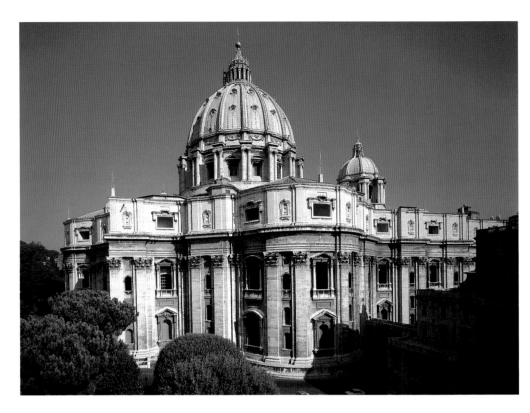

33. Dome and south flank, St. Peter's, Vatican, 1546–93.

Giant pilasters, grouped in pairs and joined by projecting entablatures, add sculptural mass and solid strength to the exterior block. Two pairs of pilasters define the apses; another two pairs, the corners; and a single pair, the angled piers between apses and corners – these last also flanked by a single pilaster bent sharply into the corners. All the pilasters are super-imposed over piers, indicated by breaks in the base and entablature, which add further lines of vertical support. Between the pilasters in rhythmic alternation are two large or three small windows and niches.

of earth and heaven been so directly and monumentally symbolized by circle and square, hemisphere and cube. Since the high attic obscures the corner domes, it is also equally remarkable how the exterior reads as a unified sculptural block, as if carved from a single mountain of travertine. This compact solidity was surely intended as a metaphor for Christ the cornerstone and Peter the rock, and its unity the oneness of the body of Christ and Christianity – precisely at the moment when the impossibility of reconciliation with the Protestants became clear.

On the exterior Michelangelo licentiously broke classical norms, played light against dark, syncopated rhythms, bent and squeezed elements, and multiplied verticals to create a visual effect of disquiet energy and unresolved struggle (see FIG. 33). But very different from his Palazzo dei Conservatori (see FIG. 14) with its skeletonized structure and emphasis on compressive load, Michelangelo has here fashioned a non-classical, almost Gothic upward surge.

A 1564 engraving by Vincenzo Luchini (FIG. 34) shows that Michelangelo intended this restless energy and upward thrust to be countered by a recessed attic which was to have read as a formless deadweight and to have emphasized its structural function as masonry loading, pressing downward to counteract the outward

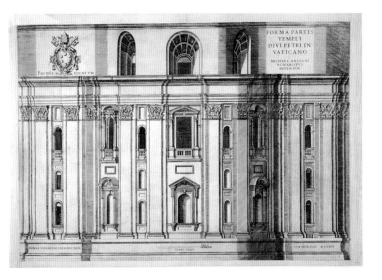

34. Vincenzo Luchini
Michelangelo's design for
the south apse of St. Peter's,
1564. Engraving. British
Museum, London.

Michelangelo's design for
an attic with completely
bare walls is confirmed by
drawings showing St.
Peter's under construction.
The unframed windows
with steeply angled
recessed panels created a
perspective illusion, making
the attic appear even
thicker and more massive.
Misunderstood by his
successors, the attic design
was changed shortly after
Michelangelo's death to its
present form (see FIG. 33).

pressure from the dome and vaults. He probably also intended a
metaphorical reading in conjunction with the walls below. That
is, the discordant energy and upward surge of the design of the
walls expressed the struggle of Christ and all humankind against
death as well as their yearning for immortality. The lack of clas-
sical equilibrium and rational order signaled that, regardless of how
strong the yearning, spiritual perfection was unattainable on earth.
The unadorned attic would have made the transition between the
terrestrial zone of the walls and the heavenly zone of the drum
and dome, signifying (by its weight and materiality) the body's
corporeality and (by its formlessness) death.

A 1569 engraving by Dupérac illustrates Michelangelo's inten-
tions for the design of the dome (FIG. 35). He followed Bramante
in raising the dome on a drum with a classicizing colonnade. Where
Bramante planned evenly spaced columns with a continuous entab-
lature, however, Michelangelo used paired columns with a broken
entablature attached to buttressing piers which were coordi-
nated with the ribs of the dome. These ribs climbed powerfully
and decisively upward to the lantern. In contrast to lower walls
which were uncanonical, uncoordinated, unbalanced, restless, and
irresolute – a sign of material imperfection – the dome was canon-
ical, coordinated, balanced, purposeful, and resolute – a sign of
spiritual perfection.

When Giacomo della Porta modified Michelangelo's design
in 1586 under Sixtus V, he raised the profile of both the dome and
lantern, emphasizing the dramatic upward surge of energy and its
release into the sky (see FIG. 21, page 43). As Dupérac's engrav-
ing shows, however, Michelangelo intended the forces to ascend

35. ETIENNE DUPÉRAC
South elevation of St.
Peter's, 1569. Engraving.
British Museum, London.

Michelangelo was inspired by the famous double-shelled, eight-ribbed dome on the cathedral in Florence by Filippo Brunelleschi (1377–1446), but he doubled the number of ribs to provide more visual lines of ascent to the climax of the lantern. He also rejected the high profile and angular facets of Brunelleschi's dome in favor of the Pantheon's hemispherical profile, which had also influenced Bramante. The attic articulation was designed by Pirro Ligorio (c. 1500–83) and the small domes by Giacomo Vignola (1507–73), Michelangelo's successors.

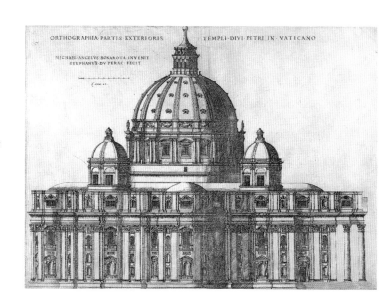

more slowly, controlled by the hemispherical profile of the dome. He also designed his lantern not to release energy upward, but to concentrate and contain it in a compact and dense mass powerfully articulated with the forms of classical perfection. What better climactic symbol for the vital, spiritual perfection of the cornerstone that is Christ or the rock that is his vicar Peter? Or for the triumph of spiritual perfection over material imperfection? Or for the conjunction of the new Rome and the new Jerusalem mediated by divine light? So compelling was the brilliance of Michelangelo's formal design that it transcended its specific symbolic meaning to inspire countless other domes all over the world, most especially on governmental buildings in non-Catholic countries.

Il Gesù

From 1527 until 1590 over fifty new churches were built in Rome and nearly all rejected the High Renaissance central plan. Rather, they developed a new longitudinal plan which reached its first full development in the Gesù of 1568–84, designed for the Jesuits by Giacomo Vignola and Giacomo della Porta under the patronage of the order's cardinal-protector, Alessandro Farnese (1520–89), grandson of Paul III.

The Gesù's huge sixty-foot-wide (18 m) barrel vault, originally undecorated, with eight large windows, provided most of the characteristics of the nave's new treatment: spatial unity, somber color, abundant light, good acoustics, and self-containment – all specifically designed for preaching to large congregations (FIG. 36).

In pre-Sack Rome sermons were usually given only during Advent and Lent. After the Sack most of the new and reformed orders, especially the Jesuits, made year-round preaching to ever larger crowds one of their principal activities and a major tool of religious reform and conversion. From Rome the practice eventually spread throughout all of Christendom.

There was also a steady increase in Masses and Communion in response to an ever more intense belief that humankind was utterly dependent on the redemptive sacrifice of Christ for salvation. In the early Renaissance few priests celebrated Mass, and, when they did, especially in churches of religious orders, it was usually offered behind rood screens invisible to the laity. After the reforms of the Council of Trent, priests were increasingly required to say Mass on a regular basis and in full view of the congregation.

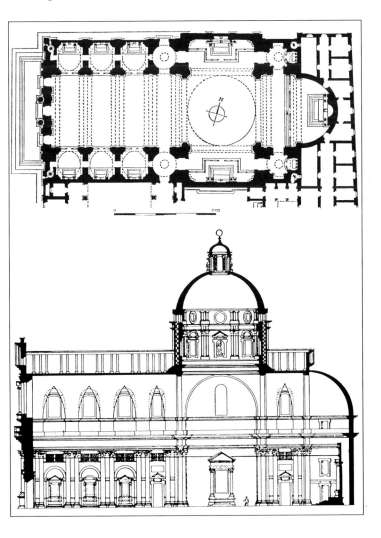

36. GIACOMO VIGNOLA
Plan and section, Il Gesù, Rome, 1568–73.

Innovative design elements emphasize the nave as a separate preaching space: the elimination of side aisles; the nave's slight separation from the crossing by the piers carrying the dome, and by the cross-axial side entrances from the street and cloister; and the nave's separation from the side chapels by marble railings. At the same time, an ambulatory for priests around the perimeter, a continuous entablature, uniform vaulting, and a modular design (based on the square of the crossing) unify chapels, nave, crossing, dome, transepts, and choir.

Eucharistic devotion also took the form of prayer before the host displayed in a monstrance on an altar. In 1550, the priest and mystic Filippo Neri (1515–95; canonized 1622), a major force in the spiritual revival of Rome, formalized this practice by establishing the ritual of the Forty Hours' Devotion in which the host was solemnly processed to the high altar and prayers were offered continuously before it for forty hours. By 1592, the Forty Hours' Devotion was moved from church to church in Rome so that the host was worshiped twenty-four hours a day, 365 days a year.

The architectural consequences of these ceremonial needs can be seen at the Gesù. The independent saucer-domed side chapels allowed the simultaneous saying of multiple Masses. In a refinement of the earlier three-apse plan, the domed crossing – emphasized by the short transepts contained within the body of the church – created a symbolic climax of celestial space and light. This set off both the nave, where the good works of preaching, prayer, and penance were accomplished, and the darker choir with the elevated and theatrically lighted high altar, where the sacrifice of Christ was reenacted in the Mass, shared in Communion, and celebrated in

37. GIACOMO DELLA PORTA Facade, Il Gesù, Rome, 1575–84.

At the lower level the four outermost pairs of pilasters precisely define the side chapels (including their walls). The outermost two pairs of pilasters at the upper level, as well as the corresponding pairs below them, frame the *space* of the nave. The design of the exterior also corresponds precisely to most features on the interior. Never before had the facade and interior been so closely integrated.

the Forty Hours' Devotion. While precedents exist for every element of Vignola's design, the coordination of the separate parts into a magnificent whole is entirely new.

The facade was designed by Vignola's successor, Giacomo della Porta, in 1575 (FIG. 37). Compared to the facade of S. Maria del Popolo (see FIG. 24) this design presents an infinitely more sophisticated solution to the problem of adapting a Roman temple front to a Christian church. The basic scheme consists of five lower bays integrated with three upper bays, each framed by paired pilasters or columns creating a strong sense of strength, stability, and balance. The upper and lower levels are linked by volutes (spiral scrolls), buttressing the vault, like the wall segments behind, their coiled energy graphically suggesting their supportive function.

This marvelous axial, hierarchical, and unified design charged with rhythmic vitality and sculptural energy, played an important urbanistic role along the Via Papale by serving first as a focal point for approaching processions and then articulating the turn to the new Via d'Aracoeli leading up to the Capitoline.

As the Jesuits and their highly successful missionary activity spread throughout the world, so too did the design of their mother church, making the Gesù one of the most influential churches in the history of architecture.

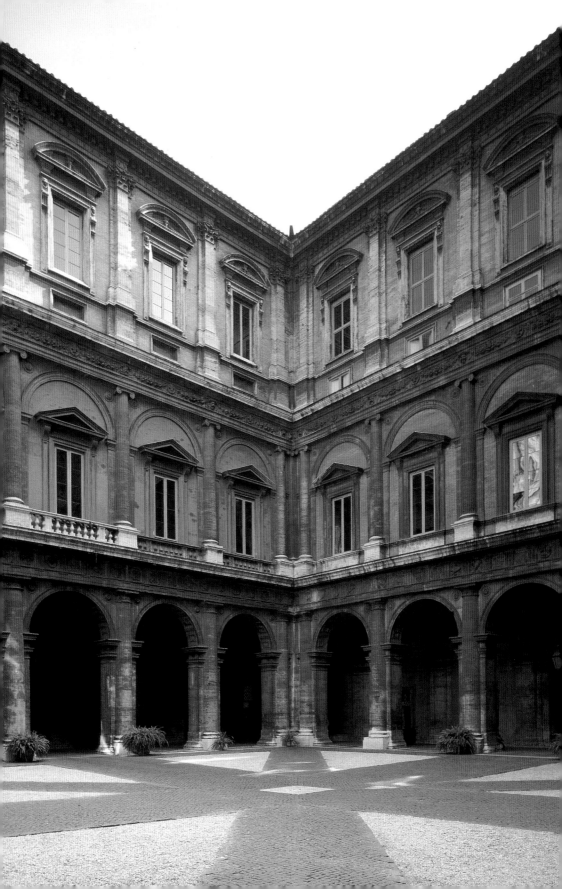

THREE

Palaces: Magnificence and Mayhem

38. ANTONIO DA SANGALLO
THE YOUNGER AND
MICHELANGELO
Courtyard, Palazzo Farnese,
Rome, 1517–89.

Michelangelo made
Sangallo's classically correct
but rather unimaginative
porticoes of the courtyard
more lively by applying a
frieze of festoons on the
middle Ionic entablature.
He also designed the third
storey of the courtyard,
which, rather like the facade
of the Palazzo dei
Conservatori (see FIG. 14),
dramatized the play of load
and support by its system of
narrow pilasters attached to
piers, and animated the wall
by inventive and capricious
windows.

T he most arresting architectural features of thirteenth- and fourteenth-century Rome were the several hundred baronial towers thrust up against the skyline at irregular intervals – fortresses against attacks of rival knights, phallic signs of military prowess. They also reflected a fragmented and warlike society dominated by a rural nobility with agricultural estates in the Campagna outside Rome. The mayhem often created by the nobles was largely unchecked, because in this period Rome mostly lacked the counterbalancing authority of a strong papacy, or, as in Florence, a powerful communal government controlled by a mercantile patriciate. Large, rambling, nondescript dwellings with exterior stairs were attached to these towers. There were also ground-floor loggias – signs of the open, nurturing, and celebratory side of clan life – for the public display of family gatherings and banquets. As the Renaissance popes slowly brought the barons under their control, they had most of the loggias destroyed and towers truncated. They also initiated a new order of dwelling designed to impress by its magnificence.

The Vatican Palace, the Palazzo Venezia, and the Palazzo della Cancelleria

One of the first and most influential of early Renaissance palaces was the north wing of the papal palace by Bernardo Rossellino (1409–64) begun under Nicholas V in 1453 and completed by Calixtus III (r. 1455–58) in 1458 (FIGS 39, nos 11-16; and 40, nos 3-6).

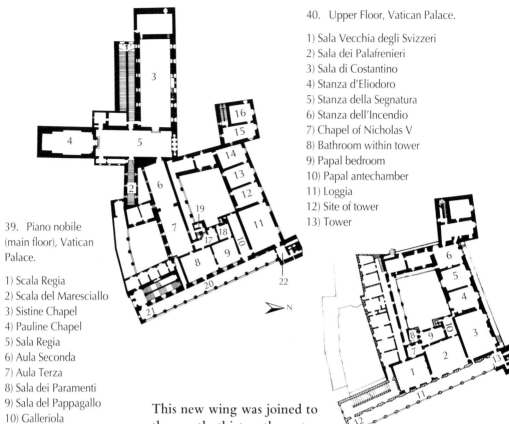

40. Upper Floor, Vatican Palace.

1) Sala Vecchia degli Svizzeri
2) Sala dei Palafrenieri
3) Sala di Costantino
4) Stanza d'Eliodoro
5) Stanza della Segnatura
6) Stanza dell'Incendio
7) Chapel of Nicholas V
8) Bathroom within tower
9) Papal bedroom
10) Papal antechamber
11) Loggia
12) Site of tower
13) Tower

39. Piano nobile (main floor), Vatican Palace.

1) Scala Regia
2) Scala del Maresciallo
3) Sistine Chapel
4) Pauline Chapel
5) Sala Regia
6) Aula Seconda
7) Aula Terza
8) Sala dei Paramenti
9) Sala del Pappagallo
10) Galleriola
11) Sala dei Pontefici
12) Sala dei Misteri
13) Sala dei Santi
14) Sala delle Arti Libere
15) Sala del Credo
16) Sala delle Sibille
17) Papal bedroom
18) Papal antechamber
19) Tower
20) Loggia
21) Site of tower
22) Tower

Halls 5–7 served for larger public consistories (assemblies of the pope and cardinals) and audiences; 9–10 for smaller semi-public or private ones; 11 for miscellaneous receptions and banquets; and 8 for the cardinals' dressing room.

This new wing was joined to the mostly thirteenth-century conglomeration of structures. The earlier rooms were largely used for the major ceremonial functions of the pope with the papal court. The uses of the new rooms of the north wing, which incorporated those built by Boniface VIII (r. 1294–1303), are not well documented, but with the exception of the papal library on the ground floor (opened only under Sixtus IV) and a room on the top floor for the Segnatura (the highest curial court presided over by the pope), they seem to have been almost exclusively state rooms for the pope himself – private audience halls, libraries, studies, and dining rooms. Access to the pope in this apartment became a rite of passage from public to private, from larger to smaller spaces. At whatever point a petitioner or intimate was allowed to reach – and the deeper the penetration, the greater the mark of privilege – the pope was further distanced and elevated by strict protocols, and, as we will see in chapter six, by the fresco decoration. The plan of the new wing, with its rational progression of rooms with doors enfilade (in a continuous line), set the standard for subsequent Renaissance palaces.

The exterior of the new wing (FIG. 41) has fortified lower walls, battlements, and a tower with a belvedere, which together project an image of strength – and defensiveness. The new tower, combined with the pre-existing two towers on the east, gave the entire papal palace the look of a late medieval four-towered ducal palace, an exemplary image of princely power, even though a fourth tower was not possible because of the location of the Sala Regia. As part of the trappings of an increasingly ritualistic and autocratic papacy, the new wing also brought a measure of order to the papal palace by creating an internal courtyard, an important precedent for later developments. Equally important were the widely imitated cross-mullion windows, derived from the papal palace in Avignon, which cast an interior shadow of a cross.

41. BERNARDO ROSSELLINO Reconstruction of the north wing of the papal palace begun by Nicholas V, 1453–55.

In 1455, Cardinal Pietro Barbo (1417–71), Venetian humanist and nephew of Pope Eugenius IV (r. 1431–37), began to build a palace adjoining S. Marco, his titular church (the church assigned to a cardinal for his financial maintenance and over which he had spiritual charge). It was to have been a more ordered version of Nicholas V's renovations at the Vatican: a square block around a central courtyard with four corner towers all surmounted by battlements.

After being elected pope as Paul II (r. 1464–71), Barbo ordered his architect Francesco del Borgo (c. 1425–68) to expand the building into a papal palace, thus establishing a strong papal presence in the center of the *possesso* route at the foot of the Capitoline as a counterbalance to the communal government. This second palace, paid for by the papal treasury and still under construction when Paul II died, was mostly completed by his nephew Cardinal Marco Barbo (d. 1491) from 1471 to 1489. It was enlarged from 1489 to 1503 by Cardinal Lorenzo Cibo (d. 1503), nephew of Innocent VIII (r. 1484–92), and modified again in the nineteenth and twentieth centuries.

On the east facade of the Palazzo Venezia (as it came to be called after 1564, when it became the Venetian embassy; FIG. 42), the first five windows from right to left belong to the new wing added after Cardinal Barbo was elected pope; the last window to the extreme left and the tower were enlargements of Lorenzo

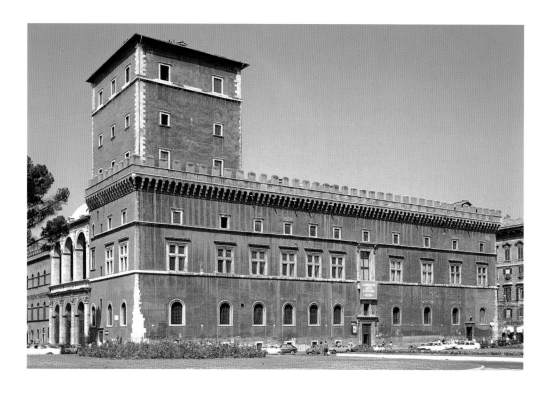

42. FRANCESCO DEL BORGO
East facade, Palazzo
Venezia, Rome,
1455–1503.

The Benediction Loggia of
1465–71 preceding the
church of S. Marco is
visible to the extreme left.

Cibo; the five windows in between belong to the original project. Although closely based on Nicholas V's new wing of the papal palace, the Palazzo Venezia is twice as large. It deploys the same symbols of strength and power – towers, battlements, and cross-mullion windows – but the design is more regular and unified, projecting a stronger image of order and harmony.

The Palazzo Venezia was also to have had a central court-yard (FIG. 43), again imitating the Vatican Palace, but again more rational and regular. It was to have been completely surrounded by a double portico, a Roman Renaissance first, inspired by the Benediction Loggia of St. Peter's (begun 1461; see FIG. 18), which in turn was derived from the piers and arches of the Colosseum (AD 72–82). The unfinished Palazzo Venezia portico (1471–89), with Doric columns on high pedestals carrying an upper order of Composite columns, however, is more massive and structural than the Benediction Loggia, and conveys a stronger sense of *romanitas* (in the ancient Roman manner), appropriate for an increasingly imperial papacy.

As a papal palace, the Palazzo Venezia had to have ceremonial spaces about equal in size and sequence to those of the Vatican (FIG. 44). In the north wing a monumental staircase provided access to the huge Sala Regia, which by analogy with the Sala Regia in

Left
43. Francesco del Borgo
Courtyard, Palazzo Venezia,
Rome, 1471–89.
Below
44. Piano nobile plan,
Palazzo Venezia, Rome,
1455–1503.

1) Scala Regia
2) Sala Regia
3) Aula Seconda
4) Aula Terza
5) Sala dei Paramenti
6) Sala del Pappagallo
7) Papal antechamber
8) Papal bedroom
9) Courtyard
10) S. Marco
11) Benediction Loggia
12) Walled garden
The early Christian church of
S. Marco was remodeled in
1465–71. The walled garden
of 1465–71 on the southeast
corner was moved to the
southwest corner in the early
twentieth century, to open
up the Piazza Venezia and
the view toward the Victor
Emanuel Monument.

the Vatican was the principal audience hall for public consistories (assemblies of the pope and cardinals), canonizations, and the reception of emperors, kings, and princes or their ambassadors. It was followed by the Aula Seconda for public consistories and the reception of lesser sovereigns and various secular officials. From here one traversed through doors enfilade to the east wing: the Aula Terza for the dispatch and reception of papal legations and the creation of cardinals; the Sala dei Paramenti, dressing room for the cardinals; the Sala del Pappagallo for private papal audiences and the daily private and semi-public consistories; and the small chambers of the pope's private apartment. Like the exterior, the plan of the Palazzo Venezia is far more logical, lucid, and harmonically proportioned than the Vatican Palace and set a new design standard.

In 1483, Sixtus IV created his young nephew Raffaelle Riario (1460–1521) a cardinal with S. Lorenzo in Damaso as his titular church. In 1489, Cardinal Riario won a huge sum of money at gambling from a French cardinal and the son of the reigning pope, Innocent VIII. With this "honest fortune" Cardinal Riario began about 1490

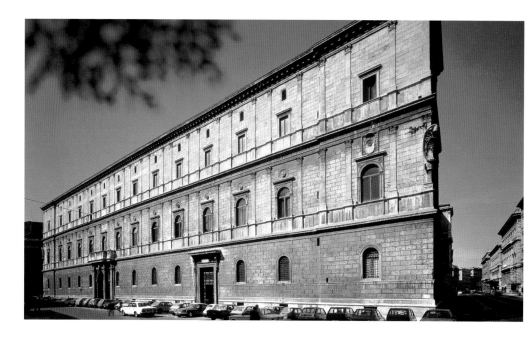

45. East facade, Palazzo della Cancelleria, Rome, c. 1489–c. 1514.

The first door opens to S. Lorenzo in Damaso. The second door with columns and a balcony, as remodeled by Domenico Fontana in 1589, opens to the courtyard.

to completely destroy, rebuild, and expand the fourth-century church and the existing mid-fifteenth-century cardinalitial palace. To make the palace (which became known as the Palazzo della Cancelleria) even larger, in 1491 he acquired two neighboring houses, invoking a recent law of Sixtus IV that allowed anyone to acquire with compensation the houses of neighbors, if planning to expand an older palace to beautify the city. Sixtus IV had also made it legal for the first time for clerics to pass on palaces to their heirs, even if built with church money, which was probably the most powerful stimulus to palace building in the entire Roman Renaissance. But since Sixtus IV had excluded palaces attached to titular churches, Cardinal Riario had no hope of willing the new palace to his heirs. Rather, he seems to have been motivated by a passion for architecture, a colossal ego, and enormous ambition.

The church and palace have a uniform east facade (FIG. 45) over 80 yards (72 m) long and almost 44 yards (over 40 m) high, making it larger than any previous cardinalitial palace. At this scale it had important urbanistic consequences, both dominating and harmonizing the entire quarter: the main eastern facade unified the new piazza that mediated between the Campo dei Fiori and the Via Papale; the southern facade straightened an entire block of the Via Pellegrino just before it entered the Campo dei Fiori and added a series of new shops contributing to the commercial life of the area; and the northern facade organized the passage

to the Via Papale. In the center of the block is a courtyard (FIG. 46) erected in 1496 and surrounded by a two-level vaulted portico carried on corner piers and free-standing granite columns, the lower columns coming from the nave, the upper ones from the aisles of the old church of AD 380. This open, airy, unified space – the largest in Italy, to date – was the first courtyard with porticoes to be completed in the Roman Renaissance.

The towers on all four corners, which have thicker walls than the rest of the palace and project slightly forward on the eastern facade, also make this the first four-towered palace of the Roman Renaissance to have been realized, even though it followed the lead of the Vatican Palace and the Palazzo Venezia. But since the towers have no battlements and are contained within the uniform crowning cornice, they are purely symbolic, signs of Riario's claim to princely power and status in line with the dignity of his family, the lords of Imola.

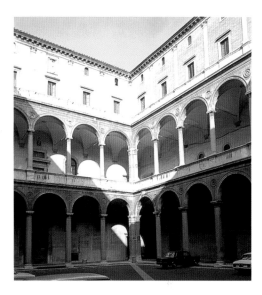

46. Courtyard, Palazzo della Cancelleria, Rome, c. 1489–c. 1514.

The interior contains a large number of apartments and rooms for the cardinal's *familia*, or court. The principal rooms on the piano nobile (or main floor), however, imitate those of the Vatican Palace and the Palazzo Venezia, having a nearly equivalent sequence of Sala Regia, Aula Seconda, Sala dei Paramenti, Sala del Pappagallo, and chapel followed by Cardinal Riario's private apartment with bedroom, study, and bathroom overlooking the gardens at the back. In contrast to Cardinal Pietro Barbo, who transformed his palace into a papal palace after being elected pope, it seems as if Cardinal Riario built his palace in eager anticipation of papal election, following in the line of his relatives Sixtus IV and Julius II, whose coats of arms flank the main facade on the corners of the northeast and southeast towers.

The most remarkable feature is the use of classical orders on the facades, the first such occurrence in the Roman Renaissance. Previously only Roman church facades featured classical orders, but here the palace has absorbed and co-opted the sacral character of the titular church to the greater glory of Cardinal Riario. His coat of arms or rosette device appear above every window on the eastern facade of the piano nobile, and the long inscription in the frieze of the entablature trumpets: "Raphael Riario Sansoni, Deacon of St. George, Chamberlain, and Cardinal of the Holy Roman Church by the honor of Pope Sixtus IV, built from the

foundations in 1495 under Pope Alexander VI with honest fortune this palace and temple dedicated to S. Lawrence Martyr."

The facade design is a Florentine import derived from the ideas of Alberti, as represented on the Palazzo Rucellai (1440s–1460s) built by Bernardo Rossellino. The key new elements are the expression of structure by classical orders, and symmetrical and proportional relationships between the parts and the whole. Social hierarchy determines the arrangement of elements: the rusticated (or rough-hewn stone) base is subordinated to the upper stories, while the upper storey (actually two stories) for retainers and servants is subordinated to the piano nobile, which, in turn, is emphasized by its greater height, richer carving, more classicizing arched windows, and the profusion of verbal and heraldic signs establishing Cardinal Riario's claims to rank, privilege, and power.

When in 1516 Cardinal Riario was disgraced for his involvement in a conspiracy to murder Pope Leo X, he was forced to pay a huge fine and to give over his palace to the papacy for use as the chancellery (hence Palazzo della Cancelleria). A product of an urbane and intelligent cardinal, the palace is also a monument to self-glorification and failed ambitions.

The Cortile del Belvedere

Challenged by the developing ideals of Renaissance palace design, Julius II commissioned Bramante to renovate the Vatican Palace. To improve circulation between rooms and present a more unified and imperial facade to the city, Bramante (and his successor, Raphael) built a three-story loggia with connecting stairways on either end, modelled on the ruins of the Septizonium (AD 203), an architectural screen built to mask the foundations of the imperial palace on the Palatine Hill when seen from the Via Appia. A new conclave hall, chapel, and massive stables were also planned, but never built.

By far the most important part of Bramante's scheme, however, was the Cortile del Belvedere (FIG. 47), begun in 1503 and completed only in 1563. It was designed to provide a covered and level passage between the papal apartments and the Villa of Innocent VIII (1485–88; see FIG. 10) by two parallel porticoes diminishing in height from three to one stories in response to the rising terrain of Monte Sant'Egidio. Derived from ancient elevated walkways, such as the one that once linked the Palace of Augustus on the Palatine to the Capitoline, and decorated with a triumphal arch motif, each arm suggested a symbolic triumphal way, elevating and privileging the pope and his court.

The space between the porticoes was developed into a garden of imperial scale. The lower court with tiered seating at the north end served as a theater for such papal spectacles as dramas, jousts, and bull fights. The towers at either end of the seating buttressed the porticoes, masked a necessary rise in the roof line, and improved the acoustics for the theater by narrowing the space. Stairs in the center of the seating led to an intermediate level with a fountain grotto. This nymphaeum was flanked by classically inspired double-ramp stairs which led to a hanging garden with open porticoes along two sides and an exedra (niche) with convex and concave stairs at the north end. Behind the exedra was a sculpture court for the papal collection of ancient works of art to which the public had access by a new spiral stairway. As the first museum since antiquity, the sculpture court vividly signalled papal wealth and classical erudition.

The entire ensemble functioned like a gigantic perspective construction, calculated to be viewed by the pope from the new wing of the Vatican Palace. The classical motifs, vocabulary, and scale – this was the largest architectural project since antiquity – helped to construct papal claims to a universal temporal empire, and the perspective scheme was a visual metaphor for the ideal Christian Commonwealth: ordered, unified, hierarchical, all-encompassing, and controlled by the all-seeing presence of the pope.

The Palazzo Caprini and the Palazzo Branconio d'Aquila

At the same time that Bramante was renovating the Vatican Palace, he was overseeing work on the Palazzo Caprini (c. 1510; FIG. 48), the first Roman High Renaissance palace which, in its correct use of classical orders on the facade, broke with both the local Roman design tradition (the Palazzo Venezia) and that imported from Florence (the Palazzo della Cancelleria).

47. Reconstruction of the Cortile del Belvedere as designed by Bramante in 1503; it was completed in 1563 under Pius IV with modifications by Pirro Ligorio, Michelangelo, and others.

1) Sistine Chapel
2) Sala Regia
3) Aula Seconda
4) Aula Terza
5) East wing of the Papal Palace
6) North wing of the Papal Palace
7) Borgia Tower
8) Lower court with side entrance aligned with the Borgo Pio
9) Intermediate court with a grotto and double-ramp stairs
10) Upper court terminating in an exedra with convex and concave stairs
11) Sculpture court
12) Spiral stairs
13) Villa of Innocent VIII

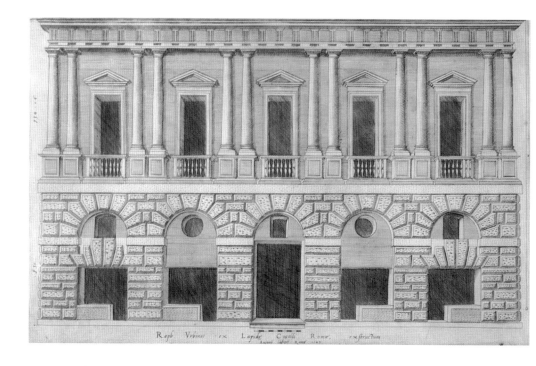

48. ANTONIO LAFRÉRY
Facade of the Palazzo
Caprini in the Vatican of
c. 1510 designed by
Bramante; from *Speculum
romanae magnificientiae*,
Rome, 1549. Engraving.
British Museum, London.

The palace was
commissioned by curialists
Adriano Caprini da Viterbo
(d. c. 1510) and his brother
Aurelio Caprini (d. 1524),
and purchased in 1517 by
Raphael. Once located on
the corner of the Piazza
Scossacavalli and the Via
Alexandrina, the palace
was destroyed in 1936 for
the building of the Via della
Conciliazioni.

The income-producing shops on the ground floor did con-
tinue a local Roman tradition going back to antiquity, but the
rough and massive yet rational and varied rustication was new, an
appropriate metaphor for the commercial activity of the shops.
If the evidence of Antonio Lafréry's engraving can be trusted, the
shop openings were arranged symmetrically; the narrow door that
led to the stairs climbing to the piano nobile created a central
emphasis; the outside framing bays were visually strengthened by
flat arches with massive voussoirs, or wedge-shaped stones; the
mezzanine windows above the shops were symmetrical but rhyth-
mically varied; a smooth cornice at the springing of the arches sep-
arated the random pattern of the rusticated piers below from the
uniform rustication of the arches and spandrels above.

Another smooth cornice separated the shops from the liv-
ing quarters defined by paired Doric engaged columns on pedestals
carrying a crowning Doric entablature. Within the identical bays
of the piano nobile were large windows topped with triangular
pediments and coordinated with the pedestals of the columns by
balustrades. Compared to the more "natural" and primordial effect
of the shop level, this floor communicated a sense of rigorous intel-
lectual control, solid stability, classical learning, and civilized refine-
ment appropriate for the Caprini brothers and later for Raphael.
The effect of the entire design was unity and order within which

FACCIATA DEL PALAZZO ET HABBITATIONE DI RAFAELE SANTIO DA VRBINO SV LA VIA DI BORGHONOVO FABRICATO
CON SVO DISENGNO L'ANNO MD.XII.IV
CIRCA-ESEGVITO DA BRAMANTE DA VRBINO

49. P. Ferrerio
Facade of the Palazzo
Branconio d'Aquila in the
Vatican, c. 1515–20,
designed by Raphael; from
Palazzi di Roma, Rome,
1655. Engraving.

The palace was built for the
papal notary Giovanni
Battista Branconio d'Aquila
(1473–1522), who
indicated his allegiance to
Leo X by placing the papal
coat of arms in the center of
the facade. The palace was
destroyed in the mid-
seventeenth century to
make room for Bernini's
colonnade in Piazza S.
Pietro.

the various functions and socio-economic strata have been clearly
expressed and differentiated.

Raphael's Palazzo Branconio d'Aquila of c. 1515–20 was closely
related to the Palazzo Caprini and just around the corner from it
(FIG. 49). Common to both was a unified block of five bays with
shops on the ground floor flanking a central doorway. The Palazzo
Branconio d'Aquila, however, was a larger building with three
levels incorporating five floors, and the engaged columns of the
five identical bays of the shops more solidly supported the base of
the piano nobile with its projecting pedestals under the niches,
columns, and window sills. Between the files of windows were
segments of wall or piers that actually supported the building, but
the appearance seems to tell another story. According to classi-
cal precedent, one would have expected columns or pilasters express-
ing vertical support continuous with the Doric columns below,
but there were only hollow niches, drooping festoons, and rec-
tangular panels that deliberately seemed to undercut the supporting
function of the piers and weaken the corners. The structural
elements framing the windows on the piano nobile (engaged Ionic
columns carrying alternating triangular and rounded pediments)
were placed over arches, unsupported from below. The mezzanine
level had no apparent support, and its festoons and the low hor-
izontal windows played against the taut rise of the pediments over

the piano nobile windows, just as the raised relief of its portrait medallions *all'antica* contrasted with the hollowed-out niches below. Finally, the rectangular panels near the top intended for relief sculpture, and the open balustrade above the crowning cornice, produced a less decisive termination of the block than the Doric entablature of the Palazzo Caprini.

The two palaces, then, offered two very different examples of the use of classical vocabulary, and both influenced much subsequent palace design: Bramante's was more canonical, structural, intellectual, controlled; Raphael's was more whimsical, restless, imaginative, and pictorial. Michelangelo's Palazzo dei Conservatori (see FIG. 14) developed Bramante's paradigm along the lines of greater dramatization of load and support, as we saw in chapter one. The Palazzo Massimo delle Colonne, as we will see, drew on Raphael's more pictorial mode.

The Palazzo Massimo delle Colonne

The Palazzo Massimo of 1533–35 by Peruzzi for the Roman noble Pietro Massimo (c. 1480–c. 1532) is remarkable for its unprecedented curved facade (FIG. 50), designed to respond to the turning of the Via Papale (see FIG. 11). The regular beat of paired Doric pilasters and columns on the ground floor seems to mirror the rhythm of a passing procession such as a *possesso*. The rhythm is also syncopated by the change from pilaster to column in the middle of the third beat and from column back to pilaster in the sixth. The loggia is stressed by its greater width, three dimensionality, chiaroscuro, and alignment with the Via del Paradiso which meets the Via Papale at right angles.

The formal tension between vertical and horizontal elements within this facade is an apt expression of the mixed loyalties of its patron. Pietro Massimo came from a family of landed nobles traditionally hostile to papal and communal encroachments on its power. Yet Pietro was given a humanist rather than a military education, worked for the papacy, and held important communal offices. As overseer of the streets, he worked directly under the papal chamberlain according to a papal agenda that included the maintenance and beautification of the Via Papale. The classic elegance and refined sophistication of the facade of the palace reflects Pietro's humanist education, and the processional rhythms and curvature of the facade his sensitivity to urban design as an overseer. Since family loggias had been banned by the papacy, the loggia here – which is both withdrawn into the block of the building yet the centerpiece of the design – is an under-

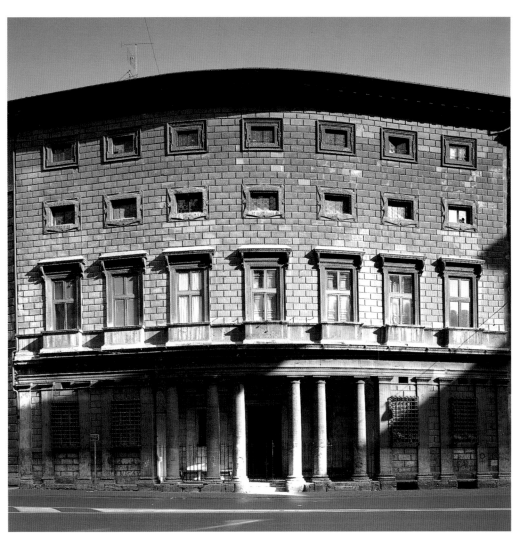

stated but rebellious revival in classical dress of a medieval sign of clan solidarity, pride, and strength.

The Palazzo Farnese

When he was elected Pope Paul III in 1534, the palace Alessandro Farnese had begun in 1517 as a cardinal was expanded to become a symbol of Farnese's new status and a residence for his cardinal nephews, first Ranuccio (1530–65), then Odoardo (1573–1626). When completed in 1589, the Palazzo Farnese (FIG. 51) was the grandest cardinalitial palace in Rome, boasting the largest court.

The palace is an impressive example of a style invented by Antonio da Sangallo the Younger, characterized by a rectangular block

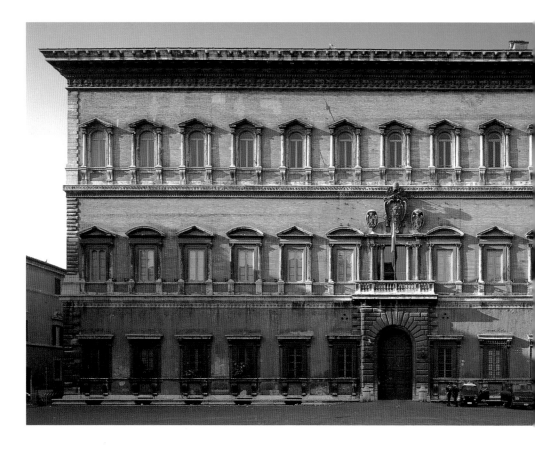

without shops unified by a large crowning cornice of classical
design; quoins (corner-stones derived from military architec-
ture) to protect the corners; facades divided into horizontal layers
(usually three), diminishing in size toward the top; and a square
or rectangular courtyard with a portico (see FIG. 38, page 61).
The type was very influential in Rome because it employed a bal-
anced, flexible, and quickly mastered additive system that could
be easily expanded or contracted, and a limited number of stan-
dardized elements that could be relatively efficiently and cheaply
produced. It also avoided the complex problems of proportion and
overall coordination demanded by the designs of Bramante or
Raphael. The Lateran Palace built by Domenico Fontana for
Sixtus V (see FIG. 19) is one of many examples inspired by the San-
gallo type.

The plans reveal something of the number and variety of spaces
needed for a court of about three hundred. On the ground floor
(FIG. 52) the barrel- and groin-vaulted portico provides covered
access to the ground-floor rooms and a triumphal way to the mon-
umental stairway conducting directly to the entrance of the *salone*

51. Antonio da Sangallo the Younger and Michelangelo
North facade, Palazzo Farnese, Rome, 1517–89.

Michelangelo, who became the architect after Sangallo's death in 1546, changed the initial design to produce one of the most magnificent palaces in Rome. He modified and enlarged the central window and placed the Farnese coats of arms above, which gave a hitherto lacking focus to the piano nobile. He also added a larger crowning cornice – and raised the top storey by 10 feet (3 m) so that it would not appear to crush the upper windows – which more forcefully unified the whole. After Michelangelo's death in 1564, the palace was completed by Giacomo Vignola and Giacomo della Porta.

52. Ground plan, Palazzo Farnese, Rome, 1517–89.

Three barrel-vaulted entrances or vestibules lead to the courtyard. The main entrance, a carriageway, is flanked by coffered pedestrian walks. Directly opposite a barrel-vaulted passage leads to the gardens which extend to the Via Giulia and which are overlooked by a three-story loggia at the rear of the palace.

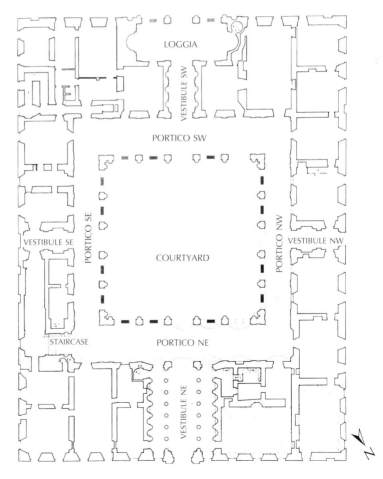

53. Piano nobile, Palazzo Farnese, Rome, 1517–89.

The huge two-storey *salone* on the front facade, lighted by five windows, is followed by a sequence of three rooms of diminishing size (A, B, and C) with doors enfilade, the last of which also gives access to the chapel (D). The room in the center is the Sala dei Fasti Farnese with frescoes by Francesco Salviati (discussed in chapter six).

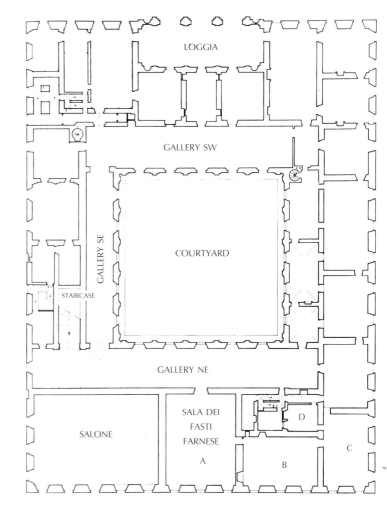

and upper portico on the piano nobile (FIG. 53). Here were the state rooms of a cardinal-prince once filled with splendid works of art such as the famous *Cassetta Farnese* by Manno Sbari (d. 1576) and Giovanni Bernardi da Castel Bolognese (1496–1553; FIG. 54). The plan was based on the sequence of halls of state in the Vatican Palace (see FIG. 39) reflecting similar ceremonial protocols and suggesting that a cardinal, whose principal and almost only duty was to advise and elect the pope, was himself a kind of mini-pope, or at least *papabile* (eligible to be elected pope). According to Paolo Cortesi (1471–1510) in a chapter on cardinals' palaces in *De cardinalatu* (*On the Cardinalate*, 1510), the functional arrangement and harmonious design of rooms were also intended to promote a virtuous and orderly life.

Taking to heart the Aristotelian notion that magnificence was a necessary part of virtue, Cortesi also argued that cardinals

were duty-bound to live a sumptuous life commensurate with their princely status, avoiding the apostolic poverty championed by Erasmus and others. Thus, cardinals' palaces should be "attractively designed and sumptuously executed" so that "the ignorant mob will be deterred from threatening the cardinals with harm and from plundering their goods by the mightiness of the building and through admiration for its opulence." It was, in fact, a calculated papal policy to encourage and even fund a princely lifestyle for the cardinals in order to enhance the dignity of the church, solidify papal control over the city, and quash popular mayhem. But what Cortesi fails to say is that by this same policy ever more authoritarian popes also bought the acquiescence and obedience of cardinals whose power they increasingly diminished.

54. MANNO SBARI AND GIOVANNI BERNARDI DA CASTEL BOLOGNESE *Cassetta Farnese*, c. 1543–61. Silver gilt and rock crystal. Gallerie Nazionali di Capodimonte, Naples.

Commissioned by Cardinal Alessandro Farnese, perhaps to house a rare classical manuscript. Hercules sits on top, while Minerva, Mars, Diana, and Bacchus sit at the corners. Engraved crystals on the front illustrate an *Amazonomachy* (battle between Amazons and Greeks) and a *Battle of Centaurs*; on the back, the *Calydonian Boar Hunt* and the *Triumph of Bacchus*; on the ends, a *Chariot Race* and a *Naval Battle*.

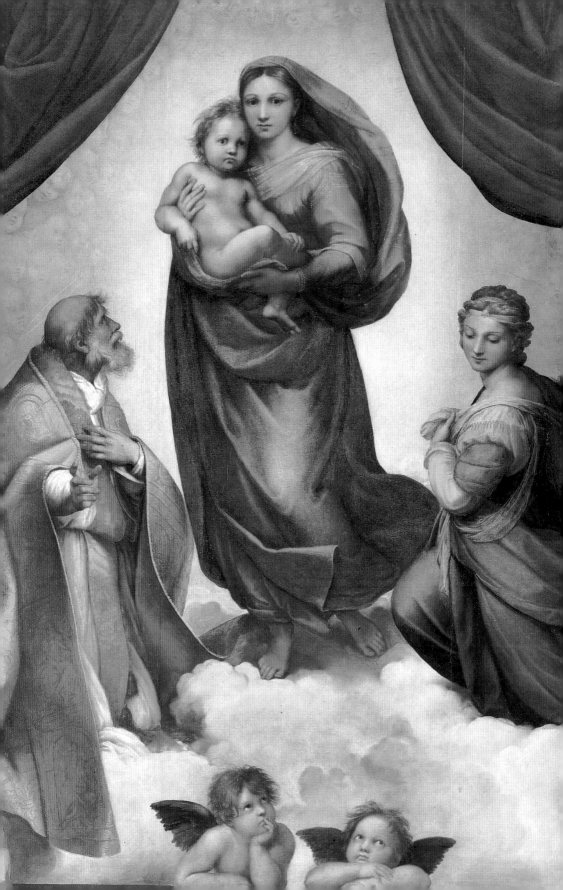

FOUR

Altarpieces: Spirit and Matter

55. RAPHAEL
Sistine Madonna, c. 1513.
Oil on canvas, 8'8" x 6'
(2.6 x 1.9 m).
Gemäldegalerie, Dresden.

The sill and the illusionistic green curtains hanging from a rod above decisively separate the material and spiritual worlds. For the moment the curtains have been pulled back to reveal a window on to heaven, a manifestation of divinity seemingly taking place in real time that allows spirit and matter to conjoin, as in the ritual of the Mass once conducted before the painting.

ltarpieces gave visual form to beliefs about the Mass or Eucharist. The essential core of the Mass was the conse-cration and elevation of the host and chalice, when the bread and wine were mystically transformed into the body and blood of Christ (called Transubstantiation) and held aloft as an offering to God for adoration by the faithful (FIG. 56). At this moment the altar was believed to be flooded with the divine spirit joining the terrestrial rites with a parallel rite celebrated perpetu-ally in heaven by angels and saints.

This conjunction of the Churches Militant and Triumphant, spirit and matter, which altarpieces always expressed in some form, was based on the Renaissance belief in the dual nature of God and humankind. Humans, it was held, were tainted with the origi-nal sin of Adam and Eve and thus subject to sin and death. Yet being created in the image and likeness of God, they also had divine souls yearning to return to their spiritual source. God was pure spirit, but took on material form in Jesus Christ, who, by his sacrifice and resurrection, redeemed humanity of original sin. By participating in the liturgy commemorating Christ's redemp-tive sacrifice and consuming the bread and wine in Commu-nion the faithful imitated Christ in renouncing worldliness and sin, and were offered the possibility of salvation through his mercy and grace.

An altarpiece also generally reflected the dedication of the altar and the interests of the patron – mostly the laity outside of Rome, but in Rome frequently the clergy. Its commission and execu-tion were understood in themselves as good works, as public expres-sions of piety and devotion, which – along with the devotions per-formed before it – would help merit salvation.

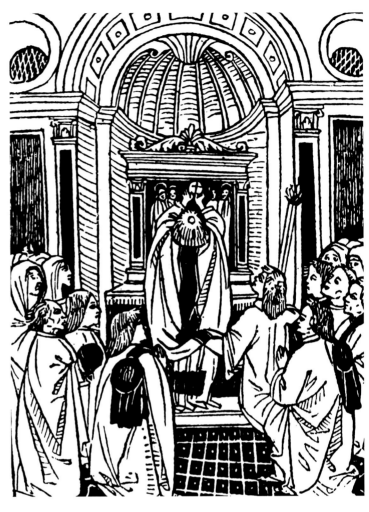

Two Altarpieces of the Early Renaissance

The first major work of art produced in Rome after Pope Martin V returned in 1420 to end the Schism was an altarpiece: the double-sided panel with the *Assumption of the Virgin* (FIG. 57) on the front and the *Founding of S. Maria Maggiore* (FIG. 58) on the rear. Commissioned by Martin V himself for the high altar of S. Maria Maggiore, this painting was executed c. 1428–32 by Masolino da Panicale (active 1423, d. 1447) in a style transitional between the International Gothic and the Renaissance. As the Virgin was both the patron of this church and the embodiment of *the* church, the *Assumption,* addressed to the congregation, expressed the triumph of the Church Militant. The resurrected Christ welcoming his mother into heaven with open arms symbolized the Church Triumphant.

The depiction of the angels of the heavenly hierarchy follows the Homilies on the Gospels by Gregory the Great: the red Seraphim and blue Cherubim, closest to the Virgin and Christ, are emblems of divine love and wisdom; the Thrones with blue mandorlas (almond-shaped haloes) form a symbolic throne for Christ; the Dominations in red with orbs and scepters symbolize the universal authority of the church; the Principalities with banners of St. George protect Christendom; the Powers in armor with shields and swords guard heaven and fight against evil; and the Virtues with inscribed scrolls bestow grace and work miracles.

The *Founding of S. Maria Maggiore*, directed to the clergy in the choir, shows Pope Liberius (r. 352–66) tracing the outline of the church's plan with a hoe in the summer snow of AD 352, generated by Christ from a dark cloud above. The miraculous snow and its cruciform shape signify the church as divinely ordained and founded on Christ's redemptive sacrifice. By tracing the plan the pope performs an *imitatio christi* of sorts, connoting that the church is controlled and shaped by Christ's vicar. The pope's supremacy is highlighted by his visual prominence, the hierarchical arrangement of the clergy behind him, and the action of the cardinal carrying his cope. The clergy is in the favored location to Christ's right, yet the blessing by the Virgin of the laity to the left implies harmony and union between the two groups. These were all urgent messages from Martin V returning to an unreceptive Roman populace after a long period of absence and schism, when the authority of the church and the prestige of the pope were at an all–time low.

Masolino heightens the topographical realism of the landscape by using the recently discovered system of one-point perspective employing a system of orthogonals and a vanishing point: the architectural cornices (the orthogonals), when extended, come together at the center of the middleground (the vanishing point). The perspective decisively separates the material world of space and time from heaven above. The hieratic expressions and gestures of Christ and the Virgin, the radiant gold ground etched with light rays, and the encompassing rainbow define an immeasurable, infinite, and unchanging spiritual world derived from scenes of the Last Judgment at the end of time. Thus, the altarpiece like the Mass visually mediates between heaven and earth, spirit and matter, here and hereafter. The agent of mediation is shown to be the pope and the Roman Church.

Greater drama, unity, and verisimilitude sharply distinguish the early Renaissance style of the *Annunciation* by Filippino Lippi (1457–1504) of 1488–93 (FIG. 59) from the more casual and courtly

57. MASOLINO DA
PANICALE
*Assumption of the
Virgin*, 1428–32.
Tempera on panel, 56
x 30" (142 x 76 cm).
Gallerie Nazionali di
Capodimonte, Naples.

Christ's status as the
invisible church has
been indicated by his
strong foreshortening
and billowing sky-blue
robe. By contrast, the
Virgin is frontal and
massive, a sign of her
status as the visible
church; her white robe
and gesture evoke purity
and sanctity. The angels
at the bottom with the
lute, portable organ, *lyra
da braccio*, and lyre
create divine harmony
and serve as messengers
to humankind. As a
whole, the altarpiece
constructs an image of
the hierarchical church
mediating between
heaven and earth.

58. Masolino da Panicale
Founding of S. Maria Maggiore, 1428–32. Tempera on panel, 57 x 30" (144 x 76 cm). Gallerie Nazionali di Capodimonte, Naples.

The landscape is a topographically accurate view of what could be seen from S. Maria Maggiore looking southwest: Testaccio (a Roman dump-heap of broken pots), the so-called Tomb of Remus, the Porta S. Paolo, the Aurelian walls, and the Alban Hills. This new example of Renaissance realism forges a link between Rome's founding and the church's founding, between the Roman Empire and Christendom.

International Gothic style of Masolino. Combined with his dramatic interaction of all the figures, Lippi created an overwhelming sense of continuity between the world of the altarpiece and that of the worshiper. He has focused the lines of perspective and light directly on the Virgin. He has shown a medieval saint and a contemporary cardinal in the intimacy of the Virgin's bedchamber. He has shaped the picture in the form of a window and repeated the classicizing architecture of the carved stone frame within the painting. He has, in short, made sacred history materially and psychologically present as never before in Rome.

The altarpiece also elevates the worshiper from the material world to a contemplation of the spiritual. Meditation on sacred images was an important part of Dominican devotion, and here the presence of the patron within the painting in an attitude of prayer and in the company of a major theologian makes the theme of meditation explicit. The perspectival focus on the Virgin's womb would concentrate thought on the mystery of the Incarnation of God in the human form of Christ. The sadness of the Virgin's face expresses her foreknowledge of her son's fate, which was originally represented in a relief of the Dead Christ on the frame, before the lower part of the altarpiece was damaged by the installation of a tabernacle. The central axis, then, would have focused contemplation on the essential elements of the Christian story commemorated in the Mass: Christ's redemptive birth and death. The address to the Virgin's womb would also invite consideration of her virginity and purity, and the passageway to the left with a traditional *porta clausa* (closed door) symbolizes the mystery of the unbreached womb. Since this dark vestibule contains the coat of arms of Cardinal Carafa in the center of the barrel vault and echoes the shape of his adjacent burial chapel, it would also symbolize the doorway to the new Jerusalem reached only through death. Finally, the gestures of the Virgin and St. Thomas directed to Cardinal Carafa, and the centrality of the Virgin between Gabriel and the cardinal graphically signalled the church's fundamental mediating role in salvation, and the role of saints such as Thomas as intercessors and examples of virtue.

59. FILIPPINO LIPPI
Annunciation, 1488–93. Fresco, Carafa Chapel, S. Maria sopra Minerva, Rome.

The altarpiece – on an altar dedicated to the Virgin Annunciate and St. Thomas Aquinas (c. 1225–74), the great Dominican theologian – shows Gabriel, accompanied by the Holy Spirit, alighting on tiptoe and announcing the Virgin's conception. The Virgin, just a moment before kneeling in a chair and praying before her lectern (the pages of the scriptures still seem to be fluttering), has rotated and glanced sidelong toward Gabriel. She raises her hand in a gesture that registers both surprise and welcome and simultaneously blesses a kneeling cardinal. The cardinal – Oliviero Carafa (1430–1511), patron of the chapel and cardinal-protector of the Dominicans – looks across at Gabriel. Thomas Aquinas gazes at the Virgin as he presents the cardinal.

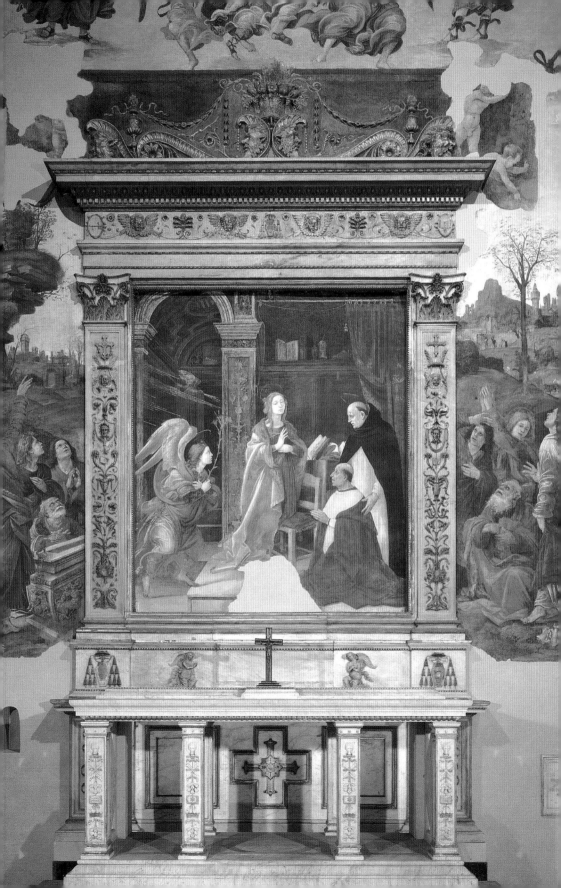

Raphael: The Sistine Madonna and the Transfiguration

The basic duality of any altarpiece – divinity within matter, time, and space, and divinity as eternal spirit – are pushed much further and more convincingly joined in dynamic equilibrium in Raphael's High Renaissance *Sistine Madonna* of about 1513, now in Dresden (see FIG. 55, page 79). The work was commissioned by Julius II for the high altar of S. Sisto in Piacenza, in part to commemorate his expansion of the Papal State northward to this city. Raphael chose saints Sixtus II (r. 257–258) and Barbara to accompany the Virgin and Child, the church having been dedicated to the martyred pope, and his relics and those of St. Barbara housed within. Like Lippi, Raphael used symbols to express the presence of divinity: cherubim-filled clouds, and two angels, who, leaning on the window sill at the bottom of the painting and gazing heavenward, mark the division between the spiritual and material worlds. But unlike Lippi, Raphael depends more on formal devices to convey the perfection of the divine: the stunning beauty, suave curvilinearity, and graceful harmony of the Virgin and Child, the enveloping golden radiance, the instantly graspable compositional order, and the clear hierarchical arrangement of figures. Simultaneously, Raphael's divine figures seem to be alive, approachable, and humane. More than any previous painting, Raphael here holds in balance the paradox of a divinity which is perfect, omniscient, and omnipotent, as well as human, loving, and compassionate.

The Virgin walks forward and downward along a slight diagonal toward the worshiper, her drapery swinging in response to her movement, her weight-bearing right leg providing visual support for the innocent and somewhat disheveled Christ Child, whom she holds up and displays, just as the priest elevates and displays the host. She conveys all the human warmth, softness, and sensuousness of Raphael's mistress, on whom she was modeled, yet she also looms above the viewer sublimely lovely and loving, suffused with an otherworldly light. While Christ looks directly out at the worshiper, his eyes conjure up the maturity and knowledge of the ages. His expression makes the Virgin's seem all the more introspective and poignant as she sadly anticipates the coming sacrifice of Christ reenacted in the Mass below. While tender and maternal, the Virgin also represents the figure of Wisdom in the book of Ecclesiasticus that made "light that never faileth, and as a cloud...covered all the earth," as well as "the woman clothed with the sun" of the Apocalypse who "brought forth a

man child who was to rule all nations...[who] was taken up to God, and to his throne." Like the first text, the painting emphasizes the Incarnation of God in Christ (prefigured by Wisdom from the beginning of time), but, like the second, it also implies the Second Coming of Christ. The altarpiece collapses into one image a single moment of time, the span of all time, and the end of time.

St. Barbara assumes a dynamic kneeling posture, a knot of potential movement (FIG. 60). She pulls one leg back, juts the other forward; with one arm she points back to her attribute of a tower, with the other she reaches around her torso to grasp her veil. Her torso is turned backward to the Virgin, and she rotates her head and neck sharply to follow her glance downward to the angels. This coiled spiral of energy finds release in the Virgin, whose movement is carried through St. Sixtus toward the faithful. This arc of movement is reinforced by the progressions of color from cool (St. Barbara) to warmer (Virgin) to hotter (St. Sixtus); a progression of psychological expressions from classicizing aloofness to pensive melancholy to passionate adoration; a progression of gestures from pointing backward at a symbol of virtue to frontal display of divinity to emphatic registration of piety and connectedness between the realms inside and outside the painting. Finally, this same compositional arc appropriately places Barbara and Sixtus in front of and below the Virgin, foregrounding their intercessory as well as their exemplary faith and sacrifice believed to be necessary for all humankind to achieve the spiritual benefits of Christ's sacrifice.

The inclusion of St. Sixtus II honors Julius II's uncle, Sixtus IV, who took the martyred pope as his namesake. But Sixtus II is also a portrait of Julius II still wearing his beard of 1510–12 as penance for his initial losses at the hands of the French. Very different from Lippi's Carafa altarpiece, then, the donor here is shown not as a witness to sacred history but in heaven as part of it. By attributes, gestures, and glance the pope – and the reference is to all popes across time to the present – is depicted as a penitent, supplicant and sanctified intercessor mediating between spirit and matter. On the sill, the threshold between heaven and earth, the tiara symbolizes his universal authority, endorsed by the Virgin and Christ Child whom he adores. The gesture of the pope's right hand, similar to that of a priest elevating the host (see FIG. 56), links the celebration of

60. RAPHAEL
Sistine Madonna, c. 1513 (detail of fig. 55 page 79). Oil on canvas, 8'8" x 6' (2.6 x1.9 m). Gemäldegalerie, Dresden.

Mass in the church below the altarpiece to the spiritual world of the painting.

Raphael's *Transfiguration* was commissioned in 1517 by Cardinal Giulio de' Medici (1478–1534, later Pope Clement VII, r. 1523–34) for his archbishopric in France (FIG. 61). To provoke the best efforts from each, the cardinal also in 1517 commissioned Sebastiano del Piombo (c. 1485–1547) to paint the *Raising of Lazarus* (discussed below) for the same church, deliberately setting up a competition between Raphael and Sebastiano (and Sebastiano's friend Michelangelo, who helped in the design). Never before in the Roman Renaissance had original invention and personal style been so clearly valued for themselves; nor had the patron's high level of connoisseurship and refined taste been so evident. As a corollary, the status of artists was never higher than in these years, primarily because of the enormously inventive and individualistic works of Raphael and Michelangelo. Encouraged by such humanists as Alberti, they no longer viewed themselves as craftsmen and members of the mechanical arts. Instead they claimed membership in the liberal arts and commanded the highest prices and patronage because of the specialized training, intellectual effort, and cultural knowledge required continually to exceed their own previous best efforts and those of their rivals, to create like demi-gods something entirely new from nothing. They concerned themselves less with commissions than the mission to advance the cause of Art. Thus, it was not entirely a coincidence that in the year he received the commission for the *Transfiguration,* Raphael also bought the Palazzo Caprini (see FIG. 48), nor that, upon his premature death just as he was finishing the altarpiece, he was buried with great ceremony in the Pantheon, one of the most prestigious sites in Rome. It was, of course, a coincidence that Raphael died on Good Friday, but it surely encouraged his epithet "divine" and the comparisons with Christ, including the use of the *Transfiguration* at his funeral.

Drawings show that Raphael first planned to depict just a Transfiguration, but then to compete more effectively with Sebastiano he added the story of the miracle immediately following it in the Bible – but never before linked with it in a painting – the Healing of the Lunatic Boy.

The Transfiguration offered scriptural proof that Christ was divine, the son of God, a messiah, and a prophet. Raphael expressed this in Christ's heavenward glance and in his enormous power as he slowly elevates and rotates himself in defiance of gravity, creating a circular aureole of blinding intensity and a divine whirlwind that sweeps the prophets Moses and Elias up beside him. The

spirituality and authority of Christ are heightened by sharp contrast with the solid and dark materiality of the mountain landscape and its crushing gravitational pull on saints James, Peter, and John.

The dialogue between Peter and Christ during this biblical episode was often cited as proof of Peter's primacy, and in art Peter was usually privileged in some way: here Raphael placed him in the center with his head turned toward Christ. But the portrayal of Peter and his companions as blinded, frightened, and helpless was unprecedented, again stressing the absolute power of Christ and the dependency of all humankind on the redemptive sacrifice of his crucifixion. Raphael visualizes this sacrifice, alluded to in the biblical account of the Transfiguration and enacted in the Mass, by Christ's cruciform posture and by the landscape light produced by either a setting or rising sun, ambiguously expressive of either death or renewal (or both).

The lower half of the painting depicts to the left the nine apostles, unable to heal the possessed youth without Christ, according to the scriptural account. When Christ returned, he exorcised the boy's demon himself, and rebuked the apostles for their lack of faith. At this moment, however, in their common helplessness the apostles look at the boy's mother with commiseration, concern, and curiosity while urgently appealing to texts or deferring responsibility to Christ. These highly rhetorical but ineffectual responses are matched by the equally dramatic reactions to the convulsive seizure of the boy by the right-hand group of nine figures: supplication, anguish, accusation, anger, fear, or incomprehension. In contrast to the circular perfection, unity, harmony, luminescence, and transcendence of the upper half, here all is angular, disjunctive, disharmonious, shadowed, and earthbound. The gestures and the diagonal rift between the two groups create a visual charge from below that reinforces the rotational movement above, but there is no direct narrative connection. Those below are unaware, literally in the dark.

In Rahael's *Sistine Madonna* the material and spiritual worlds conjoin. St. Sixtus, Christ's vicar, serves as an agent of salvation, mediating between the Church Militant and the Church Triumphant. Divinity is accessible, tender, and loving. In the *Transfiguration* the material and spiritual realms are juxtaposed and riven. Peter and the apostles are totally dependent on Christ, and divinity is here more distant and majestic. The shift reflects a reformist strain of thought in the Catholic church that foreshadowed Luther's position that salvation depends solely on humble faith in the mercy and grace of Christ, rendering good works and the church hierarchy unnecessary.

61. RAPHAEL

Transfiguration, 1517–20. Oil on panel, 13′3″ x 5′9″ (4 x 2.7 m). Pinacoteca, Vatican.

Justus and Pastor, patron saints of the cathedral of St. Just in Narbonne, are depicted at the upper left in attitudes of prayer. The altarpiece was never sent to France, but rather placed on the high altar of S. Pietro in Montorio in 1523.

Altarpieces: Spirit and Matter

62. SEBASTIANO DEL PIOMBO
Raising of Lazarus, c. 1517–19. Oil on panel transferred to canvas mounted
on board, 12'6" x 9'6" (3.8 x 2.8 m). National Gallery, London.

Sent to the cathedral of St. Just in Narbonne, France, c. 1520.

Sebastiano del Piombo and Parmigianino

Sebastiano's *Raising of Lazarus* (c. 1517–19), for which Michelangelo supplied several figure studies, was directly linked to the Mass, because Christ himself says that the raising of Lazarus prefigured his own resurrection (FIG. 62). In a remarkably lucid and balanced composition the twelve apostles crowd around Christ with an additional seven figures at the upper left; twelve Jews also crowd around Lazarus with seven more at the upper right. The groups are arranged along two diagonals in a V-shaped design in both two and three dimensions with Christ and Lazarus, inspired by Michelangelo's *Creation of Adam* in the Sistine Chapel (discussed in chapter five), confronting each other in the foreground.

Like an orator on a dais demonstrating resurrection by raising his right hand, Christ with his outstretched left hand seems to command: "Lazarus, come forth." Christ's stately majesty is magnified by his columnar, heavily draped, spotlighted figure in a state of rotational contrapposto and by the deep landscape behind him. The fervent devotion implicit in the kneeling postures of saints Peter and Mary Magdalene, who, with Christ, form a stabilizing visual triangle, as well as in the apostles' animated expressions responding to the miracle, magnifies manyfold the intensity and grandeur of Christ's gestures. Peter's position in front of the other apostles signals his primacy, but he remains, however, very much subordinate to Christ.

In contrast to Christ's miracle-working gesture, Martha recoils in revulsion, implying her shocked utterance, "Lord, by this time he stinketh, for he is now of four days." Death and the putrefaction of flesh are underlined by the five figures holding their noses, the tomb on which Lazarus sits, the shrouds constricting his dark body, the severed tree at his feet, and the nocturnal chiaroscuro. A Herculean giant as tall as Christ in a complex serpentine pose, Lazarus begins to remove his own shrouds as the light of a new day illuminates his spiritually regenerated body. The Eucharist celebrated in the church, beneath the painting, promises a similar renewal.

In the so-called *Vision of St. Jerome* by Parmigianino (1503–40) of about 1526–27 the mediation between matter and spirit is dramatized by St. John the Baptist lunging forward, looking outward, and pointing up to the Virgin and Child (FIG. 63).

Recalling Antiope in the contemporary *Jupiter and Antiope* (Paris, Louvre) by Correggio (1494–1534), St. Jerome reclines seminude in the landscape to the right with his traditional attributes of crucifix, skull, and cardinal's hat. The arm over the head is

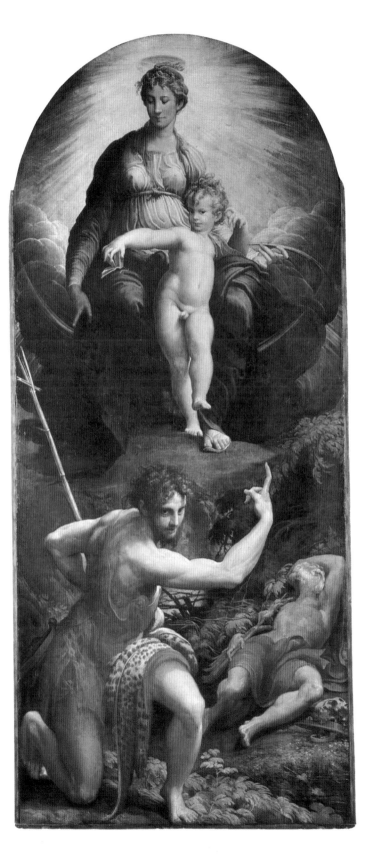

63. PARMIGIANINO
Vision of St. Jerome,
c. 1526–27. Oil on panel,
11′3″ x 4′10″ (3.4 x 1.5 m).
National Gallery, London.

Painted for the Caccialupi
Chapel in S. Salvatore in
Lauro, Rome. Inspired by
works of Michelangelo,
Parmigianino has twisted
John into an impossibly
contorted serpentine figure,
with head and shoulders
parallel to his thighs, and
arms and legs forming a
rough swastika with one side
of his body nearly parallel
with the picture plane, the
other turned on a diagonal
into depth. Drawing on the
example of Leonardo,
Parmigianino has also
feminized St. John, endowing
him with a pronounced hip,
full lips, curly hair, and
precious gesture. Further, in
contrast to his rough hair
shirt, he has over his knee a
soft and sensuous leopard
skin, attribute of Bacchus,
which associates his
androgyny and urgency with
Bacchic love and ecstasy.

the Greco-Roman posture of sleep – known in Rome from sculptures representing the sleeping Ariadne abandoned by Theseus on Naxos just before her discovery and rescue by Bacchus – which suggests that Jerome's ascetic self-denial and penitential self-torment in imitation of Christ has produced an inward vision of divinity analogous to Ariadne's sight of Bacchus on awakening.

Within the rounded top of the painting Parmigianino has depicted an exquisitely refined Virgin seated on a roiling semicircular cloud with a sunburst flashing behind her against a dark sky (attributes of both Wisdom of Ecclesiasticus and the Woman of the Apocalypse), which express her majesty across all time. As the link between the Old Testament and the New, John the Baptist also embodies the span of biblical time.

A coy and elegant Christ Child with preciously curled hair stands between the Virgin's legs, an allusion to his Incarnation; the act of lifting his foot traditionally refers to his acceptance of his fate by stepping out into the world, a motif inspired by Michelangelo's *Bruges Madonna* of 1503–5. Christ's passion is foretold by the scriptures that Christ leafs through with his right hand as the Virgin looks on, as well as by the palm of martyrdom, the reed cross, and the crucifix held by the Virgin, John, and Jerome. Parmigianino has subtly modeled Christ's rather mature serpentine figure on Michelangelo's *Risen Christ* in S. Maria sopra Minerva of about 1518–22, alluding to the resurrected Christ of the Second Coming. Since Jerome experienced visions of the Last Judgment in the desert, his sleep may also refer to the Second Coming. Finally, the rock on which both Christ and the Virgin have conspicuously placed a foot symbolizes the church of which Christ was the cornerstone.

According to contemporary art theory, artists were expected to imitate both nature and the works of other masters in order to create synthetic works true to God's creation, but expressive of its underlying perfection as well. In the *Sistine Madonna* Raphael demonstrated brilliantly this union of matter and spirit. In the *Transfiguration* he dramatized their dissimilarity, but without breaking the bounds of natural plausibility. Parmigianino has pushed this disunion even further, in a style that came to be called Mannerism. He did so by intensifying the beauty of form by referring to previous exemplars of beauty. He then refined, elaborated, and elongated form and format to a level of extreme artificiality as a metaphor of divine perfection and magnificence. At the same time all actions – flipping pages, stepping out, lunging forward in urgent address, withdrawing into visionary sleep induced by asceticism and penitence – dramatize the corruptibility of nature,

and the need to repent and to imitate Christ for redemption. This tension between artifice and action related to an unresolved contemporary debate about the nature of the reformed church: more magnificent and civilized to compel awe and obedience, or more primitive and ascetic to exemplify the virtues of the early church. The sacking of Rome by Imperial troops in 1527, as Parmigianino was finishing this work, tipped the scales in the latter direction.

Altarpieces in Rome after the Sack of 1527

One of the earliest manifestations of the doom and gloom provoked by the Sack of Rome was Michelangelo's *Last Judgment*, discussed in the next chapter. The *Deposition* of 1541–45, now badly damaged, by Daniele da Volterra (c. 1509–66) for the Orsini Chapel in Trinità dei Monti, was one of the first responses in an altarpiece to the drama of Michelangelo's fresco and to the new temper of the times (FIG. 64). With its promise of redemption, the crucifixion was *the* central tenet of faith reenacted in the liturgy of the Mass. Thus the crucifixion and the many events preceding and following it became increasingly popular subjects for altarpieces. Here, without subtle explorations of questions of theology or ideology the worshiper is presented directly and forcefully with the drama of lowering Christ from the cross.

Christ's body moves diagonally through space toward the worshiper, his foot at the surface in the center of the picture plane. Movement is further communicated by the spoke-like configuration of powerful Michelangelesque figures in strong states of organic torsion with billowing drapery, as if blown in a windstorm. The composition has been dynamically displaced toward the left, but stabilized by the two ladders on the right played off against a single ladder on the left, and by the latticelike grid they create close to the surface.

At the bottom of the painting the drama of the Virgin's swooning grief is enacted, her angular body closely related to Christ's, but draped and disposed on a contrary diagonal. The gestures and expressions of the three Marys, the vibrant colors of their draperies, and the deep chiaroscuro intensify her poignant pathos. The triangular-shaped lower group is dynamically linked to the X-shaped upper group near the foot of Christ by the outflung arms of John the Evangelist and Mary Magdalene, one of whom looks up while the other looks down. While not lacking in magnificence, the altarpiece communicates primarily primitive pain and suffering.

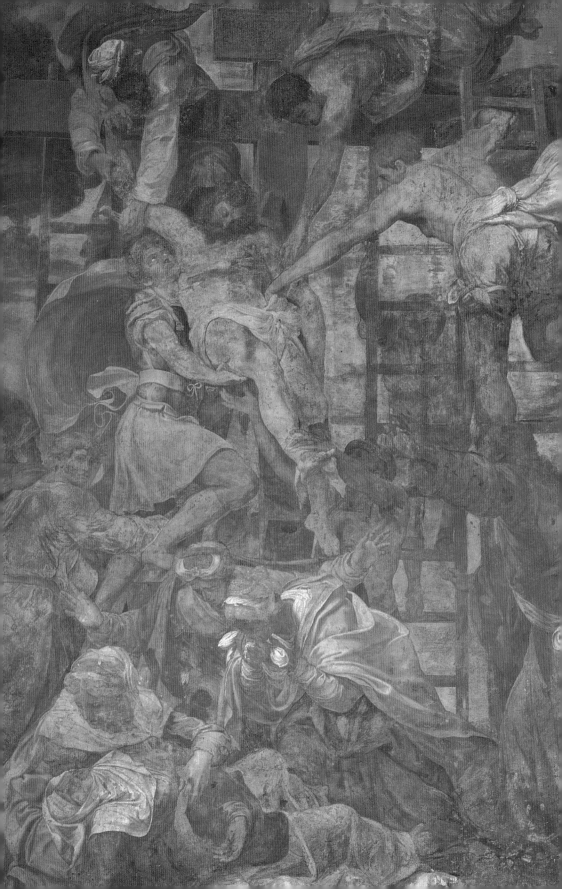

Around mid-century, as a part of the general reform movement, numerous verbal attacks focused on the art of Michelangelo and his followers, partly in response to Protestants' ridicule of excesses in Italian religious art. The Catholics found religious art far too useful a tool for teaching, propaganda, and devotion to reject it as idolatrous, as did the Protestants. The reformers argued, however, that art must be controlled by the clergy, contain nothing secular, pagan, or lascivious, and, as Raffaele Borghini (c. 1537–88) stated in his *Il Riposo* (1584), be "derived from Holy Scripture simply and purely." Unlike Parmigianino's *Vision of St. Jerome*, Daniele's *Deposition* was certainly safe in these regards. Given, however, his second-generation Mannerist style of highly rhetorical gestures and expressions, as well as his virtuoso demonstration of the male anatomy under stress, he might have had trouble passing muster with a critic such as Giovanni Gilio da Fabriano, who believed "a thing is beautiful in proportion as it is clear and evident" and that the wisest artist is one "who fits his art to the truth of the subject...[rather] than one who adapts the purity of the subject to the beauty of art."

The *Coronation of the Virgin* of about 1568 by Federico Zuccaro (1540/41–1609) for the high altar of S. Lorenzo in Damaso, commissioned by Cardinal Alessandro Farnese, represents an early example of the new reformed art (FIG. 65). The work's clear geometric structure is derived from Raphael's classic *Foligno Madonna* of about 1511, once on the high altar of S. Maria in Aracoeli, and the scene of martyrdom in the background is drawn from Titian's *Martyrdom of St. Lawrence* of about 1548–57, which Federico had viewed in the Gesuiti on a recent trip to Venice. The circular upper zone, emblematic of divine perfection, has none of the complexity of meaning of Raphael's prototype, but is instead a straightforward glorification of the Church Triumphant in which the Virgin is a majestic but humble and pious queen and Christ a resplendent king surrounded by angels and the golden radiance of the Holy Spirit.

In the lower zone arranged in a semi-circle are embodiments of the Church Militant. Standing in the background with their attributes of keys and sword are the founders of the Roman Church, Saints Peter and Paul, who look out directly at the worshiper. By pointing upward Peter indicates that the church mediates between earth and heaven. In front of St. Peter and exchanging glances with the Virgin is the builder of the original church, St. Damasus (c. 304–84). Kneeling in prayer on the same side as Christ, dressed in the regal splendor of full papal regalia, framed by the keys of St. Peter and the tiara, this papal saint (r.

64. DANIELE DA VOLTERRA *Deposition*, 1541–45. Fresco transferred to leather, c. 13 x 9′ (4 x 2.8 m). Bonfili Chapel, Trinità dei Monti, Rome.

Originally in the Orsini chapel in the same church.

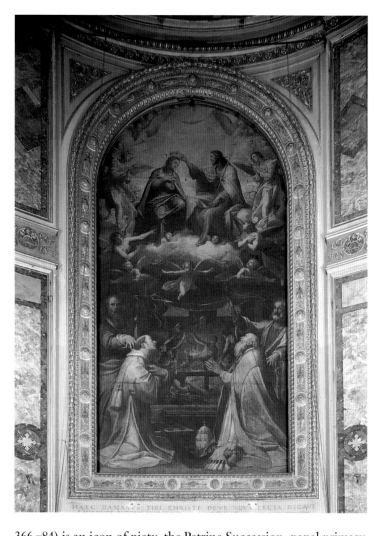

65. Federico Zuccaro
Coronation of the Virgin,
c. 1568. Oil on slate, 29'4"
x 12'5" (8.9 x 3.8 m).
S. Lorenzo in Damaso,
Rome.

Opposite

66. Scipione Pulzone
Lamentation, 1591. Oil on
canvas, 9'6" x 5'8" (2.9 x
1.7 m). Metropolitan
Museum of Art, New York.

Painted for the Chapel of
Angels and Archangels in
the Gesù.

366 –84) is an icon of piety, the Petrine Succession, papal primacy, and universal temporal and spiritual power. Clad in a deacon's robes and looking adoringly at Christ, the dedicatory patron of the church, St. Lawrence (d. 258) kneels in front of St. Paul. As a deacon who controlled the wealth of the church, and as a martyr on a fiery gridiron for giving that wealth to the poor, Lawrence exemplifies the faith and good works necessary for salvation according to the decrees of the Council of Trent, but denied by the Protestants. Gilio da Fabriano would surely have been pleased with the almost diagrammatic clarity of this image of the reformed church and the artist's subordination of his medium to the message.

The 1591 *Lamentation* by Scipione Pulzone (c. 1550–98), originally for the third chapel on the right in the Gesù (FIG. 66), is an even more fully developed example of this Counter Refor-

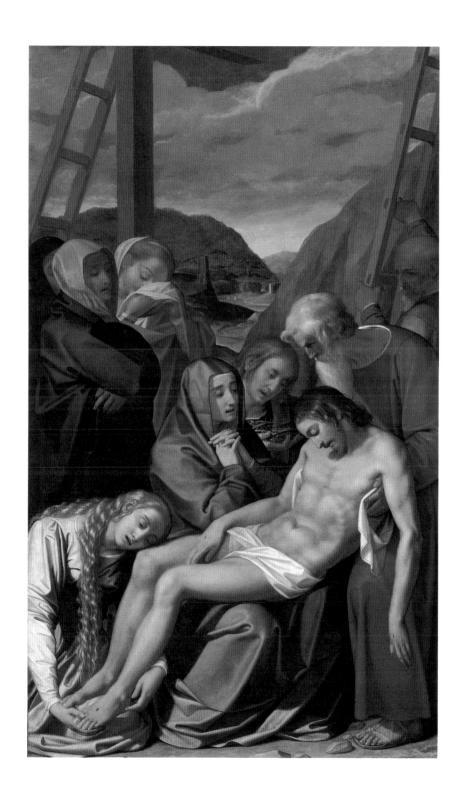

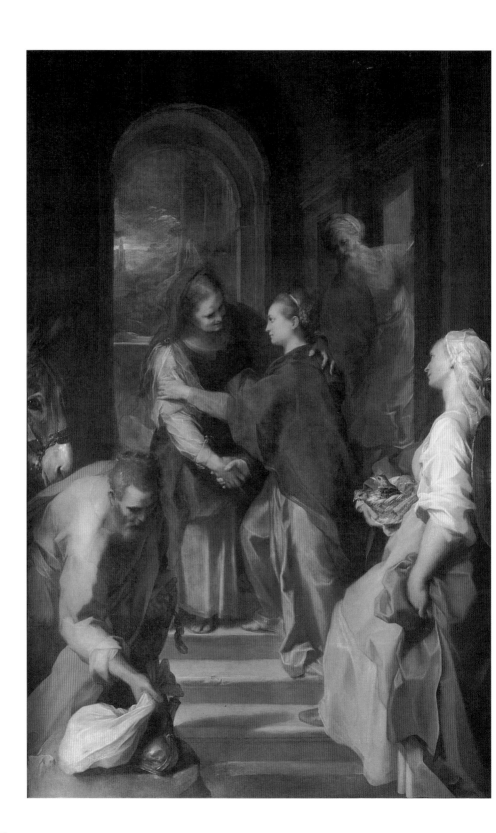

mation style. Compared to the emotional turmoil and physical drama of Daniele da Volterra's *Deposition*, this altarpiece is clear, unforced, and decorous. The Virgin is not swooning, the three Marys and John the Evangelist are not emotionally out of control, Joseph of Arimathea and Nicodemus are not straining, Christ is not being moved. The figures are all meticulously groomed in freshly ironed drapery and drained of all emotion except for piety, here conventionalized by heavy-lidded, sad red eyes, open mouths, and folded hands. The light is steady, the color harmonious, the dress vaguely classicizing, neither modern nor historical, and the composition and figures are simplified variations on works of the High Renaissance. Appropriately termed *arte senza tempo* (art without time or place), it remains the basis of much saccharine religious art to this day, designed to evoke pious devotion in a maximum number of unsophisticated worshipers with minimal aesthetic means.

A more historically important aspect of the many strains of Counter Reformation art is exemplified by the *Visitation* of 1584–86 by Federico Barocci (c. 1535–1612) on an altar dedicated to the Visitation in S. Maria in Vallicella (FIG. 67). Barocci has synthesized elements from central and northern Italian works of the High Renaissance by using rich and harmonious colors, a clear and concentrated X-shaped compositional structure both on the surface and in depth, lively and varied movement, a focused and active play of light and dark, and a complex space defined by architecture of classical design. The effect is an inventive composition of great dignity and nobility appropriate to the moment in which St. Elizabeth, pregnant with John the Baptist, and Mary, pregnant with Christ, mark the union of the old order and the new, when Mary glorifies Christ in the song of the Magnificat. Specifically reflective of the Counter Reformation is the emotional tone of tenderness, joy, and love, which exceeds even Raphael's example, as well as the details symbolic of clarified Counter Reformation doctrine: St. Joseph placing his provisions of food and drink on a rock are signs of the Eucharist and the church, and the handmaid's offering of birds, a sign of charity and sacrifice. This magnificent work points the way forward to Baroque art and a confident, self-assured reformed church.

67. FEDERICO BAROCCI *Visitation*, 1584–86. Oil on canvas, 9'4" x 6'2" (2.8 x 1.8 m). Cappella Pozzomiglio, S. Maria in Vallicella, Rome.

Characteristic of this period is Barocci's delight in such carefully observed mundane details as the head and halter of the donkey, the dent in the metal wine jug, the chip in the marble step, the weave of the reed basket and the straw hat, all of which serve as signs of humility.

Michelangelo's Pietàs

Michelangelo's Vatican *Pietà* (the Virgin holding the dead Christ) of 1497–1500 (FIG. 68), commissioned by Cardinal Jean de Bihères Lagraulas (d. 1499), was lighted originally from windows high

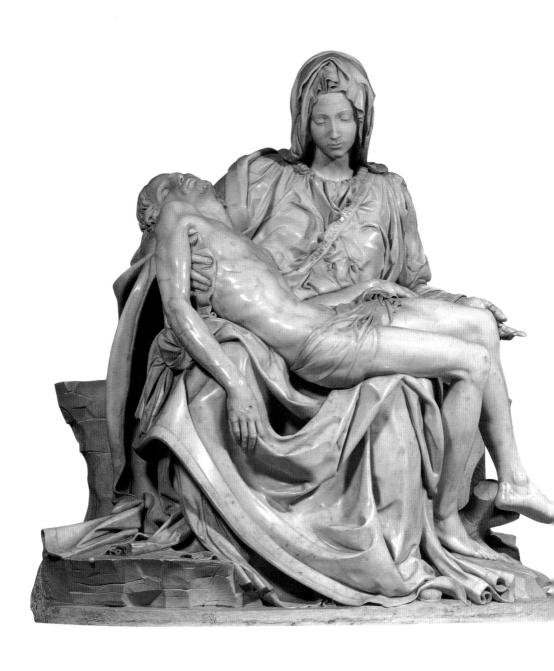

68. MICHELANGELO

Pietà, 1497–1500. Marble, 5'8" x 6'5" x 27" (1.7 m x 1.9 m x 69 cm). Cappella della Pietà, St. Peter's, Vatican.

For the first and only time, Michelangelo has here boldly signed his work. Using Latin and Roman block letters on the ribbon between the Virgin's breasts— *MICHAEL ANGELUS BONAROTUS FLORENTINUS FACIEBAT* – Michelangelo claims his mastery of antiquity. Indeed, the serenity and beauty of the Virgin and the muscular strength and radiant grace of Christ – inconceivable without a knowledge of ancient sculpture – associate the *Pietà* with the classical tradition of the lament for a dead hero. Michelangelo has daringly infused classical grace and idealism as signs of divine perfection and regeneration into a subject that traditionally emphasized death and despair.

in the drum of the French chapel of S. Petronilla, a round fifth-century imperial mausoleum attached to the south transept of old St. Peter's (see FIG. 10). As the chapel was destroyed before 1520 to make way for new St. Peter's, it is unknown whether the sculpture originally served as an altarpiece, as displayed today in St. Peter's, or as a tomb memorial. Either way its purpose was, like the Eucharist, to mediate between life and death through Christ's sacrifice.

The hands, feet, and side of Michelangelo's life-size Christ are marked with the wounds of the Crucifixion, and his head is wrenched lifelessly away from his mother's body. His body sags and tips, literally a deadweight seemingly about to slip off the Virgin's lap. His legs are emaciated and awkwardly bent indicating the onset of rigor mortis. His left foot rests against the severed stump of a young tree, which represents life cut off in its prime.

Yet the severed tree also promises renewed life, since God "set the salvation of humankind upon the tree of the cross, so that whence came death, thence also life might rise again." And, indeed, Michelangelo has also represented Christ as embodying this promise of renewed life. While his left hand seems lifeless, his right seems almost to grip with an inner will the Virgin's drapery. In contrast to the stiff, angular legs his upper body wraps around the Virgin in an embracing serpentine pose. The torso is muscular and pliant, with an inner vitality like that of a classical hero. Christ's physiognomy with mouth and eyes slightly open recalls a youthful Apollo, and the highly polished, subtly modulated surface would have glowed with an internal radiance when spotlighted by the light from the high chapel windows of its original site.

That same light would have cast the veiled face of the Virgin into shadow, emphasizing her deep inner grief expressed by her bowed head and lowered, nearly closed eyes. With one hand she frames Christ's wound, with the other she offers her dead son to the worshiper with a gesture recalling a priest about to elevate the host. Yet she too embodies the promise of renewed life.

Represented as a young and beautiful bride with the idealized features of an ancient goddess and seated on an outcropping of marble, the over-lifesize Virgin symbolizes the regenerative potential of the church wedded to Christ, the cornerstone, who founded his church on Peter, the rock. The blood and water that flowed from the framed wound evoke the sacraments of salvation, Baptism and the Eucharist; and the gesture of the Virgin's left hand signifies (as in many representations of the Last Judgment) reception into heaven. To form a base of sufficient visual strength to support a grown man, Michelangelo has spread the Virgin's knees

very far apart, thereby also recalling Christ's birth. The sweeping, looping folds between her legs support and animate Christ's body. The anatomical torsion of her pose (left leg and shoulder lowered, right leg and shoulder raised, leaning toward Christ's knees yet rotating her head toward his torso) indicates that she is lifting and pulling Christ's upper body toward her as if reenacting the moments when she fed him at her breasts. Michelangelo emphasized the breasts with the diagonal ribbon that pulls the drapery taut over them and sets up a swirling cascade of tight folds expressive of their life-giving vitality.

There are larger contrasts as well. The right side of the work is more open and visually alive, yet here are the clearest signs of death. The left side is more closed and less visually animated, yet here are the clearest signs of life. While Christ is dead yet evocative of spiritual life, he is essentially depicted as a physical human body. While the Virgin is both suffering for Christ's passion and expressing the promise of renewed life, she is essentially spiritual, constructed of abstract drapery patterns that undercut a sense of her underlying anatomy. At every point spirit and matter are in tense balance, expressive of the central paradox of the Christian faith.

Classical writers often praised the virtuosity of sculptors for supposedly carving multifigure sculptural groups from a single block of marble. Renaissance sculptors often tried to emulate their ancient counterparts, as Michelangelo did here, and his signature seems to boast his success. Although seemingly effortless, Michelangelo's achievement required extraordinary concentration, advanced planning, and intellectual control. The signature would also be Michelangelo's way of proudly offering his artistic labor to God for the salvation of his own soul – hence its location on the ribbon between the life-giving breasts of the Virgin, who embodied the church. Thus, even the making of the work would express the struggle between creative spirit and recalcitrant matter, with the signature suggesting the ultimate triumph of the former.

Michelangelo originally carved the *Pietà* in the Museo dell'Opera del Duomo in Florence of about 1547–55 for his own tomb, planned for S. Maria Maggiore in Rome (FIG. 69). Again, it is unclear whether it was to have been a tomb memorial or an altarpiece (as it became in 1721, when it was placed on the high altar of Florence Cathedral). But since the massive, Herculean body of Christ is displayed fully and frontally as is the host, and since it also gives the impression of sinking downward, as if about to be lowered onto the altar, which is always considered to be a symbolic tomb, it seems most likely that the *Pietà* served as an altarpiece.

69. MICHELANGELO *Pietà*, c. 1547–55. Marble 7'5" x 48" x 37" (2.3 m x 1.2 m x 94 cm). Museo dell'Opera del Duomo, Florence.

Vasari reports that, because of a flaw in the marble, Michelangelo himself damaged the work, thus accounting for Christ's missing left leg. Vasari also writes that Michelangelo's assistant Tiberio repaired the work, so that with the exception of the missing leg what we see today is probably close to the way it was left and intended to be.

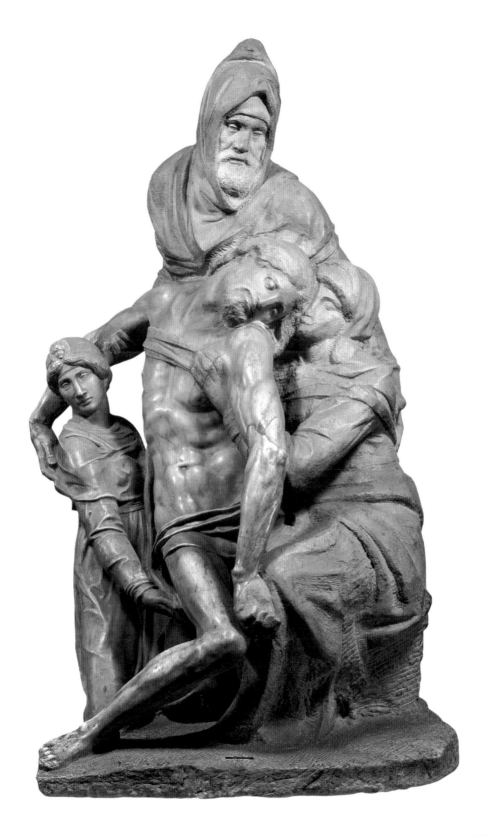

In any case, as Christ's body sinks on emaciated leg(s) it also rotates from left to right as cued by the fall of his head toward the Virgin, the curve of the torso, the turn of the knee(s) and leg(s), and the direction of the glance of the figure who supports Christ from behind. The striking similarity of Christ's body to the *Discus Thrower*, the well-known Roman copy of a lost Greek statue by Myron (active c. 480–445 BC), whether intentional or not, underlines the strong directional impulse from left to right. Within this implied movement Christ seems to embrace Mary Magdalene, his shroud falling between her breasts and thighs, just as she embraces his thigh and (by implication) lower back. The sensuality of her gestures, her glance outward toward the worshiper, and her material presence, communicated by the polish and finish of her figure, evoke the notion of this ex-prostitute as the supreme embodiment of earthly love and passion. But the turn of her head away from Christ suggests her sense of unworthiness, just as her kneeling posture and covered hand express her adoration of Christ's body as sacred.

Originally Christ "embraced" the seated Virgin with his left leg crossed over her left thigh, a sign of sexual union and a metaphor for the love between Christ and his bride, as the Virgin was often called. This union is spiritualized by the heavy drapery covering the Virgin's body, the imprecise and diffuse rendering of her unfinished form, and the literal fusion of her face and hand with the face and shroud of her son/groom. Equally unfinished and spiritualized is the ghostly, hooded figure who looms up from behind to support Christ, both countering and guiding his downward spiral. Paradoxically the rough surface with its clear chisel marks emphasizes the hard stoniness of the marble of a work *in progress*, indicating matter becoming spirit, and spirit being that which is most solid and permanent.

The background figure could be Joseph of Arimathea who gave Christ his tomb, into which Christ is seemingly being lowered. It could also be Nicodemus, the Pharisee who came to Jesus at night, and who according to St. John's Gospel brought the myrrh and aloes for preserving Christ's body. Nicodemus would be especially appropriate, since by legend he was a sculptor, and it has been universally recognized that the figure's face is Michelangelo's self-portrait. In either case, the self-portrait functions as the signature on the Vatican *Pietà*, to identify Michelangelo as the maker who offers his creation to God as a good work. But more than maker and witness, Michelangelo here enacts his faith and dependence on Christ for salvation by personal identification with the sacred drama, much in the way recommended by the founder

of the Jesuit order, Ignatius Loyola (1491 or 1495–1556), in his *Spiritual Exercises*.

There have been a number of suggestions as to why Michelangelo damaged his work: there was a flaw in the marble, as Vasari claims; the "slung-leg" motif was too sexually explicit; or Michelangelo's identification with Nicodemus implicated him in Nicodemism, a Catholic reform movement – a dangerous association in 1555 with the election of Pope Paul IV, who was strongly opposed to anything even slightly hinting of heresy.

But there is no apparent flaw in the marble. The slung-leg motif used as a metaphor of spiritual love was justified by a long tradition and became explicitly licentious, with few exceptions, only later. And Michelangelo did not destroy the face of Nicodemus, who in any case could be Joseph of Arimathea. But he did destroy Christ's left leg, which was originally slotted and fastened into the work as a separate piece of marble, almost certainly by Michelangelo himself. If so, Michelangelo failed the challenge of antiquity to create a four-figure group from a single block, thereby diminishing the merit of his offering to God. Could this be the reason why he damaged the work?

Chapel Decoration: Space, Time, and Eternity

T he first important Roman chapel decoration after the return of Pope Martin V was the Chapel of the Sacrament in S. Clemente, frescoed by Masolino from 1428–32 (FIG. 71). Like an altarpiece, the decoration of a chapel was almost always programmatically related to the Mass and to the dedication of the altar, just as here the *Annunciation* on the triumphal entrance arch and the *Crucifixion* above the altar are fundamental to the meaning of the Eucharist. But, unlike a Renaissance altarpiece, the decoration of a chapel consisted of one or more multi-episode, often multi-level narrative sequences usually taken from the Bible or, as here, the life of a saint or saints. Scenes were usually arranged chronologically, and in multilevel schemes those at the top almost always came before those below. Here they read from left to right, the scenes from the life of St. Ambrose on the right wall unfolding away from the altar, the scenes from the life of St. Catherine of Alexandria on the left wall toward it. In both cases the upper level is read first followed by the lower level. Two common alternatives were to begin the narratives on either side of the altar and proceed in parallel bands down the side walls to the opposite end, or to begin at the altar and proceed clockwise around the space back to the altar. Finally, like an altarpiece, the subject matter and its ideological interpretation were often closely related to the chapel's patron. Here the patron was Cardinal Branda Castiglione (1360/5–1443), who had S. Clemente as his titular church from 1411 to 1431. Both Ambrose – the patron saint of Milan, a great scholar, a fighter against schism and heresy – and Catherine – a

71. SEROUX D'AGINCOURT Chapel of the Sacrament of 1428–32 in S. Clemente, Rome. Engraving.

defender of the faith and church orthodoxy – were appropriate role models and intercessors for the cardinal who was a humanist from Milan and a major figure in defending the church against schismatics and heretics at the Councils of Constance (1414–17) and Florence (1438–45).

Jacopo de Voragine (c. 1230–98), in his enormously popular *Golden Legend* (c. 1275), wrote that the young Catherine tried to covert Maxentius (r. 306–12) to Christianity. Unable to counter her arguments, Maxentius called to Alexandria fifty of the best "masters of logic and rhetoric," who argued that "it was impossible for God to become man or to suffer." But she succeeded in convincing and converting them, whereupon the emperor ordered the scholars to be burned alive, and Catherine to be tortured on a spiked wheel and beheaded. Both the emphasis in the legend on the Incarnation and the Passion, and the faith and self-sacrifice of Catherine and the scholars are closely related to the Mass.

In the debate scene the orthogonals of the perspective are focused on Maxentius enthroned on a dais with a cloth of honor behind (FIG. 72). The shift of the vanishing point to the left of center creates a space that responds to the oblique viewing position of worshipers in the chapel and allows Masolino to open a large window in the elongated wall of the fictive room to reveal the martyrdom of the scholars beyond. Already with her halo, Catherine stands in the center of the pictorial field, facing the worshipers and confidently ticking off the arguments on her fingers: she is the real scholar. By recalling scenes of Christ among the doctors, the composition also suggests that her defense of the faith replicates that of Christ.

The damaged *Crucifixion* is remarkable for its panoramic breadth – achieved by a high point of view, tall crosses, and a deep landscape (FIG. 73). The crosses of the good and bad thieves, the former slightly higher than the latter, have been canted to increase the sense of depth, while Christ, completely above the distant horizon and silhouetted against a broad expanse of sky, seems truly cosmic.

Equally remarkable is the drama. A demon takes the soul of the bad thief, an angel carries the soul of the good heavenward. The mounted Roman commander to the right gives orders. In response a horseman rides up from behind the hill and, with a gesture echoing that of the commander's, prepares to break the

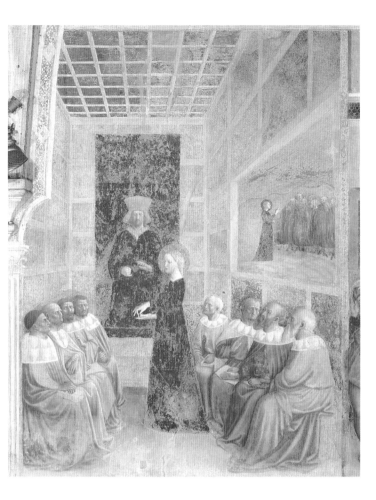

72. MASOLINO DA PANICALE
*St. Catherine Debates the
Scholars of Alexandria*,
1428–32. Fresco. Chapel
of the Sacrament,
S. Clemente, Rome.

legs of the bad thief. In the right middleground soldiers fight over
Christ's robe. Horsemen to the left ride up and down the hill. Hav-
ing just pierced Christ's side with his lance and been converted,
the Roman soldier Longinus adores Christ near the cross of the
good thief. The burnished silver leaf that once embellished the
soldiers' armor, helmets, and swords would have made their actions
even more prominent.

Judas stands with his fellow conspirators in the left foreground
(appropriately enough under a horse's posterior), holding the
bag of silver for which he betrayed Christ. In the central foreground
are the saints, once with haloes of burnished gold leaf: the Vir-
gin swoons into the arms of one of the Marys, John the Evange-
list holds his head mourning, and Mary Magdalene passionately
caresses the cross.

The high viewpoint and the vast panorama were inspired
by the early fifteenth-century Netherlandish works of the Van

Chapel Decoration: Space, Time, and Eternity 111

73. MASOLINO DA PANICALE *Crucifixion*, 1428–32. Fresco. Chapel of the Sacrament, S. Clemente, Rome.

Eyck brothers and their followers, the massive figures and deep space by Masaccio (1401–28, with whom Masolino worked in Florence and Rome in just these years), the monumental male figures by classical Roman sculpture, and the ornamental metallic details by the International Gothic works of Antonio Pisanello (c. 1395–1455) and Gentile da Fabriano (c. 1370–1427), both of whom were working in Rome from 1427 to 1432. The *Crucifixion* was thus not only the most artistically advanced work in Rome, but its narrative captured much of the decorum, variety, eloquence, and grandeur of classical rhetoric being revived by such humanists as Cardinal Branda Castiglione.

The Chapel of Nicholas V in the Vatican Palace

In the private papal chapel of Nicholas V (see FIG. 40), each band of the two-level decoration by Fra Angelico (c. 1400–55) of about 1448–50 begins at the right of the altar and unfolds chronologically clockwise around the walls (FIG. 74). At the top are scenes from the life of St. Stephen, first deacon and Christian martyr, who was stoned to death outside of Jerusalem. He was the dedicatory saint of the early Christian church of S. Stefano Rotondo near the Lateran Palace. At the bottom are scenes from the life of the Roman deacon and martyr St. Lawrence, the patron saint of Rome. He was the dedicatory saint of the private papal chapel in the Lateran, the Sancta Sanctorum. When Stephen's body

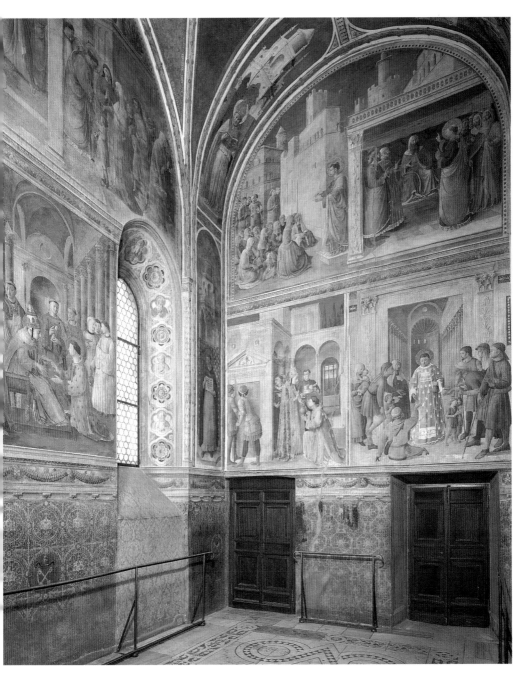

was transferred from Jerusalem to Rome in the sixth century, it was buried with Lawrence's in S. Lorenzo fuori le mura. Nicholas V had their tomb opened in 1447, and both bodies were found to be well preserved. Just as their common burial was a sign of the church's universality, East and West, so was this decoration intended

74. FRA ANGELICO
West and north walls,
Chapel of Nicholas V,
c. 1448–50. Fresco.
Vatican Palace, Vatican.

Chapel Decoration: Space, Time, and Eternity 113

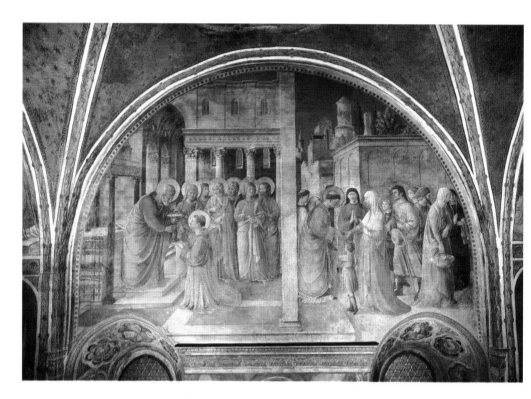

75. FRA ANGELICO
Ordination of St. Stephen
and *St. Stephen Distributes
Alms*, c. 1448–50. Fresco.
West lunette, Chapel of
Nicholas V, Vatican Palace,
Vatican.

to borrow their aura of sanctity from around the Lateran in the
east of Rome and bring it to the Vatican in the west, where Nicholas
had just established the permanent residence of the popes.

The grand architecture of the Temple of Jerusalem in the *Ordination of St. Stephen* probably reflects the Nicholine scheme for the
restoration of St. Peter's discussed in chapter two (FIG. 75). This
conflation of the two monuments suggests a shift of the center
of Christianity from East to West. The pier and columns of the
nave frame the first seven deacons who were appointed to relieve
the apostles – busy with preaching and converting – of the burden of daily services and the routine administration of the church.
The arch of the transept magnifies the massive figure of Peter
elevated on a dais before the high altar, leaning forward to offer
the gold chalice and paten to Stephen kneeling in a dalmatic (deacon's robe). This act signals that the sole authority to ordain resides
with the Vicar of Christ and that only ordained priests may perform the Eucharist.

The deacon in the foreground, who turns and gestures toward
the right, leads the worshiper's eye to the scene of *St. Stephen Distributes Alms*, which has the same floor and perspective construction
as the *Ordination*, the common vanishing point located at the
center of the pilaster separating them. But the much stronger "per-

spective rush" of the right scene visually energizes Stephen, who gives alms, and his assistant, who reads a list. At the angle of the high wall a man dressed in green piously joins his hands together in prayer, creating a tabernacle of sorts over the transaction of Stephen's offering and the mother and child's acceptance. Behind the mother some figures walk forward to receive alms, while others are turned to the right, leading the eye on to the next scene.

There is no mention of St. Stephen distributing alms in Acts or in the *Golden Legend*, although offering alms was indeed included in the duties of deacons. Furthermore, almsgiving was of special importance to Nicholas V, because he had founded a large almshouse in the Vatican. This scene, then, suggests his charity toward the Romans and their pious acceptance. The unstated subtext is the economic depression in Rome that necessitated almsgiving, and the resistance to papal control by the Romans, some of whom in the next few years would try to assassinate the pope.

The Sistine Chapel: 1475–82

From about 1475 to 1482 Sixtus IV had his architect Baccio Pontelli rebuild the old Palatine Chapel of Nicholas III which henceforth would be called the Sistine Chapel (FIG. 76 and see FIG. 39). The chapel was designed to accommodate the ceremonies of a corporate body called the *capella papalis* or Papal Chapel, which included the pope and about two hundred high-ranking clerical and secular officials. The *capella* met at least forty-two times a year, and celebrated twenty-seven Masses. A marble screen (or *cancellata*) divided the chapel in half. The western half with the altar (the *sancta sanctorum*) was reserved for the members of the Papal Chapel, the eastern half for less important clerical and lay observers. From about 1480 to its dedication on the Feast of the Assumption on 15 August 1483, the chapel was frescoed by a group of central Italian artists, mostly under the direction of Pietro Perugino (c. 1450–1523).

76. Reconstruction of the Sistine Chapel in the fifteenth century.

The earliest popes from Peter through Marcellus I (r. 308–9), who together embodied and confirmed the Petrine Succession, stood in twenty-eight illusionistic niches between the windows, organized in a zigzag fashion from altar to entrance. Two narrative cycles ran chronologically below the windows in two parallel bands from the altar to entrance:

77. SANDRO BOTTICELLI
Punishment of Korah,
1480–82. Fresco. Sistine
Chapel, Vatican.

eight scenes from the life of Moses on the left, illustrating the world under law; eight scenes from the life of Christ on the right, illustrating the world under grace. The altarpiece depicted the *Assumption and Coronation of the Virgin*, symbolically the triumph of the Church Militant.

The *Punishment of Korah* by Sandro Botticelli (1445–1510), the sixth scene of the Moses cycle, is represented, as are all the narratives, as if it were a life-size *tableau vivant* viewed through an opening in the wall (FIG. 77). The inscription above the scene states the general theme: "Challenge to Moses bearer of the written law." Like all the other scenes, it is organized in three parts with several episodes. The white haired and bearded Moses is shown three times, gold rays of light shining from his forehead, and clad in a green cape and gold tunic. At the right a mob of Israelites rebels against Moses and prepares to stone him. At the left Moses causes the ground to swallow up the Jewish schismatics, Datham and Abiram, protecting, however, the Israelites, specifically the sons of Korah. In the center Moses destroys by fire with his rod five figures with censers around a flaming altar: probably Korah, Datham, and Abiram, the sons of Eliab, and Nadab and Abihu, the rebellious sons of Aaron. Directly behind Moses are two additional figures,

also with censers: Aaron is dressed in blue; between Aaron and Moses is most probably the figure of Eleazar, Aaron's son and a legitimate priest. The inscription on the Arch of Constantine translates "Let no man take this honor [of priesthood] upon himself unless called by God as was Aaron." Thus, the scene represents the triumph of Moses over those who challenged his supremacy. Since Moses was always understood as a Christ type, and since his successor Aaron wears a papal tiara, the scene prefigures Christ consigning the keys to Peter, confirms the doctrine of the Petrine Succession, and warns schismatics against challenging papal authority.

The similarity of the inscription above Perugino's *Christ Consigns the Keys to St. Peter* – "Challenge to Christ bearer of the law" – to that above the *Punishment of Korah* shows that these two scenes, as all the cross-wall pairs, were conceived as a unit, and that the Old Testament scenes prefigured the New (FIG. 78). The middle ground depicts the challenges to Christ. At the left is the Tribute Money, an effort to subordinate Christ to temporal authority. The Stoning of Christ, an attempt to deny that Christ was the son of God, is portrayed at the right. But the imitations of the Arch of Constantine behind the two episodes evoke the triumph of Christ over these challenges.

78. PIETRO PERUGINO
Christ Consigns the Keys to St. Peter, 1480–82. Fresco. Sistine Chapel, Vatican.

It is likely that the fifth figure from the right is a portrait of Perugino; the third from the right holding a compass, Baccio Pontelli, architect of the Sistine Chapel; and second from the right holding a carpenter's square, Giovanni de' Dolci, construction supervisor for the building of the Sistine Chapel.

Six apostles in the foreground on either side of Christ respond with stately gestures as Christ gravely consigns the keys to St. Peter, thus founding his church. The building in the background on which the perspective lines converge is the Temple of Solomon in Jerusalem which will be replaced by the Roman Church through Peter's move from East to West. Together the *Punishment of Korah* and the *Christ Consigns the Keys* evince the pope's power of the keys to damn and to save. The arches likewise express the union of church and empire under Constantine and the universality of the pope's power.

In *Christ Consigns the Keys*, Peter is dressed in blue and gold, the colors of the della Rovere, the family of Sixtus IV, and the arches are inscribed: "You, Sixtus IV, unequal in riches, but superior in wisdom to Solomon, have consecrated this vast temple [the Sistine Chapel]." Together these details depict the Sistine Chapel as a new Temple of Jerusalem and Sixtus IV as a new Solomon and a new Peter.

Compared to the narratives of Masolino or Fra Angelico, the geometrical and mathematical clarity of the one-point perspective, the breadth and depth of the space, the grandeur of the architecture, and the solemnity of the main action impart a dignity and majesty that make this scene one of the great landmarks of Western art.

The Carafa Chapel, S. Maria sopra Minerva

For the *Assumption of the Virgin* of 1488–93 in the Carafa Chapel Filippino Lippi imitated in fresco the real architecture of the triumphal entrance arch of the chapel (FIGS 79 and 80), painting away the altar wall behind the altarpiece of the *Annunciation* discussed in chapter four (see FIG. 59). Although spatially unified, the scene is divided into two levels, earth and sky, by the banner above the altarpiece. This banner may be understood as belonging to the material world below, but as a cloth of honor carried into place and supported by angels, it is also part of the spiritual world above.

With their animated discussions and excited expressions and gestures the apostles in the lower foreground link earth and heaven. Saints Peter and Paul kneel on either side of the altarpiece piously looking heavenward, Peter in the honored position on the Virgin's right closest to her classicizing sarcophagus. St. Thomas in the middle ground to the left has just received the Virgin's belt. Since by legend he was absent from the Assumption, the Virgin dropped it to allay his doubts.

The Virgin looks down at the patron while the apostles gaze heavenward. She stands on a cloud carried aloft by three angels with torches, symbols of spiritual illumination, while blue cherubim, symbols of divine wisdom, issue from the smoke of two pairs of candles to form a mandorla around her; within the mandorla

79. FILIPPINO LIPPI
Carafa Chapel with the
Assumption of the Virgin,
1488–93. Fresco. S. Maria
sopra Minerva, Rome.

80. FILIPPINO LIPPI *Assumption of the Virgin*, 1488–93 (detail). Fresco. S. Maria sopra Minerva, Rome.

The angelic band surrounding the Virgin play celestial music on a tambourine, a trombone, a flute, a hammered three-string *tambourin du Béarn*, drums, a hammered trapezoid, and a bagpipe. These authentic Renaissance instruments would never have been played together, so loud and percussive would they have been. But that is just Lippi's point: the angels are making a noisy and tumultuous music as they race to and fro with agitated draperies, leaping for joy at the triumph of the Virgin.

a multitude of golden rays clothe her in light. These attributes conflate the Virgin of the Assumption with Wisdom of Ecclesiasticus and the Woman of the Apocalypse, evoking her presence from the beginning of time, at a specific moment of time, and at the end of time. Similarly, the Annunciation shown at the bottom of the central axis marks the founding of the Church Militant; the Assumption at the top, its final triumph. The altarpiece portrait of Cardinal Carafa, successor of the apostles, and the presence of his cardinalitial coat of arms held by angels on the entablature of the painted triumphal arch, connect both events to the present. Finally, the censers being swung by angels at the feet of the Virgin, and the two pairs of candles transform the drama into a celestial liturgy conjoined with the terrestrial liturgy performed on the altar.

The Sistine Chapel: 1508–20

Michelangelo's Sistine Chapel ceiling of 1508–12 illustrates nine scenes from Genesis surrounded by prophets and sibyls, the ances-

tors of Christ, and other scenes (FIGS 81 and 82). Combined with the scenes of the world under law and under grace on the walls below, the Genesis scenes from the world before law complete the standard threefold division of Christian history.

The nine narratives are arranged, with two inconsistencies, chronologically from altar to entrance and subdivided into triads, three scenes devoted to the Creation, three to Adam and Eve, and three to Noah. The central scene of the middle triad, the *Creation of Eve* – emphasized by the unique X-shaped configuration of its composition and surrounding *ignudi* (nudes), as well as its placement over the *cancellata* or screen – functions like a fulcrum dividing the narratives into two counterbalanced units or diads.

The narrative structure reflects Renaissance perceptions of the structure of Christian history. The chronological arrangement indicates a belief in a linear and sequential unfolding of events according to divine plan to the end of time. The diadic units (that is, four scenes of the creative majesty of God over the western half of the chapel in counterpoint to four scenes of fallen humankind over the eastern half) relate to the fundamental Christian experience of history as a struggle between binary opposites such as spirit/matter, good/evil, and death/life. The triads express the traditional division of history into the three eras – the first two prefiguring the third – and divinity into three persons.

Michelangelo executed the scenes in reverse chronological order from entrance to altar. Therefore, the first scene, the *Separation of Light and Dark* on the first day, was executed last (FIG. 83). This event was often interpreted as a sign of the eternal conflict between good and evil, and the ultimate triumph of truth over falsehood. Since it could also prefigure Christ's earthly struggle against, and victory over, the forces of darkness, this scene appropriately appears over the altar.

At the height of his powers near the end of the fresco campaign, Michelangelo here conceived of God as embodying both the dynamism of youth and the wisdom of age, the strength of a male and, as signaled by the developed breasts, the fecundity of a female. His God is omniscient and omnipotent, embodying the principles of conception and creation. This titanic humanoid of unearthly anatomical power, scale, and grandeur remains uncontainable within the cosmic field as he rotates through time along a diagonal axis in a double helix evoking some huge galactic force in process of formation.

The large scene of the *Creation of Adam* shows God channeling divine grace to the first human (FIG. 84). As revealed by the power, gesture, and disposition of his anatomy, Adam is being created in

Overleaf

81. MICHELANGELO
Ceiling, west half, 1508–12.
Fresco. Sistine Chapel,
Vatican.

DANIEL

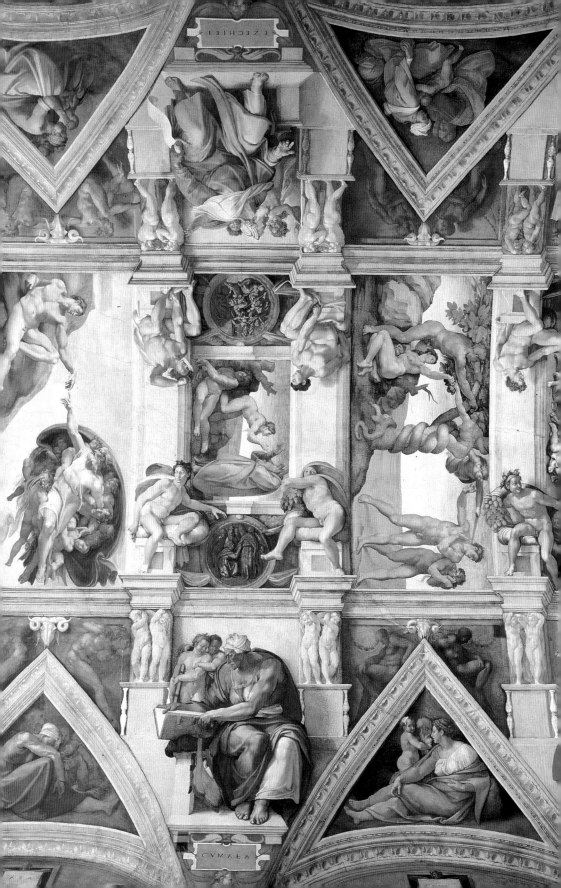

EZECHIEL

CVMAEA

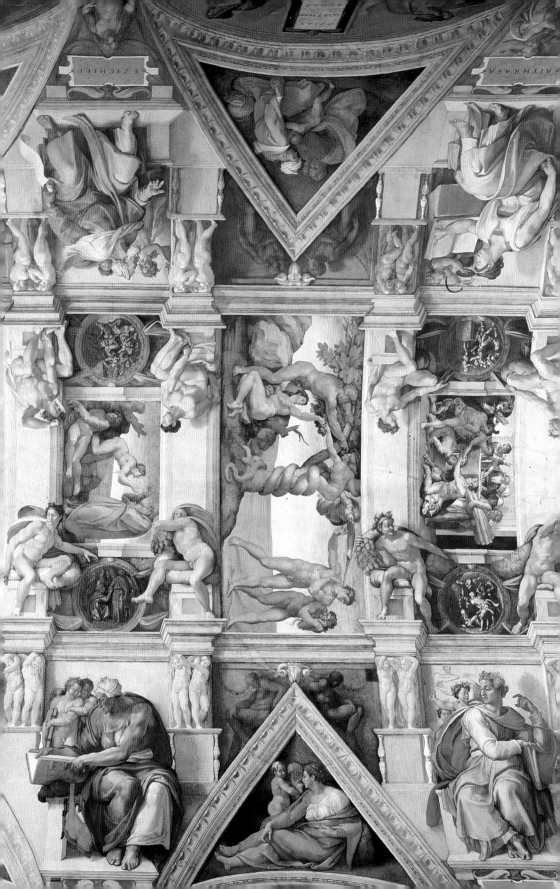

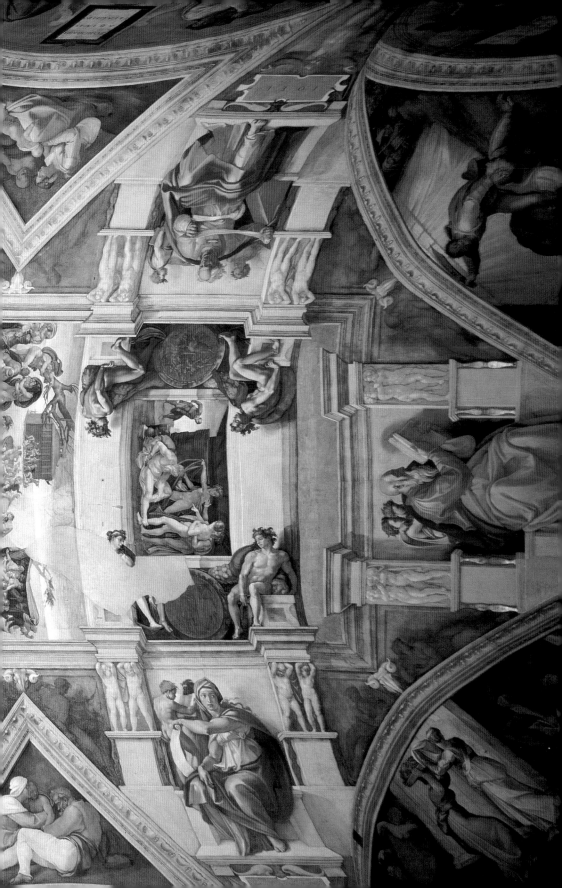

Previous pages

82. MICHELANGELO
Ceiling, east half, 1508–12.
Fresco. Sistine Chapel,
Vatican.

God's image and likeness. But he is also earth-bound and lethargic, essentially material. By contrast God – silhouetted against the sky, his billowing drapery crammed with angels, moving through the air at high velocity – is represented as essentially spiritual. But God also contains the mass, substance, and form of matter, and Adam the youth, beauty, and grace of spirit. More than just the creation of Adam, then, Michelangelo has represented the moment when God by the touch of a finger endows Adam with a soul, the moment when spirit and matter first conjoin. The green of the fluttering ribbon and the earth cues the fecundity of that junction.

Since Christ was commonly referred to as the second Adam, the scene also prefigures the redemptive Incarnation. The woman under God's left arm, from whose loins the green drapery originates, was probably intended to be Eve, preordained from the beginning, and standard prefiguration of the Virgin, the vessel of the Incarnation. Thus, the robust child held by the two fingers of God's left hand – just as a celebrant priest holds the host during the Mass – prefigures Christ.

The final scene of the first triad representing the *Separation of Water from Firmament* on the second day is chronologically out of order with respect to the preceding *Creation of Sun, Moon, and Planets* on the third and fourth days (see FIG. 81). The *Sacrifice of Noah* is also out of chronological sequence with the next scene, the *Flood*, because here Noah and his family give thanks for the end of the deluge (see FIG. 82).

These transpositions are in fact symbolic. The water of the *Separation of Water from Firmament* suggests the regenerative potential of Baptism believed to cleanse the soul from the taint of original sin, and God hovering over the water, the divine grace believed to be channeled to the faithful by Baptism. Noah sacrificing a ram prefigures the Mass which made such blood sacrifices unnecessary. With the Eucharist and Baptism comprising the two essential sacraments for salvation, Michelangelo transposed these scenes to bracket the central triad with the creation and fall of humankind.

Mastery of the nude was the essential measure of achievement for any artist in the High Renaissance and nothing posed a greater challenge than the sculpture of antiquity. The *ignudi* became the means by which Michelangelo honed his skills at depicting human anatomy, came to terms with

83. MICHELANGELO
Separation of Light and Dark, 1508–12. Fresco. Sistine Chapel, Vatican.

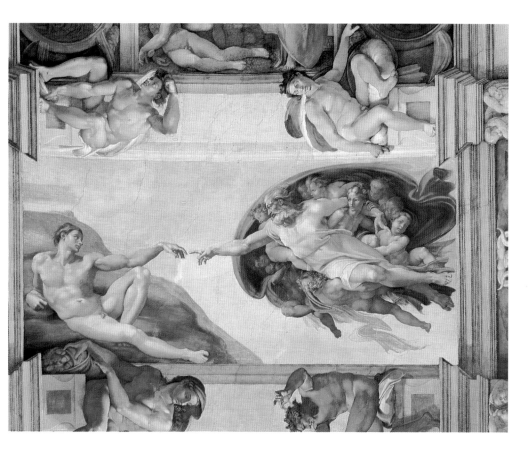

84. MICHELANGELO
Creation of Adam,
1508–12. Fresco. Sistine
Chapel, Vatican.

classical art, and developed a new heroic style. In spite of their aggressive masculinity the *ignudi* are probably best understood as angels – embodiments of divine spirit and agents of God – who confirm the earliest history of humankind they witness.

The first nudes Michelangelo executed surrounding the *Drunkenness of Noah* – directly derived from a well-known classical type found on medals and gems – are the least inventive (see FIG. 81). The nudes around the *Sacrifice of Noah*, especially the one nearest the ram who leans forward with a sharp bend of the body and a strong turn of the head, are much bolder and draw inspiration from a far more challenging antique example, the famous *Laocoön* (FIG. 85). By the time Michelangelo had completed the nudes near the *Separation of Water from Firmament*, he had created nothing less than a whole new canon of form – a canon characterized by more developed muscles, narrower hips, broader shoulders, a thicker torso, and a higher center of gravity, which together communicated greater strength and gracefulness than ever before (FIG. 86). And in the nude to the right the intensity of the drama exceeds even that of the *Laocoön*, a drama expressed by

contrary diagonal axes of torso and limbs, curled toe, strongly turned shoulders, intense expression, and hair flying forward in response to the figure's almost violent leap backward.

In the last bay Michelangelo, now in full command of the nude, demonstrates his sheer technical virtuosity (see FIG. 83). One *ignudo* to the left of the feet of God communicates supreme linear gracefulness developed along a diagonal axis achieved by creating a somewhat flattened form in a complex contrapposto with an active, broken silhouette. His companion to the right expresses extreme organic compression and mass along an opposite diagonal, compacted and contained within a closed silhouette, but with his contrapposto still pushed to the extreme. Here Michelangelo has far exceeded any works of classical antiquity in terms of titanic scale, muscular power, and compact density. He has reached the absolute limits of organic perfection, creating angelic nudes that embody supreme Herculean power and Apollonian grace – the perfect formal expressions of divine perfection.

Imitation tapestries had been painted in fresco on the lower walls of the Sistine Chapel under Sixtus IV (see FIG. 76). A set of ten real tapestries was commissioned by Leo X and completed in the Brussels workshop of Pieter van Aelst (d. 1532) by 1520 after designs by Raphael of 1515–16. Under the Christ cycle on the right were four scenes from the life of St. Peter, and under the Moses cycle on the left, six scenes from the life of St. Paul. Like the frescoes above, both the Petrine and the Pauline set were hung to read from the altar toward the entrance and all but one hung on the altar side of the dividing screen. Martyred in Rome, according to legend, on the same day and sharing the same feast, Peter and Paul represented the first generation after Christ in the era under grace.

The *Miraculous Draught of Fishes* (FIG. 87), designed to hang at the right of the altar, shows the moment following the miracle on the Sea of Galilee when Peter kneels in recognition of the divinity of Christ and his own unworthiness saying, "Depart from me, for I am a sinful man, O Lord," and Christ responds, "Fear not: from henceforth thou shalt catch men." Christ's words mark the calling of the first apostle and confirm the primacy of Peter.

The scene opens on the left with Zebedee punting the boat; he looks away and leans back unaware, for he will not become an apostle. But the diagonal of his pole begins a crescendo of movement, energy, and perception which continues with his two sons, James and John, bent over, straining at the net, pulling upward,

85. HAGESANDROS, POLYDOROS, AND ATHENODOROS OF RHODES
Laocoön, c. 20 BC to AD 20. Marble, height 6' (1.84 m). Sculpture Court, Cortile del Belvedere, Vatican.

Discovered in Rome on 14 January 1506, in the Baths of Trajan on the Esquiline Hill, the statue was moved to Julius II's sculpture collection in the Cortile del Belvedere. Laocoön, the Trojan priest of Apollo, flanked by his two sons, is attacked by a serpent sent from the sea by Athena. Athena, who was on the side of the Greeks during the Trojan war, was angry that Laocoön had warned Troy about the trap of the wooden horse.

very much aware of the miracle of fishes. But while James's hair blows forward, he pulls slightly backward and does not perceive the action in Christ's boat. As if completing the action of James, John – a more open and dynamic figure with billowing drapery – bends less severely, pulls slightly forward with only one hand, holds the net higher, and glances at Christ. All the straining in the first boat finds its release in the next with Andrew, stepping forward and spreading his arms in a rhetorical gesture – an indication of his full awareness of both the miracle and Christ's divinity. The shorelines and the cranes reinforce this crescendo: both shores recede on a diagonal into depth and rise upward on the surface; the first crane is calm, the second squawks with its head back, the third squawks with its neck extended and wings flapping. Peter drops to his knees, leans forward, and clasps his hands in prayer, creating a sudden and dramatic diminuendo. Monumentalized by the broad expanse of calm water and the vast sky filled with birds circling toward him, Christ brings the movement to a full stop as he sits blessing Peter, facing the altar and the pope who was enthroned in front of the left wall.

Woven at a huge cost with an abundance of gold and silver threads, the tapestries expressed the wealth, power, and majesty of the church. Leo X, however, was so profligate that he considerably

86. MICHELANGELO *Ignudi* (above the Persian Sibyl), 1508–12. Fresco. Sistine Chapel, Vatican.

87. PIETER VAN AELST

Miraculous Draught of Fishes (after Raphael's cartoon of 1515–16), 1516–19. Tapestry, silk, and wool, with silver and gilt threads, 15'11" x 14'5⅝" (4.9 x 4.4 m). Pinacoteca, Vatican.

The bottom border depicts Cardinal Giovanni de' Medici (1475–1521) leaving Florence (indicated by allegories of the city and the River Arno), arriving with his retinue in Rome (personified by the River God Tiber, a she-wolf, and Romulus), and shaking hands with a soldier in ancient Roman armor in front of St. Peter's. In one compact scene – epic in its mix of history, myth, and poetic allegory – Giovanni de' Medici absorbs the temporal power of imperial Rome and the spiritual authority of the church. At the far right, enthroned under Christ, Giovanni de' Medici has now been elected Pope Leo X, just as Peter in the scene above was called to be Christ's vicar; the cardinals show their obeisance, just as the apostles above pay homage to Christ.

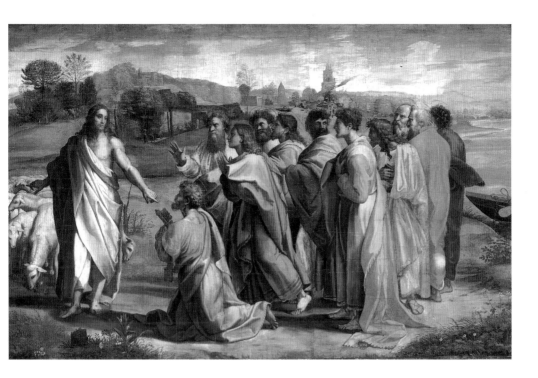

diminished all three. As a contemporary satire had it: "Leo has eaten up three pontificates: the treasury of Julius II, the revenues of his own pontificate, and those of his successor."

The next scene around the corner, the *Charge to Peter*, links with the previous scene by the reappearance of the boat and shoreline, and by a composition which constructs a crescendo of excitement followed by the diminuendo of Peter's kneeling (FIG. 88). Yet the finale is very different. Here Christ, dressed in white, stands in front of a mountain, rhetorically pointing to the sheep with one hand, as if selecting Peter to be the new shepherd of the flock by commanding him "Feed my lambs." With his other hand he points to Peter's keys, as if saying "Thou art Peter and upon this rock I will build my church..." Indicative of the increasingly strong attacks on the church in this period, the two scenes combine for the first time and on a monumental scale the three major New Testament texts of Peter's primacy.

The Borgherini Chapel, S. Pietro in Montorio

The *Flagellation* by Sebastiano del Piombo (assisted by Michelangelo) of 1516–24 for the Borgherini Chapel of S. Pietro in Montorio also concerns the church challenged (see FIG. 70, page 109). In a tour de force of perspective manipulation Sebastiano neu-

88. RAPHAEL
Charge to Peter, 1515–16. Cartoon, gouache on paper, now transferred to canvas, 11'3" x 17'5" (3.4 x 5.3 m). Victoria and Albert Museum, London.

Raphael designed all the cartoons in reverse, since the tapestries were woven from the back reversing the design. Thus the boat and shoreline to the extreme right are to be understood as continuing the boat and shoreline in the previous scene of the *Miraculous Draught of Fishes* (see FIG. 87).

tralized the curvature of the wall and created a spatial cube by setting three massive Corinthian columns on each side; the back wall opens into a niche echoing the chapel itself. The four flagellators have angular anatomies, coarse physiognomies, and ruddy complexions, while Christ recalls an Apollonian hero. By using oil rather than fresco Sebastiano has also achieved a deep tone, resonant color, and vibrant chiaroscuro that imparts an appropriate sense of impending doom.

The artist frescoed the *Transfiguration* in the apse above (FIG. 89). St. James resembles a river god as he reclines to the left along the curvature of the cornice, chest to the worshiper, gesturing into the chapel space, and twisting around toward the light. As if about to spring up from a crouching posture, St. John looks and gestures at Christ, his face bathed in the light. Above, where the apse curves sharply around and upward, Moses displays the tablet of law in Hebrew. On the right St. Peter also reclines on the cornice, his back to the worshiper, gesturing into the pictorial space. Elias hovers above with hands in prayer. The left side is more heavily weighted, outwardly focused, and darker than the right; this contrast reinforces Christ's rotation from left to right toward the light communicated by his contrapposto, turn of head, and billowing drapery. Although Christ seems to be standing at a point farthest from

89. SEBASTIANO DEL PIOMBO *Transfiguration*, 1516–24. Fresco. Borgherini Chapel, S. Pietro in Montorio.

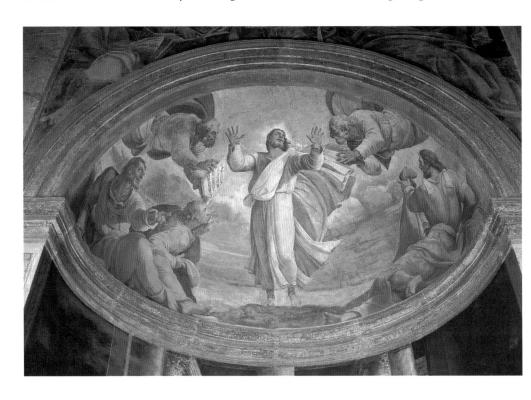

the worshiper, he is visually detached by the apselike expanse of sky and intense white light behind him. He seems, in fact, to float transfigured in the center of the apse within a perfect spherical space, symbolic of the Church Triumphant, which contrasts strongly with the cubic space below, symbolic of the Church Militant.

The Sistine Chapel: The Last Judgment

Michelangelo's *Last Judgment* also represents the triumph of the church. But here the accent falls on the unworthiness of humankind and its helpless dependence on the awesome power of Christ at the end of time. This in turn reflects the pessimism after the Sack of Rome, when most Romans felt that they had been punished by God for their sins and the abuses of the church. The work was commissioned in 1533 by Clement VII, who personally witnessed the Sack. When he died shortly afterward, the commission was renewed in 1534 by Paul III and completed in 1541.

To prepare the wall Michelangelo had all previous decoration destroyed. In the process he changed the wall's slant from backward leaning to forward leaning at the top in order to enhance his vision of the drama (FIG. 90).

On a patch of earth and against a deep blue sky are four bands of figures, each tipped toward the right as if they were giant balance beams responding to the ascent of the elect on the left and the descent of the damned on the right (FIG. 91). Never before in scenes of the Last Judgment was the movement so pervasive, or the illusion so strong that the wall had dropped away to reveal the drama in progress. The source of the movement is Christ, the embodiment of supreme good, directly above hell's mouth, sign of complete evil. Christ is a classicizing hero of superhuman strength; he appears to be standing, rotating from left to right, and raising his hand in order to lift up the elect with his right hand and draw them toward him with his left. Simultaneously, he seems to be sitting down on his celestial throne of clouds, about to throw down his right hand in the direction of his glance and lash out with his left to cast out the damned. Given the size of the pictorial field, Michelangelo has supplemented Christ's movement with angels who blow trumpets, assist the elect to ascend, drive down the damned, and carry the instruments of the Passion.

90. Diagram showing how Michelangelo had the west wall of the Sistine Chapel prepared to receive the *Last Judgment.*

The wall was cut back about six inches (15 cm) at the top (AC), then cut away ever more deeply until reaching a depth of about two feet (60 cm) at the bottom (BD) which involved the removal by hammer and chisel of about 2,200 cubic feet (62 cubic m) of masonry. Then to carry the first rough *intonaco* layer of the fresco, the wall was faced with six-inch bricks (EG, IK, FH, JL). The net effect was a wall whose top overhung the bottom by about one foot (30 cm) with respect to the true vertical, an overhang that can be seen and felt like the entasis of a column.

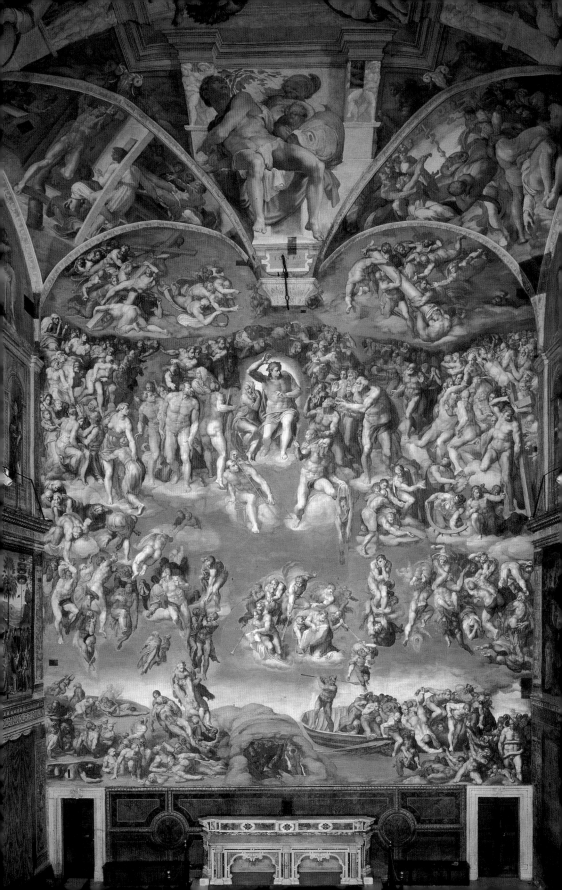

The Virgin cowering against Christ amplifies his visual impact, and the left to right rotation of her complex serpentine form responds to his movement. But she is a closed, veiled figure who initiates no movement herself, suggesting that at the end of time the Church Militant no longer has a role to play. Similarly, St. Peter to the right seems to be offering to return the keys to Christ. However, Peter, paired with Paul – an unprecedented juxtaposition within the visual tradition of Last Judgments – certainly symbolizes the founding of the church and its importance as the agent of salvation before the Second Coming. The representation of John the Baptist on Christ's favored right side, and equal in stature and counterpart to Peter, is also unprecedented. Thus John here plays his historical role as the precursor of Christ linking the eras under law and under grace, and embodies penitence and baptism necessary for salvation. Behind John and Peter kneel Adam and Eve, representative of the beginning of time before law. All time, then, is shown to be directed, gathered, and brought to an end by Christ.

Visualizing the drama's conclusion helps to understand the slanting wall. The damned in the two lower zones at the right will disappear into the underworld through the entrance at the far right. These lost souls are being shepherded by two mythological figures from Dante's *Divine Comedy*: the ferryman Charon and the serpent-coiled Minos. The souls in the lower left will break free of earthly constraints, ascend with those in the next zone, and, while gaining about three feet in stature, will compact even further the already densely populated zone of the elect. The zone of the elect is also being pressed down from above by the angels in the lunettes and sealed off from below by the martyrs at the right acting out their martyrdoms. In the end only the elect will remain crowded around Christ. In cooperation with this growth of the elect in number, scale, density, and self-control the wall gets thicker and pushes the figures forward. The elect in turn appear to evolve from background to foreground becoming ever larger, more anatomically articulate, and more purposeful. In other words, in much the same way that Michelangelo designed the dome of St. Peter's to culminate in the dense, compact, and fully articulated lantern suspended over the crossing void, here the saved souls are becoming solid, massive, and vigorous forms suspended in heaven, contrary to the law of gravity.

To the extreme left in the zone of the elect, in front of a group composed mostly of women, a bare-bosomed personification of the church charitably shelters a genuflecting woman who embraces her fecund body, signifying the potential of regeneration through

91. MICHELANGELO
Last Judgment, 1534–41. Fresco. Sistine Chapel, Vatican.

Near the left foot of Christ, St. Bartholomew holds a skin that is probably a self-portrait of Michelangelo – a kind of signature indicating the artist's concern for his approaching death and his hope for resurrection merited by offering the fresco as a good work, as an enormous physical and intellectual self-sacrifice.

the church. Opposite on the extreme right, at the head of a group composed mostly of men, a man plants a cross on the cornice, signifying Christ's sacrifice which makes salvation possible. Between the two groups the male and female principles fruitfully conjoin in Christ and the Virgin.

In contrast to the heroic and graceful figures of the ceiling, here figures are lumpy and without much refinement. Christ alone is youthful, graceful, and autonomous. But the evolution of figures from bottom to top and from background to foreground in terms of size, articulation, and purpose implies that by the end of the drama all the souls will have become the image and likeness of Christ. The slant of the wall also pushes the figures forcefully into the natural light from the windows. But their physical matter and the natural light are transmuted into spirit, since Christ – modeled on the famous *Apollo Belvedere* in the sculpture court of the Cortile del Belvedere and silhouetted against a golden mandorla – is a new Apollo, the eternal radiance of truth rising mystically in the west contrary to nature.

Lay Confraternities and their Oratories

Confraternities originated in the Middle Ages and were found all over Europe. They could vary in size from a few dozen to several hundred members – all male, all female, or mixed – with governing boards elected from the membership. Members came from all classes, although most were from the middle and lower classes, and often shared common interests or ethnic origin. Motivated by a sense of sinfulness, the members of the confraternity met regularly in their oratories for communal prayer, song, and Mass to assist in the salvation of their souls. In flagellant confraternities members whipped themselves on the back through a hole in their rough hooded habits when in penitential procession, the purpose being "to atone for the sins of the world and to placate the wrath of God by re-creating the suffering of Christ." Confraternities also engaged in charitable good works such as ministering to criminals, as in the case of S. Giovanni Decollato, or caring for the sick and elderly and giving dowries to poor girls, as in the case of the Gonfalone. They also provided members with financial assistance and burial services.

Encouraged by the papacy to help service the increase in popular piety during the Counter-Reformation, over sixty new confraternities were founded after the Sack of Rome. Most used existing chapels in churches as their meeting places, but seven built new buildings, three of which were decorated with frescoes. Many

contemporaries saw building and decorating an oratory as an inappropriate expression of worldliness, and the record of so few new and decorated oratories in Rome, as compared to Venice, indicates the degree of Roman austerity in the Counter-Reformation.

The oratory of S. Giovanni Decollato, built in the 1530s for the Florentine community, was decorated from 1536 to 1553 with eight frescoed scenes from the life of John the Baptist, the patron saint of Florence. The narrative begins at the right of the altar and continues clockwise around the room. The second and third scenes on the right wall are by Francesco Salviati (1510–63) and dated 1538 and 1551.

The earlier *Visitation* (FIG. 92) is a typical example of Mannerism as discussed in chapter four (see FIG. 63). Seen through an illusionistic opening in the wall, the event is asymmetrically staged like a *tableau vivant* viewed from a slightly oblique angle.

92. FRANCESCO SALVIATI
Visitation, 1538. Fresco.
S. Giovanni Decollato,
Oratory, Rome.

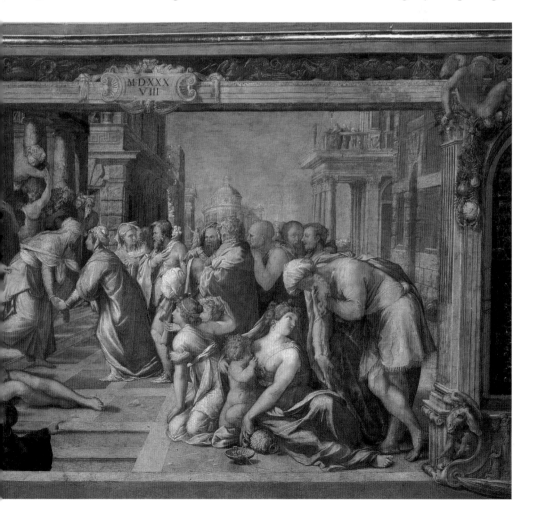

93. FRANCESCO SALVIATI
Birth of John the Baptist, 1551.
Fresco. S. Giovanni Decollato,
Oratory, Rome.

The youth and fecundity of the
serving women (one of whom
carries a basket of flowers on her
head), the triumphal arch, the
victory column seen through the
door, and the contrast between the
ancestor bust and the crib suggests
the coming triumph of the new
order of Christ's grace, which John
will announce, over the Old
Testament world of law.

138 *Chapel Decoration: Space, Time, and Eternity*

The two patrons in their somber black clothes – Battista da Sangallo, builder of the oratory, and Giovanni da Cepperello – walk upstairs from below onto the stage as if directly experiencing the sacred drama. Yet the narrative has been distanced by its presentation as an artifice: the stage is spatially artificial, the architecture fanciful, the perspective arbitrary, the composition deliberately based on works of other artists – a common characteristic of Mannerist art – and the quotations then elaborated and fantacized. For example, the female porter to the left – taken from works of antiquity, Pontormo (1494–1556), and Raphael – has had her hair refined, color enhanced, and drapery agitated beyond reality or narrative requirements. Her female potency has been heightened by the exposure of her breasts and her juxtaposition with a heroic semi-nude youth. Indeed, female fertility is a recurring compositional theme as nearly all the women are young, beautiful, and fecund, while the men are mostly old and marginalized. Aside from Zacharias and Joseph, almost lost in the background, these figures are extraneous to the narrative and added for visual interest. The result is a tension between the spatial immediacy of an actual event and the aesthetic distance of a charged, super-real, feminized world that is a metaphor for the joy, excitement, and ecstasy at the coming birth of John the Baptist and Christ. Comparison with Barocci's *Visitation* (see FIG. 67) makes a dramatic contrast between Mannerist and Counter-Reformation art.

The adjoining *Birth of John the Baptist* of 1551 marks a radical change in style, owing in part to the impact of Michelangelo's *Last Judgment* – reflected in the more massive figures, slower rhythms, and more somber atmosphere – and in part to the ever stronger impact of the Counter-Reformation – indicated by the greater spatial and narrative clarity, and the more symbolic and sacramental content (FIG. 93).

Unprecedented in this scene is the presentation of a pair of turtle doves to Elizabeth by the Virgin, said in the *Golden Legend* to be present at the birth of John. In the visual tradition doves are associated most often with the required sacrificial payment in scenes of the Presentation of Christ in the Temple and the Purification of the Virgin. Thus, the doves tend to conflate the births of Christ and John, and, without the naming of John by Zacharias, this scene is in any case indistinguishable from a Nativity. The circular canopy supported by five angels symbolizes both the perfection of the youthful Virgin and the sanctity of the aged Elizabeth and Zacharias. The gesture of the infant John suggests his eventual beheading and the water being poured for his bath, his preaching about baptism.

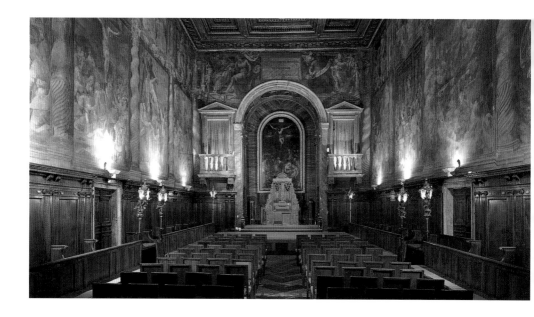

94. View toward the altar, Oratory of the Gonfalone, Rome.

The fresco cycle recalls the Passion play that the confraternity performed in the Colosseum between 1490 and 1539. The privilege was revoked by Paul III after a number of Jews were killed during a riot in the ghetto provoked by the savage treatment of Christ in the play.

The Gonfalone, founded in 1264–67 as a flagellant order, had a new oratory built from 1544 to 1557. It was decorated from 1568 to 1576 under the patronage of Cardinals Alessandro Farnese and Otto Truchsess von Waldburg (1514–73), Cardinal-Bishop of Augsburg. The subject of the decoration was the Passion of Christ in a cycle of twelve frescoes running clockwise around the room, beginning at the right of the altar (FIG. 94). Passion cycles on this scale were almost unknown in Rome before, although they became more common afterwards. The choice of subject is a good indication of the ever greater emphasis on humankind's dependence on Christ's sacrifice during the Counter-Reformation.

The general layout conceived by Jacopo Bertoja (1544–74) consists of illusionistically framed pictures between dynamic spiral columns that carry an attic with prophets and sibyls. The columns symbolically transformed the oratory into a new Jerusalem, since they imitated those surrounding the tomb of St. Peter believed to have been from the porch of the Temple of Solomon and brought to Rome by the emperors Titus and Vespasian.

The cycle opens with Bertoja's *Entry into Jerusalem* (FIG. 95). The figures to the left indicate by their gestures the narrative flow from left to right and focus attention on Christ, shown humbly riding an ass but majestically offering a sign of benediction. The adoring, pious, and joyful crowd, which includes a bearded portrait of the artist to the right, provides a counter movement. The Temple of the Holy Sepulchre in the background, where Christ will be buried, telescopes the beginning and ending of

the Passion. The child with a bundle of palms behind Christ also associates the biblical narrative with the ritual of Palm Sunday.

The *Flagellation* by Federico Zuccaro is dated 1573 (FIG. 96). Although still an illusionary framed picture, it is especially theatrical. Curtains pulled back reveal soldiers standing or leaning on a ledge and holding the crown of thorns and mock scepter. Some look outward and engage the eyes of the members of the congregation, others witness the Flagellation in progress on a raised stage. Still others look on from balustrades behind Christ. This theater in the round not only recalls the Passion play once performed by the confraternity, but produces the kind of narrative clarity demanded by Michelangelo's critics. The architecture is also a straightforward symbol of both a triumphal arch and a tabernacle dressed with curtains for the display of the host. The action thus shifts from challenge to triumph, from history to liturgy. Like much Counter-Reformation art, this work is also based on an authoritative High Renaissance example, Sebastiano del Piombo's *Flagellation* (see FIG. 70).

95. JACOPO BERTOJA
Entry into Jerusalem, 1568.
Fresco. Oratory of the
Gonfalone, Rome.

Reflecting the temper of the times, Bertoja's usual Mannerist style – still evident in the frieze of rhythmically connected figures pushed to the surface by the landscape – has been considerably moderated.

96. FEDERICO ZUCCARO
Flagellation, 1573. Fresco. Oratory of the Gonfalone, Rome.

For the first time in art Christ is shown tied to a short column modeled
on the supposed authentic relic in S. Prassade, brought to Rome from
Jerusalem in 1223 during the Fifth Crusade.

Chapel Decoration: Space, Time, and Eternity

Flagellation was a public expression of penitence in the face of Protestant denial, and, as the column reminded, a replication of Christ's own suffering. As stated in the 1572 rules of the Gonfalone: "The Sacrament of Penance and that of Holy Communion are the two columns which support and conserve firmly and stably the spiritual edifice of the confraternity...They [the members of the confraternity] will use whips...in memory of the whips with which our Lord himself, when tied to the column, was beaten for our sins; they will use them...not only for their own sins, but also for those of humankind." Federico's scene showing Christ both flagellated and displayed as the host alludes to these columnar spiritual supports of the Gonfalone.

This quintessential art of the Counter-Reformation differs only in degree from previous Renaissance art we have examined: it is more dramatic, lucid, and theatrical; more strictly based on the Bible; and symbolically more directly related to Penance and the Eucharist. Like the *Spiritual Exercises* of Loyola, it promotes an active and sensual identification with the Passion through visualization to achieve an understanding of sacramental doctrine.

FIRMITATEM COMMODAM VTILITATEM

SIX

Halls of State: Arts of Power

97. PERINO DEL VAGA
AND ASSISTANTS
Emperor Hadrian (center);
*Sacrifice at Lystra with
Charity and Abundance*
(over left door); *Martyrdom
of Saints Paul and Peter
with Hope and Charity*
(over right door). Fresco,
south wall. Sala Paolina,
Castel Sant'Angelo, Rome,
1545–48.

A Roman Renaissance hall of state was an unconsecrated space where political power was exercised or claimed. Most were commissioned by popes, but many by cardinals and communal officials as well. Its decoration was designed to glorify and legitimate the claimant and the regime. As in a chapel the scenes were usually organized chronologically to begin or end at the head of the space but unlike a chapel they were usually drawn from secular history or, more rarely, mythology. In place of an altar at the end of the spatial axis there was a dais with a throne and a canopy, or, for communal officials, a bench without a canopy. Since popes claimed spiritual authority as well as political power, the decoration at the head of their halls almost always suggested that the charismatic papal body was virtually equivalent to an altar as an agent of mediation between heaven and earth.

Among the earliest surviving decorated papal halls of state are those in the Borgia Apartment in the Vatican Palace, commissioned by Alexander VI and executed by Pinturicchio (1454–1513) and his workshop from 1492 to 1494 (see FIG. 39), the most important of which was the Sala dei Santi (FIG. 98). A petitioner or courtier would probably have approached the pope from the Sala dei Misteri through the door in the east wall and would then have turned toward the south wall where the throne was probably located. Scenes from the Bible and the lives of saints in the lunettes, scenes more common to chapels than to halls of state, indicate the transitional character of the room. Representations in the two groin vaults of the myths of Osiris and Isis, the principal deities of ancient Egypt, reflect the interests of Giovanni Annio of Viterbo (c. 1432–1502), the pope's secretary, who probably devised the program of decoration for the room. Since the spiritual wisdom of

98. PINTURICCHIO
AND WORKSHOP
South and west walls, Sala
dei Santi, Borgia Apartment,
Vatican, 1492–94.

The Borgia Apartment is now
used to display part of the
Vatican collection of modern
religious art.

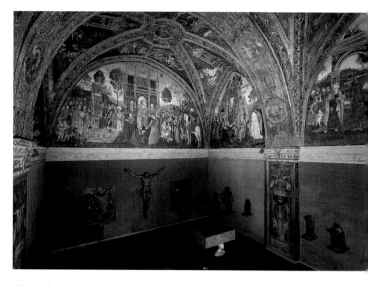

99. PINTURICCHIO AND
WORKSHOP
Story of Isis, Osiris, and Apis,
1492–94. Fresco, south vault.
Sala dei Santi, Borgia
Apartment, Vatican.

these founders of the earliest religion was believed to have been
passed on to Moses, and from Moses on to Christ, it seems almost
certain that these myths were understood as prefigurations of Christian history.

The four scenes in the south vault above the throne read counterclockwise (FIG. 99). The first shows the assassination and dis-

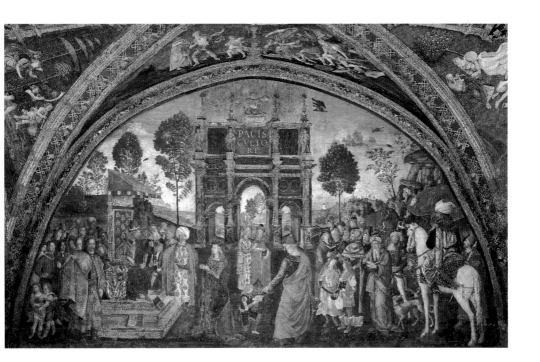

100. Pinturicchio
and Workshop
*St. Catherine Debates the
Scholars of Alexandria*,
1492–94. Fresco with
stucco relief, south lunette.
Sala dei Santi, Borgia
Apartment, Vatican.

memberment of Osiris by his evil brother Typhon, prefiguring the sacrifice of Christ. The next, typifying Christ's entombment, is inscribed: "His wife [Isis] then finds the scattered members [of Osiris] for which she has a tomb constructed." The tomb is a pyramid, an Egyptian symbol of divine light, as it was correctly understood in the Renaissance. In the next scene Osiris has resurrected from the tomb as Apis the bull, a benign Egyptian god of agriculture and fecundity. This would not only allude to the resurrection of Christ, but also Alexander VI's election as the vicar of Christ, the bull being an emblem on the Borgia family coat of arms. The last scene represents the triumph of Apis, prophesying the triumph of Christ, and is inscribed (in reference to the previous scene): "They had no sooner begun the sacred rites than the bones rose up as a bull displayed to the people." These scenes, then, with their star-studded blue backgrounds would have formed a heavenly canopy over the pope's throne, including him in the divine plan that prefigured his investiture with universal spiritual power from the very beginning of recorded history.

The courtier or petitioner would also have seen the pope enthroned with his back to the largest, best-lighted pictorial field in the room, which depicts St. Catherine debating with Maxentius and his scholars about the Incarnation and Passion of Christ prefigured in the Osiris/Apis scenes just above (FIG. 100). Compared to Masolino's rendition of the same episode about sixty years

earlier (see FIG. 72), this scene is notable for its rhetorical variety and grandeur as well as the conspicuous presence of the Arch of Constantine, a sign of the triumph of Catherine and the converted scholars over paganism and ignorance.

But the arch also refers to the rivalry between Maxentius, who ruled the eastern half of the Roman empire from Alexandria, and Constantine, who ruled the western half from Rome. As Catherine was Constantine's niece, so the legend goes, Maxentius persecuted her to goad Constantine. When Maxentius returned to Rome with his army to unseat his rival, he was defeated at the Milvian bridge by Constantine, whose victory was aided by the sign of a cross that came to him in a dream. Constantine thus converted, made Christianity the state religion, and built the arch to celebrate his victory. The arch, then, also signifies the victory of the church over a challenge from the East, as well as the establishment of the imperial church upon which papal claims to universal temporal power were based. Catherine has been shifted to left of center so that nothing would distract from the alignment of the enthroned pope with the arch and the statue of Apis, whose inscription "To the cultivator of peace" refers equally to Apis, Christ, and Alexander VI. The decoration thus focuses on the pope and serves to legitimate his claims to supreme temporal and spiritual power and to mediate between earth and heaven.

The Stanza d'Eliodoro

On 26 November, 1507, Julius II made it known that he no longer wished to live in the Borgia Apartment surrounded by the arms, devices, and portraits of his hated enemy Alexander VI, and intended to move to the apartment upstairs on the third floor (see FIG. 40). One of these new rooms, decorated by Raphael and his workshop from 1511 to 1514, is now known as the Stanza d'Eliodoro (FIG. 101). As in the Sala dei Santi, the throne of this audience hall was probably placed on the south wall and normally would have been approached by entering the door on the east wall from the Sala di Costantino and turning left. The decoration begins chronologically on the east wall with the Old Testament *Expulsion of Heliodorus* and continues counterclockwise around the room with the New Testament *Liberation of St. Peter from Prison* on the north, the *Repulse of Attila in AD 452* from the early Christian period on the west, and the *Mass of Bolsena in 1263* from late medieval history on the south behind the throne. Compared to the Sistine Chapel, the emphasis here is much more on recent history, especially since Julius II or his successor Leo X are depicted as wit-

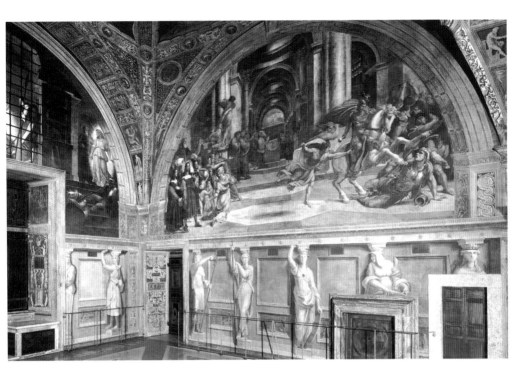

101. Raphael and
Workshop
North and east walls,
Stanza d'Eliodoro, Vatican,
1511–14.

nesses, creating the impression that these challenges to the church are ongoing in the present. This contemporaneity communicates a strong sense of urgency, as if the apocalyptic time of troubles is imminent. Yet paradoxically, given the fact that the challenges are all overcome, it also suggests the approaching millennium. The chronological sequence begins and ends at the throne, implying all history culminates in the pope at the cutting edge of time.

Reading in the normal left to right direction, the *Expulsion of Heliodorus* opens with Julius II being carried in on his portable throne by Raphael (under his left hand) and other courtiers, who by looking out draw the viewer in (FIG. 102). An image of vivid physical and psychological immediacy, Julius II leads the viewer by his concentrated gaze to his predecessor, Onias. The high priest of the Temple of Jerusalem prays for deliverance from Heliodorus, who has come to plunder the temple's treasure, an allusion to those who would loot the Roman Church. The connection between the two priests is reinforced by the blue and gold della Rovere colors of Onias's costume and by their full beards. All previous Renaissance popes were clean shaven, but Julius grew a beard in late 1510 and early 1511 as a sign of his vow of vengeance for the grave challenges to his authority from all sides, by the French especially, but also by the Turks, Bolognese, and Romans. He did so in imitation of his namesake, Julius Caesar, who, upon

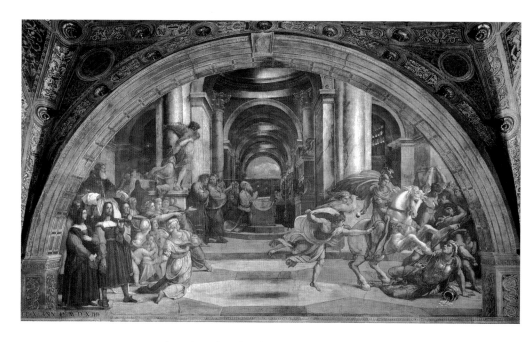

102. RAPHAEL
Expulsion of Heliodorus,
1511–14. Fresco, east wall.
Stanza d'Eliodoro, Vatican.

hearing that his legions had been cut to pieces by the Gauls in 54 BC, "let his hair and beard grow long, and would not cut them until he had taken his vengeance" (Suetonius, *Life of Julius Caesar*). Thus, Julius is more than a patron or witness. He is a supplicant who, in a time of need, turns to history and art to influence the course of events by prefigurative suggestion.

Although overwhelmed with troubles and a nearly fatal illness in 1511, Julius II is shown enthroned and elevated above all others, an icon of supreme confidence, self-righteousness, and authority. His masculine power is magnified by contrast with the frenzy and terror of the women and children at his feet in awe of the miracle represented on the right, but who, for mutual protection, recoil, spiraling backward into an imploding sphere. Although self-canceling and ineffective, the women's agitation finds release in two youths at the column who direct attention to Onias.

The perspective focuses on the altar at the fresco's center and pulls the viewer's eye through the sweeping illusionistic framing arch into depth across the octagons of the pavement and altar dais, symbols of the salvation for which Onias prays. The spatial perfection and muscular might of the architecture is enlivened by the strong play of flickering light across the gilt surfaces from the menorah, sign of divine light. Together the drama of perspective, architecture, and light create a powerful visual energy expressive of the fervent faith of Onias (and Julius II) and the strength of the spirit to which the prayers are directed.

At the left the spirit is made manifest by the appearance of three angels in headlong movement from left to right. Yet the horse rears, the drapery billows backward, the angels' right arms are drawn back to the point just before the release of their blows with mace and scourges. Heliodorus and his fallen companions simultaneously twist back to brace themselves for counter blows. Here two unequal forces are captured at the moment of dramatic equilibrium just before one crushes the other. Similarly, within the composition as a whole, supplication and divine apparition are caught in a tension-filled balance with explosive scourging and implosive recoiling.

A comparison between the *Expulsion of Heliodorus* and Pinturicchio's *St. Catherine Debates the Scholars of Alexandria* (see FIG. 100) indicates a higher degree of dynamism, concentration, and counterbalance in the High Renaissance style than that of the early Renaissance. This intensification was in part provoked by the increasingly competitive artistic environment of the High Renaissance. But it was also fostered by the greater ambition and idealism of the Julian age, which led to greater challenges and disappointments and a stronger sense of the imminence of the apocalypse and the millennium.

For thirty-two years before his election as pope, Julius II was known as Cardinal St. Peter in Chains after his titular church S. Pietro in Vincoli. Therefore, Julius II is not portrayed as a witness in the *Liberation of St. Peter*, he "is" St. Peter (FIG. 103). His imprisonment probably refers to the schismatic Council of Pisa called in 1511 to depose Julius II, a threat which he met by calling (not

103. RAPHAEL
Liberation of St. Peter from Prison, 1511–14. Fresco, north wall. Stanza d'Eliodoro, Vatican.

"faking," as Erasmus would have it) the Fifth Lateran Council in 1512, important as a forerunner of the Council of Trent.

To solve the problem of the intrusive window in the pictorial field, Raphael constructed illusionistic stairs parallel to the picture plane, providing a stable base for the cubic prison defined by huge rusticated piers with buttresses, massively thick walls supporting a heavy barrel vault, and a strong iron grille. This exceptionally secure and solid prison both connotes the strength of Peter, the rock on which Christ founded the church, and the seriousness of the challenge to papal authority.

The static quality of the architectural setting is brought to life by Raphael's virtuoso handling of light. In the center the angel's blinding circle of light is sufficiently harsh and glaring to abstract and dissolve the forms of the prison and guards. The juxtaposition with the window heightens the light's intensity while the framing arch magnifies its shape. On the right the liberation is accompanied by a softer, more velvety illumination, its oval shape reflecting the steep downward slope of the proscenium arch and the silent descent of Peter and the angel past the sleeping guards. On the left the dramatic gestures of the soldiers and extreme contrappostos accentuate the noisy sounding of the alarm. So does the remarkable variety of light – the flickering torchlight playing off the guards and the architecture, the glow of the rising sun tingeing the far-off horizon with yellow, orange, and pink, and the silvery white of the moonlight reflecting off the clouds. The extremes of solid matter animated with mobile radiance construct an apt sign for the Church Militant and the Church Triumphant.

The Sala di Costantino

The Sala di Costantino was executed by Raphael and his workshop from 1519 to 1524 for the Medici popes Leo X and Clement VII and was used in the sixteenth century for secret and semi-public consistories, papal audiences, ceremonies of appointment and investiture, and even occasionally for sermons, masses, weddings, and banquets (FIG. 104). Organized in clockwise order, eight over-lifesize popes from St. Peter to Gregory the Great enthroned in niches with angels, each flanked by a pair of virtues, embellish the corners. Together they "proved" the Petrine Succession and the legitimacy of papal spiritual authority. Between the popes were four simulated tapestries with scenes from the life of Constantine. These scenes demonstrated the source of papal temporal authority and the supremacy of the church over the empire.

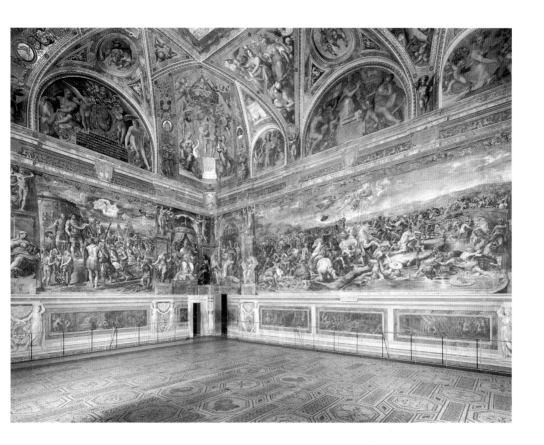

Most features of the decoration were derived from the Sistine ceiling, including forms that appear to be on, just behind, or slightly in front of the wall surface. But here the location of details is more uncertain, and most figures appear less real as a result of their lavish ceremonial dress, allegorical meaning, or status as part of another work of art such as a tapestry or bronze relief.

These contradictions, tensions, and ambiguities mark the first appearance in Roman halls of state of a highly charged Mannerist style that parallels the ever greater intensity of challenges to papal authority and the church. The decoration also marks the beginning of a triumphalist aesthetic of profusion, mirroring an insecure church's response to attack by ever more self-righteous assertions of legitimacy, authority, and victory. This triumphalist decoration of halls of state as befitting trophy cases, treasure troves, or museums, constructed an image of wealth, prosperity, peace, and erudition designed to overwhelm and compel by the sheer density of sign and symbol.

St. Peter with Ecclesia and Aeternitas in the northeast corner indicates just how dense this sign system could be (FIG. 105).

104. RAPHAEL AND WORKSHOP (including Giulio Romano and Gianfrancesco Penni) East and south walls, Sala di Costantino, Vatican, 1519–24.

The room originally had a wooden beam ceiling carved with Medici coats of arms and devices by Antonio da Sangallo the Younger. Between 1582 and 1585 the masonry vault was added and frescoed by Tommaso Laureti. The original floor, mirroring the ceiling, was replaced in the nineteenth century with the present second-century BC Roman mosaic.

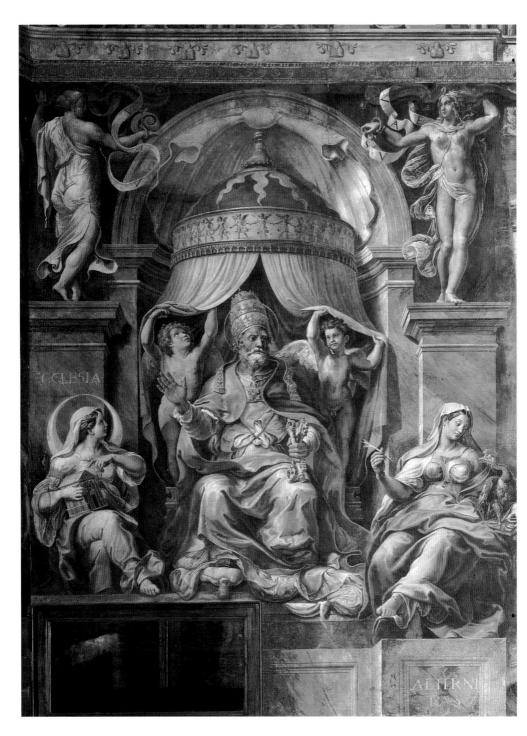

105. RAPHAEL AND WORKSHOP
St. Peter with Ecclesia and Aeternitas, 1519–21.
Fresco, east wall. Sala di Costantino, Vatican.

Although the costume was unknown in his own time, Peter wears full papal regalia, designed for the most formal court ceremonies to indicate the highest rank of priesthood. The tiara and the imperial purple of the robes symbolize Peter's universal temporal authority. His halo and the angels lifting the curtains of his canopy as in a divine manifestation are signs of his universal spiritual authority, while his keys and gesture equivocating between benediction/welcome and command/subjugation evince his power to save and damn. Exposed on a cushion, the right-foot slipper marked by a cross evokes the foot-kissing ritual performed to show humble submission to the new Christ on earth. The canopy symbolizes the cosmos; the surrounding chain of angels, the twenty-four hours of a day; and the sunburst on top, Christ the sun of justice. The moon of Ecclesia (the church) reflecting the sun's light is an emblem of the Virgin; the architectural model toward which she points, the church founded by Peter. The quill and ink pot of Aeternitas (eternity) suggest recorded history; the phoenix, the renewal of life at the end of time, toward which all history is directed.

The word "SUAVE" inscribed on the caryatids atop the pilasters recalls Leo X's motto from the words of Christ promising the faithful that "you shall find rest for your souls, for my yoke is sweet [suave] and my burden light." The word thus indicates devotion to Christ and obedience to the pope as a necessary condition for salvation. Subservience is visualized by the yokes to which the women are chained, and the burden's sweet reward by the youthful grace and erotic sexuality of the women – a decidedly male vision of salvation encouraged by the libertine atmosphere of the Medici court.

All textual sources and previous representations refer to a dream that Constantine had the night before the battle against Maxentius in AD 312. In his dream an angel advised him to carry a cross into battle for "by this you will be victorious." Here in the *Vision of Constantine* three angels carrying the cross and the phrase "Conquer by this" in Greek appear as Constantine addresses his troops before the battle (FIG. 106). This seemingly authentic classical setting derives from a relief of the same subject on the Arch of Constantine, built to commemorate the victory over Maxentius. Most details are also inspired by classical reliefs. But in a sophisticated Mannerist ploy, history is "refined" by the aesthetic elaboration of the forms and by the artifice of a fresco imitating a tapestry imitating ancient sculpture.

The diagonal into depth draws the eye to a series of ancient monuments reconstructed from partially existing ruins and ancient descriptions: (from right to left) the tomb of Augustus with one

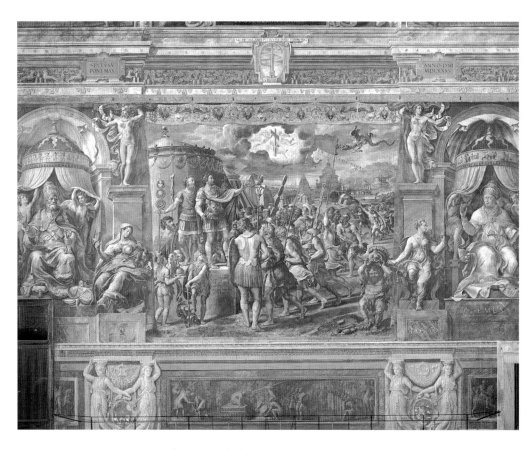

106. RAPHAEL AND
WORKSHOP
Vision of Constantine,
1519–21. Fresco, east wall.
Sala di Costantino, Vatican.

of its two obelisks; the *pons Aelius* (Ponte Sant'Angelo); the tomb of Hadrian (Castel Sant'Angelo); the *meta Romuli* (Vatican pyramid); the hippodrome of Hadrian. The accuracy of this erudite invention indicates to the knowing viewer that he is looking north up the Tiber in the direction of the Milvian bridge and that Constantine, by divine preordination, stands on the west bank of the Tiber at the very site where, after his battle and conversion, he will build St. Peter's. Indeed, the podium on which he stands (inscribed "The address by which divinity impelled the army of Constantine to obtain victory") is a metaphor for Peter, the rock, on whom Christ, the cornerstone, founded his church.

Since the papal throne was almost certainly at the opposite end of the room, this scene addressed the gaze of the pope. The gold balls on Constantine's tent referred to the *palle* on the Medici coat of arms, and the lion on a standard, lions' heads on the tent, and the lion skin on a soldier, evoked his papal name. The scene would thus have suggested Leo X as a new Constantine with imperial sovereignty. And just as Constantine founded old St. Peter's, contemporaries would have known that Leo was continuing the

construction of new St. Peter's begun by Julius II. Finally, the juxtaposition of the cross and the dragon, a common Renaissance symbol of evil and heresy, recalled the challenges to the Leonine regime.

The *Baptism of Constantine* is also given an authentic historical setting, the Lateran baptistery built by Constantine and repaired by the Medici popes (FIG. 107). Since the right-hand inscription records "that which was begun by Pope Leo X was completed by Clement VII in 1524," it is therefore Clement VII, in the guise of Pope Silvester, who performs "the baptism of renewed life of Gaius Valerius Constantine" (left-hand inscription). Thus, the pope sat enthroned in line with a demonstration of his supreme spiritual power to save. This authority was extended back to the beginning of time by the replacement of the caryatids on this wall with images of Apollo and Diana, prefigurations of Christ and the Virgin. The inclusion of costumes, liturgical vessels, and portraits, which show the baptismal rite as contemporary rather than early Christian, projects the authority of the pope forward into the present.

107. RAPHAEL'S WORKSHOP *Baptism of Constantine*, 1523–24. Fresco, west wall. Sala di Costantino, Vatican.

108. RAPHAEL'S WORKSHOP *Donation of Constantine,* 1523–24. Fresco, north wall. Sala di Costantino, Vatican.

The two inscriptions – "The endowment of the church given by Constantine" and "Now at last it is possible to profess Christ freely" – proclaim both temporal and spiritual power. Staging the scene as if it were a contemporary semi-public consistory and representing the donation as a statuette of *Roma aeterna* (eternal Rome) show this dual power to extend across all time and space.

The inscription on the liturgical book – "Today is salvation come to Rome and the empire" – is derived from the Gospel of St. Luke, where Christ converts the sinner Zaccheus. After Zaccheus donated half of his goods to the poor, Christ responded: "Today is salvation come to this house," thus prefiguring the donation of Constantine, who gave the western half of his empire to the pope, as shown in the next scene. Wearing a tiara, part of the imperial regalia supposedly included with the donation, instead of a miter proper for any liturgy, the pope is also presented as exercising supreme temporal power to which even the emperor is subservient.

Conversely, in the *Donation of Constantine* Pope Silvester wears a miter conflating his spiritual authority with the reception of his temporal dominion (FIG. 108). The inseparable link between the pope's temporal and spiritual power is also illustrated by setting the scene in the consecrated space of old St. Peter's (by this date about half destroyed), and by focusing the lines of perspective on the two major signs of papal spiritual legitimacy, the Eucharist and St. Peter (i.e. on the Mass taking place above the tomb of Peter and under a mosaic of the resurrected Christ).

On 24 February 1520, about four years before the *Donation* was completed, Luther wrote:

> I have at hand Lorenzo Valla's proof that the Donation of Constantine is a forgery. Good heavens, what darkness and wickedness is at Rome. You wonder at the judgment of God that such unauthentic, crass, imprudent lies not only lived, but prevailed for so many centuries, that they were incorporated in the canon law...and became as articles of faith. I am in such a passion that I scarcely doubt that the pope is the Antichrist expected by the world, so closely do their acts, lives, sayings, and laws agree.

In response to such attacks on the political ideology and spiritual doctrine of the papacy, the frescoes offer a self-serving history in which an idealized and falsified past is used to stabilize a conflicted present and to shape an uncertain future. The ambiguities and immediacy of the Mannerist style allude to the insecurity and anxiety of this period of crisis, yet the erudition and sophisticated artifice express equally the elitism and self-righteous superiority of this moment of high cultural achievement.

The Sala Paolina

The poor state of the accommodation in the Castel Sant'Angelo became painfully obvious when Clement VII and the curia were forced to retreat there during the Sack of Rome. As a result, Paul III had the fortress remodeled to provide a sumptuous papal apartment with a large audience hall, the Sala Paolina, decorated by Perino del Vaga (1501–47) and assistants from 1545 to 1548 (FIG. 109). The narrative scenes, represented as framed paintings in the vault, and the simulated bronze reliefs on the walls unfold in a clockwise direction around the room beginning on the north throne wall. Eleven scenes from the life of Alexander the Great, in reference to the pope's Christian name, Alessandro Farnese, evoke challenges to papal temporal power met and overcome, as well as papal patronage, magnanimity, peacemaking, and empire building. The central scene on the east wall, which shows Alexander cutting the Gordian knot to fulfill a prophecy of world rule, prefigures the expected millennium when Christendom – especially the area of Alexander's Macedonian empire now controlled by the Turks – would once again be united under the church (FIG. 110). Emperor Hadrian, builder of the Castel Sant'Angelo, represented in the center of the south wall and facing the pope

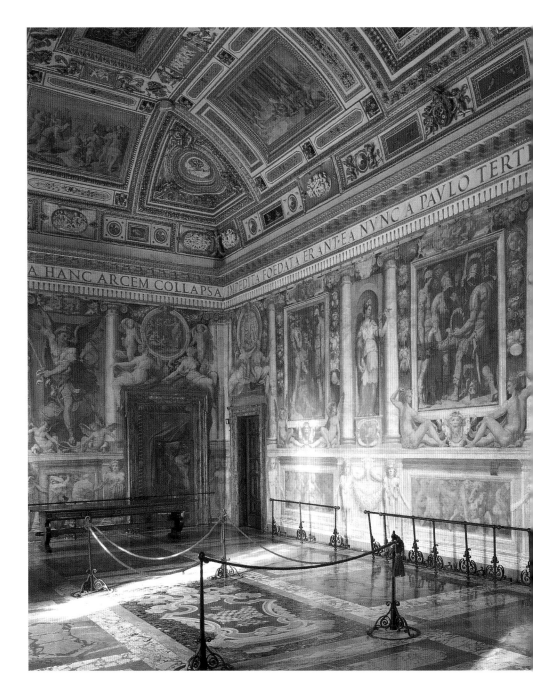

109. Perino del Vaga and assistants
North and east walls and vault, Sala Paolina, Castel Sant'Angelo, Rome, 1545–48.

The inscription on the frieze of the entablature reads: "Those things which in this fortress were once collapsed, useless, and ruined are now by Paul III, Pontifex Maximus, in strong solidity, comfortable usefulness, and refined beauty conspicuously replaced, restored, and decorated."

110. Perino del Vaga and assistants
Alexander the Great Cutting the Gordian Knot, 1545–48.
Fresco, center of east wall. Sala Paolina, Castel
Sant'Angelo, Rome.

enthroned opposite, provides a model for papal patronage and temporal power (see FIG. 97, page 145).

In the simulated bronze medallions above the doors are scenes from the life of St. Paul, in reference to Paul III's papal name, which allude to triumph over challenges to papal spiritual power. The dynamic figure of *St. Michael* depicted behind the papal throne mercifully sheathing his sword after the punishing plague of 590 creates the now familiar alignment: the pope enthroned directly under an image of divine power to save and damn. Side wall niches feature Plato's cardinal virtues of rule – Temperance, Prudence, Fortitude, and Justice – and Muses figure above the doors. On the end walls above the doors are the theological virtues – Faith, Hope, and Charity – and allegories of Theology, Religion, Concord, and Abundance. Combined with the festoons, angels, and winged victories surrounding bronze plaques and medallions, these personifications suggest the prosperity and harmony of papal rule, and its promise and means of salvation.

Visual opulence, classical erudition, and a dense display of imperial and ecclesiastical symbols of wealth, military strength, virtue, and victory construct papal authoritarian rule to a greater degree than any previous papal audience hall. The decoration, however, remains a relatively cheap frescoed sham within a defensive refuge and the many scenes of conflict, violence, and challenge project simultaneously a stronger image than ever before of anxiety, constraint, and weakness.

The Sala Regia

Originally built by Nicholas III in the late thirteenth century, the Sala Regia, the largest of all papal audience halls, was rebuilt under Paul III. Giorgio Vasari (1511–74), the Florentine artist and famed author of the *Lives of the Artists*, believed it to be "the most beautiful and the richest hall that there has ever been in the world" (FIGS 111 and 112, and see FIG. 39). Executed in fits and starts by many different artists over the reigns of seven popes, the decoration was not completed until 1573.

As we have come to expect, the program essentially concerns papal primacy, or as the anonymous author of a preliminary proposal put it, "the submission due to the priesthood and the inferiority of temporal rule."

The scenes above the doors represent a series of donations justifying the legitimacy of the pope as a temporal sovereign and lord of the Papal State. Smarting from Protestant ridicule, such as Luther's comment above on the fraud of the Donation of Constantine, about

Left

111. ETIENNE DUPÉRAC *Coronation of Cosimo I de'Medici as Grand Duke of Tuscany in the Sala Regia on 18 February 1570,* c. 1570. Engraving.

Below

112. East, south, and west walls, Sala Regia, Vatican.

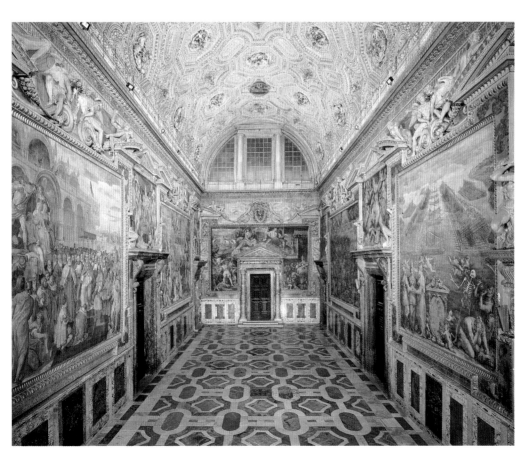

GREGORIVS·II·GERMANIAE·MAGNA
PARTE·AD·VLRI·DEI·CVLTVM·TRADVCTA
ARITHPERTI·LONGOBARDORVM·REGIS
DONATIONE·PER·LVITHPRANDVM·SVCCESOREM
CONFIRMATA·ANNO·SVI·PONT·X·VII·DECESSIT

113. GIOVANNI BATTISTA
FIORINI
*Pope Gregory II Receives in
716 from Liutprand the
Confirmation of the
Donation of Aritpert*, 1565.
Fresco. Sala Regia, Vatican.

basing papal claims on ahistorical or faked sources, the curial programmers of these scenes conducted careful research, producing a selection rarely, if ever, represented before. *Pope Gregory II Receives in 716 from Liutprand the Confirmation of the Donation of Aritpert*, for example, is taken from the *Liber Pontificalis* and this gift of the Cottian Alps (an area in the western Alps) to John VII (r. 706–7) is still today believed to mark the founding of the Papal State (FIG. 113). The setting – an altar in old St. Peter's

with new St. Peter's under construction in the background – indicates the validity of the donation in the present and the interlocking of temporal authority with spiritual.

Defeat of heretics and heathens was an old theme in papal halls of state. But the Sala Regia is unique in including examples from contemporary events rather than from history. All five of the large scenes on the west and north walls, representing the defeat of the Turks at Lepanto in 1571 and the massacre of the Huguenots (French Protestants) on St. Bartholomew's Day in 1572, were begun only months after the events actually occurred (FIG. 114). Just how unique this was can be judged by the reaction of Vasari's adviser, Vincenzo Borghini (1515–80), who saw the Huguenot scenes as "too specific, too base, and not worthy of that hall" because they paid too much attention to "a traitor of his Lord and God." For Borghini they lacked the rhetorical restraint and decorum that historical scenes would have provided.

114. GIORGIO VASARI AND WORKSHOP
Massacre of Coligny and the Huguenots on St. Bartholomew's Day, 24 August 1572, 1573. Fresco. Sala Regia, Vatican.

A few days before learning of the St. Bartholomew's Day Massacre, Gregory XIII (r. 1572–85) was reported to have said, "For the exaltation of the Catholic faith, we desire nothing else than the extermination of the Huguenots." In view of such hatred, it is not surprising that Coligny, leader of the Protestant Huguenots, who is shown being thrown from the second storey window of his palace, is depicted as if he were the evil Simon Magus felled by St. Peter, and that his followers in the lower foreground are shown to be demons.

115. FRANCESCO SALVIATI
Aeneas Armed by Venus (center);
Mars (left); *Minerva* (right); *Ranuccio
Made Commander of Venetian Forces*
(upper left); *Ranuccio Made
Commander of Papal Forces by
Eugenius IV in 1435* (left of Aeneas);
*Pietro and Ranuccio Commanding
Florentine Forces Defeat Pisa in 1363*
(right of Aeneas); *Ranuccio Made
Commander of Florentine Forces at
the Death of Brother Pietro in 1363*
(upper right); 1552–55. Fresco,
northwest wall. Sala dei Fasti Farnese,
Palazzo Farnese, Rome.

The donation scenes, then, reflected the escalating Counter-Reformation concern for the documentation, clarification, and justification of principles and beliefs based on an accurate appraisal of history. The Lepanto and Huguenot scenes expressed the period's intensifying millennial fear and hysteria, or the perception that danger from contemporary foes prophesied the imminence of the Second Coming.

The Sala dei Fasti Farnese

During the 1551–52 war over Parma the Farnese were exiled from Rome. When Cardinal Ranuccio Farnese returned in 1552, he commissioned Francesco Salviati to celebrate the victory of the Farnese over the papacy by frescoing the glorious history of his

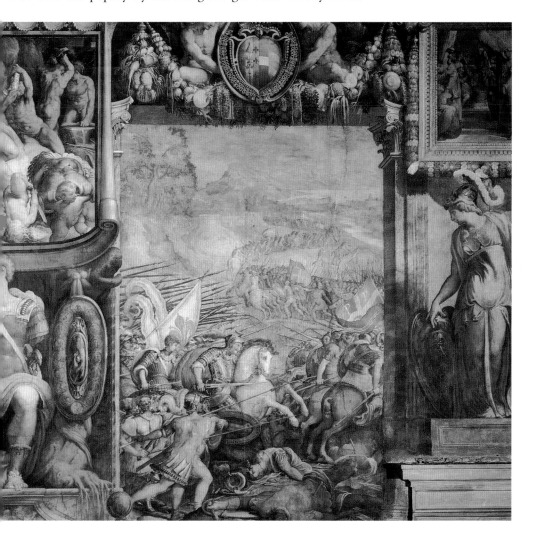

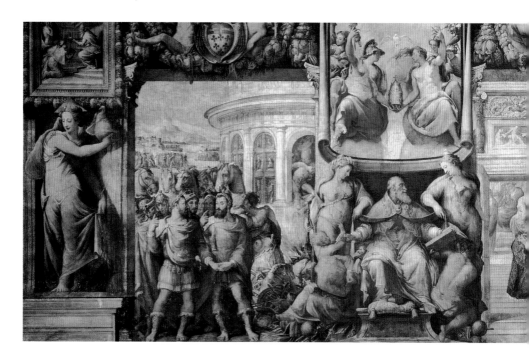

family on the walls of his second-largest reception hall (see FIG. 53). The long northwest and southeast walls were designed in the usual triumphalist mode with a simulated architectural structure and a wealth of illusionistic paintings, tapestries, festoons, coats of arms, and allegorical figures.

In the center of the wall opposite the fireplace, in front of which Cardinal Ranuccio probably sat, Aeneas is being armed under an oak by Venus, cupids, and cyclops, as described by Virgil (FIG. 115). By virtue of his might and wisdom, indicated by the flanking deities of Mars and Minerva, Aeneas is already the victorious founder of Rome, highlighted by the captives and piles of armor to his right. The sixteen Farnese devices on his shield also identify him as the founder of the Farnese family in Farneto (from *farno,* meaning oak) north of Rome in Latium.

To compliment Cardinal Ranuccio, the four narratives represent the warlike deeds of other Ranuccios, *condottiere* (leaders of mercenary troops) who helped to establish the fortunes of the Farnese family. At the upper left Ranuccio, who died in the battle of Taro in 1495, is made commander of the Venetian forces. To the left of Aeneas, Eugenius IV gives another Ranuccio a golden rose and the baton of command of the papal forces in 1435; dressed in Roman armor, receiving his helmet from an allegory of Rome, and looking at Aeneas, this Ranuccio links the destiny of the Farnese family with that of ancient Rome.

116. FRANCESCO SALVIATI *Pope Paul III* (center); *Allegory of Spiritual Sovereignty* (left); *Allegory of the Power of the Keys* (right); *Charles V and Francis I Make Peace at Nice in 1538* (left of Paul III); *Conference of Ratisbon in 1541* (right of Paul III); *Pope Paul III Creates Alessandro Farnese and Guido Ascanio Sforza Cardinals in 1534* (upper left); *Pope Paul III Continues the Building of St. Peter's* (upper right); 1552–55. Fresco, southeast wall. Sala dei Fasti Farnese, Palazzo Farnese, Rome.

To the right of Aeneas, Pietro and still another Ranuccio are depicted in the service of Florence defeating the Pisans in 1363. Since the brothers are clad in contemporary armor and their soldiers in Roman armor, the glory of ancient Rome is again shown to be continued by the Farnese. At the upper right is an epilogue to the larger scene: Ranuccio is proclaimed commander of the Florentine forces at the death of his brother Pietro in 1363.

Taking a cue from Raphael's Sistine Chapel tapestries (see FIG. 87), Salviati has here combined myth, epic, and history on a monumental scale to endow the history of this petty upstart family of knights with the dignity and majesty it lacked in reality.

The center of the fireplace wall features the real founder of Farnese fortunes, Pope Paul III, seated in triumph beneath a tapestry with Virtue (holding a dagger) and Fortune (holding a star) – alluding to Cicero's dictum "Where virtue leads, fortune follows" – along with signs of his temporal and spiritual power, and his virtues (FIG. 116). He is flanked by the armor-burning figure of temporal peace with wheat in her hair, and by spiritual peace with a dove in her hair. To the extreme left the allegorical figure suggests the church that Paul III heads and his spiritual sovereignty. To the extreme right a combined winged victory and angel of the apocalypse connotes Paul III's power to save and damn.

To the left of Paul III the Emperor Charles V and King Francis I of France (1494–1547) make peace at Nice in 1538 under the auspices of Paul III in front of the Roman Temple of Peace with the doors closed and the personification of war chained inside. Clad in Roman armor and laurel wreaths, and shaking hands in the ancient Roman gesture of concord, they are shown to continue the imperial destiny of Rome in the service of the church which has inherited that destiny. To the right of Paul III Cardinal Casparo Contarini (1483–1542) debates with the reformer Martin Bucer (1491–1551) during the 1541 Conference of Ratisbon called by Charles V in an attempt to reconcile Catholics and Protestants. The conference takes place behind the spiral columns of the Temple of Jerusalem, and Moses, in a relief above the door, hands down the tablets of law, as if he prefigures the authority of the Old Testament evoked to support arguments of Contarini. This failed attempt at reconciliation resulted in the 1546 war against the Schmalkaldic League of German Protestants, represented in the right half of the scene with Charles V in the center, flanked by Ottavio Farnese (1524–86), the commander of the papal troops, and his brother Cardinal Alessandro Farnese, the papal legate.

At the upper left Paul III is depicted creating his first two cardinals on 18 December 1534 – his grandson Alessandro Farnese,

aged fourteen, and his great-grandson Guido Ascanio Sforza (1518–64), aged sixteen – an unabashed and technically illegal act of nepotism only to be repeated in 1545 by the creation of Ranuccio, another grandson, at the age of fifteen. Yet in Farnese circles the many cardinals that Paul III created were viewed as an essential element of church renewal, for they included many reformers such as Contarini. To the upper left Paul III is shown with an allegory of architecture ordering the building of new St. Peter's, the greatest Renaissance symbol of the reformed church.

As this example indicates, a Renaissance cardinalitial hall of state could resemble a papal one in terms of subject matter, formal structure, and style. Both usually shared the same general ideology championing the legitimacy of the church, its universal temporal and spiritual dominion, and the superiority of the church over the empire. But since the independent princely sovereignty of a cardinal did not become important until the seventeenth century, scenes are rarely organized with reference to a throne. A cardinalitial hall is also usually more concerned about family history, as well as the place of the family in the church, Christendom, and the plan of salvation.

The Sala dei Capitani

The halls of state for the Consiglio Generale (the Sala degli Orazie e Curiazi) and for the Consiglio Segreto (the Sala dei Capitani) in the Palazzo dei Conservatori had been frescoed in the early sixteenth century by Jacopo Ripanda (active 1490–1530). In the former were scenes of the founding of Rome and its early history under the Etruscan kings, and in the latter the establishment of the Roman republic under Brutus and the defeat of the Etruscan kings. Because of the damage caused by Michelangelo's renovation, these scenes were replaced by ones of the same or similar subjects, those in the Sala dei Capitani by Tommaso Laureti (c. 1530–1602) in 1586–92 (FIG. 117).

Since the commune lacked spiritual authority, its halls of state did not construct an axis connecting heaven and earth like those of the papacy. They did follow the papal lead in using idealized history to justify authority and legitimacy in the present, but in a futile effort to establish independence from the papacy, the commune skipped over the history of imperial Rome and linked its destiny to the justice, might, and piety of the Roman republic.

Inspired by Livy's *The Early History of Rome*, the narratives of these simulated paintings, hanging from hooks in the cornice, begin at the head of the hall with the *Justice of Brutus in*

117. TOMMASO LAURETI South and west walls, Sala dei Capitani, Palazzo dei Conservatori, Rome, 1586–92.

509 BC and continue chronologically clockwise around the room with *Horatio Defending the Sublican Bridge, Mucius Scaevola Attempting to Kill Porsenna*, and the *Defeat of Tarquinius and the Latin League at Lake Regillus in 449 BC*.

The first scene portrays the founder of the Roman republic, Lucius Junius Brutus, standing on a podium commanding the official to his right to read a decree (FIG. 118). The decree orders the beheading of his own two sons (center foreground) with the other conspirators (led in from either side), who were involved in a plot to overthrow the Republic and restore King Tarquinius. Unresponsive to the pleas for clemency of the official to his left and of his wife in the foreground, Brutus is the embodiment of uncompromising justice. The arch behind him with statues of Jupiter and

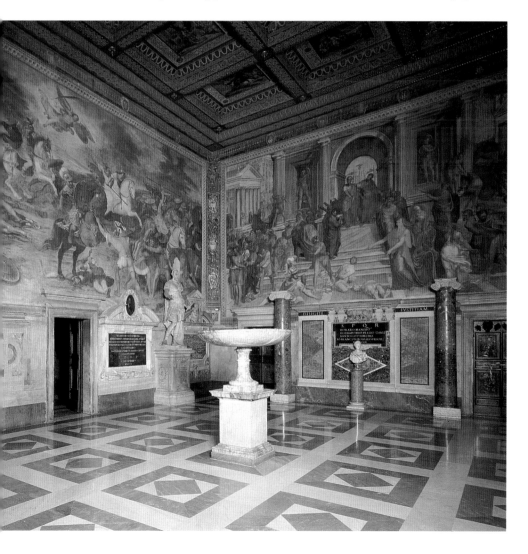

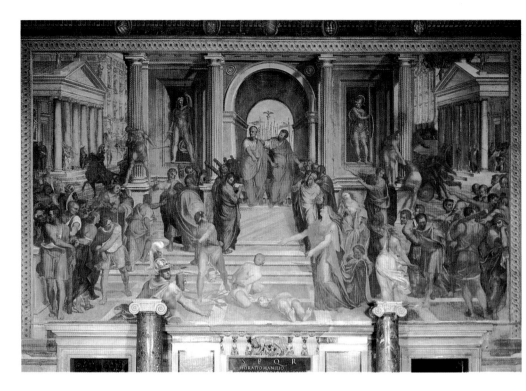

118. TOMMASO LAURETI
Justice of Brutus in 509 BC,
1586–92. Fresco, west wall.
Sala dei Capitani, Palazzo
dei Conservatori, Rome.

Mars signals the authority, strength, and triumph of the republic, while the temples on either side, recalling the Capitoline temples to Jupiter and Juno, evoke its piety. Continuity between republican virtue and the present is represented both by the buildings under construction in the background, based on Michelangelo's design for the new Palazzo dei Conservatori, and by the placement of the dais and bench for the prior and the three conservators below this scene, facing the rest of the Consiglio Segreto.

Compared to scenes in previous halls of state, Laureti's *Brutus* fresco is notable for its symmetrical arrangement of figures on either side of a central triangular group containing the narrative action on the left and reaction on the right. This rejection of the tensions and ambiguities of Mannerism and the return to the compositional clarity and narrative drama of High Renaissance works by Raphael mark a reform of triumphalist halls of state parallel to the reform movement within the culture generally.

Conclusion: 1600 and Beyond

B
y 1600 the papacy was a very different institution than when Martin V entered Rome in 1420. Popes had nearly absolute power within the church and the Papal State and inflexibly, often harshly, imposed discipline. They ruled effectively and efficiently through the curia, which had been streamlined and reorganized into congregations (standing committees of cardinals and prelates) in charge of every aspect of ecclesiastical government. In nearly every diocese throughout the Catholic world the popes' newly empowered bishops uniformly implemented the Tridentine reforms in catechism, liturgy, scripture, and doctrine. Less elitist and more all-embracing, the papacy also promoted education, preaching, and missionary work through its many new or revitalized orders. It consolidated its hold on Italy, regaining much lost ground in Europe, especially in Poland and Germany, and brought many new converts into the fold, principally in the Americas and Asia. Less defensive and backward looking, the papacy took the offensive and moved forward in a spirit of triumph. Although their political power in Europe was diminished, the pope's moral and spiritual authority was enhanced. As never before, the church defined itself as *Roman* Catholic and Rome as the capital of christendom. As a result, Italy also began to resemble a modern nation with a common religion, language, literature, and art.

The Roman popes, clergy, and laity continued to vigorously patronize the arts and to amass even greater collections. In the course of the next two centuries they transformed Rome into the most magnificent showpiece of the Catholic world. The Rome we know today, in fact, is more a Baroque city than a Renaissance one. It was in the Baroque period that Sixtus V's urban plan was filled out and embellished, and Bernini dazzled the world with his great theatrical works integrating architecture, sculpture, and painting into unified schemes animated by light and ritual. Yet the Baroque would have been inconceivable without the art and ideology of the Roman Renaissance.

Politics and culture	Religion

1400-1450

1420 Martin V enters Rome, reestablishing papal authority	**1414-18** The Council of Constance: the Great Schis
1434 Eugenius IV driven into exile by the Romans	(1378-1417) ends with the election of Mart
1440 Lorenzo Valla: *De Falso Credita e Ementita Constantini Donatione* (exposé of the Donation of Constantine)	in 1417
	1438-45 The Councils of Ferrara (1438-39), Florenc (1439-43), and Rome (1439-45): temporar
1443 Eugenius IV returns to Rome from exile in Florence	unites the eastern and western churches

1450-1500

1452 Leon Battista Alberti: *De re aedificatoria* presented to Nicholas V	**1450** Jubilee: over 200 pilgrims killed on the Por Sant'Angelo
1453 Fall of Constantinople to the Turks; plot of Stefano Porcari and a band of Roman nobles to assassinate Nicholas V discovered	**1460** Pius II issues the bull *Execrabilis* confirming supremacy of the pope
1475 Sixtus IV founds the Vatican Library	**1472** Christian fleet under Cardinal Oliviero Cara defeats the Turks at Symrna
1491 Turks driven from Granada	**1475** Jubilee
1492 Columbus discovers America	**1497** Alexander VI excommunicates Savonarola
1494 Charles VIII of France invades Italy	Florence

1500-1550

1506 Julius II defeats the Bentivogli and enters Bologna in triumph	**1500** Jubilee
1507 Julius II's triumphal entry into Rome	**1512-17** Fifth Lateran Council: convened by Julius I address church reform
1510 Paolo Cortesi: *De cardinalatu*	**1517** Plot to assassinate Leo X discovered; Luther his Ninety-Five Theses against indulgences Schlosskirche at Wittenberg
1512 Battle of Ravenna, a pyrrhic French victory, allows Julius II to extend the Papal State to Piacenza	
1517 Desiderius Erasmus: *Julius exclusus*	**1525** Jubilee: sparsely attended
1522 Fall of Rhodes to the Turks	**1537** *Consilium de emendanda ecclesia* by a commission of cardinals and prelates
1525 Battle of Pavia	
1527 Sack of Rome by Imperial troops	**1540** Jesuit Order founded
1530 Clement VII crowns Charles V emperor in Bologna	**1541** Conference of Ratisbon: Protestants and Ca try (unsuccessfully) to resolve doctrinal differences
1531 Formation of the Protestant Schmalkaldic League	
1535 Turks in Tunisia defeated by Charles V	
1536 Charles V's triumphal entry into Rome	Ignatius Loyola's *Spiritual Exercises* comple
1538 Treaty of Nice between Charles V and Francis I brokered by Paul III as a first step toward a crusade	**1542** Inquisition re-established
	1543 *Beneficio di Cristo*
1546 Imperial and papal forces defeat the Schmalkaldic League	**1545** Council of Trent opens: three sessions: 154. 1551-52, 1562-63

1550-1600

1550 Georgio Vasari: *Le vite de' più eccellenti pittori, scultori, e architettori*	**1550** Jubilee: sparsely attended
	1564 Decrees of the Council of Trent published; Oratory of Saint Filippo Neri (Oratorians) founded
1551-52 War of Parma: the Farnese allied with France defeat the papacy allied with Charles V	
1559 Treaty of Cateau-Cambrésis: ends the wars in Italy and confirms imperial (Habsburg) hegemony over Italy	**1571** Congregation of the Index founded
	1575 Jubilee: over 400,000 pilgrims attend
1562 Vignola: *Regola delli Cinque Ordini d'Architettura*	**1588** Cesare Baronius (1538-1607) begins public of his *Annales Ecclesiastici* (12 vols; 1588-1 the Catholic response to the Protestants' *Ce of Magdeburg* (1559-74)
1571 Battle of Lepanto: the Holy League (Spain, Venice, and the Papacy) defeats the Turks	
1572 St. Bartholomew's Day Massacre of French Huguenots, Paris	**1592** Revision of the Vulgate (the approved Latin edition of the Bible) completed

Urbanism and architecture	Painting and sculpture
25 Martin V re-issues the Latin code of the *magistri viarum* and brings the overseers of the streets under papal authority 31-47 Eugenius IV clears and paves the piazza in front of the Pantheon 34-44 Building of S. Onofrio al Gianicolo	1428-32 Masolino's high altarpiece for S. Maria Maggiore and his frescoes of the lives of SS. Catherine of Alexandria and Ambrose for the Chapel of the Sacrament in S. Clemente 1448-50 Fra Angelico's frescoes of the lives of SS. Stephen and Lawrence in the Chapel of Nicholas V in the Vatican palace
50-53 Nicholas V's renovation of the Piazza S. Celso and Castel Sant'Angelo 53-55 Rossellino's north wing of the Papal Palace 55 Palazzo Venezia begun (completed by 1503) 72-78 S. Maria del Popolo 75 Ponte Sisto completed for the Jubilee 82 S. Pietro in Montorio begun (completed by 1500) 1490 Palazzo della Cancelleria begun (completed by c. 1514)	1473-83 Frescoes of the life of Sixtus IV for the Ospedale di Santo Spirito 1475-81 Frescoes of the lives of Moses and Christ for the walls of the Sistine Chapel 1488-93 Lippi's frescoes of the lives of the Virgin and Saint Thomas Aquinas for the Carafa Chapel in S. Maria sopra Minerva 1492-94 Pinturicchio's frescoes for the Borgia Apartment 1493 Pollaiuolo's bronze tomb for Sixtus IV 1497-1500 Michelangelo's *Pietà* for St. Peter's
00 Via Alexandrina built for the Jubilee 02-10 Bramante's Tempietto 03 Bramante's Cortile del Belvedere begun (completed by 1563) 06 Julius II lays the foundation stone for new St. Peter's on April 18 (completed by 1614) 07-8 Via Giulia begun 1510 Bramante's Palazzo Caprini 14 Palazzo Farnese begun by Antonio da Sangallo the Younger (completed by 1589) 15-20 Raphael's Palazzo Branconio d'Aquila 25 Sangallo's façade of the papal mint for the Jubilee 33-35 Peruzzi's Palazzo Massimo delle Colonne 34-49 Piazza Farnese and Via dei Baullari 38 Michelangelo commissioned by Paul III to renovate the Capitoline; monument of *Marcus Aurelius* moved to center of hill 42-46 Via Paola and Via di Panico and the second trident	1508-11 Raphael's frescoes for the Stanza della Segnatura, Julius II's private library 1508-12 Michelangelo's frescoes for the Sistine Chapel ceiling 1511-14 Raphael's frescoes for the Stanza d'Eliodoro c. 1513 Raphael's *Sistine Madonna* 1515-16 Raphael's cartoons of the lives of SS. Peter and Paul for the Sistine Chapel tapestries 1517-20 Raphael's *Transfiguration*; Sebastiano's *Raising of Lazarus* 1519-24 Raphael's and his workshop's frescoes of the life of Constantine in the Sala di Costantino 1526-27 Parmigianino's *Vision of St. Jerome* 1534-41 Michelangelo's *Last Judgment* in the Sistine Chapel 1541-49 Michelangelo's frescoes for the Pauline chapel in the Vatican 1545-48 Perino del Vaga's frescoes of the lives of Alexander the Great and Saint Paul for the Sala Paolina in the Castel Sant'Angelo 1547-55 Michelangelo's Florentine *Pietà*
559-65 Civitas Pius and Via Pia 561-65 Michelangelo's Porta Pia 568-84 Il Gesù by Vignola and della Porta 575 Via Merulana constructed for the Jubilee 585-90 Fontana's new Lateran Palace and Benediction Loggia 585-88 Acqua Felice and Moses Fountain 586 Vatican obelisk erected by Fontana 587 S. Maria Maggiore obelisk erected 587-89 Bronze statues of SS. Peter and Paul placed on top of the columns of Trajan and Marcus Aurelius 588 Lateran obelisk erected 589 S. Maria del Popolo obelisk erected	1552-55 Salviati's frescoes of Farnese deeds for the Sala dei Fasti Farnese in the Palazzo Farnese c. 1568 Federico Zuccaro's *Coronation* in S. Lorenzo in Damaso 1568-67 Frescoes of the life of Christ for the Oratory of the Gonfalone 1584-86 Barocci's *Visitation* in S. Maria in Vallicella 1586-92 Laureti's frescoes of the founding of the Roman republic for the Sala dei Capitani in the Palazzo dei Conservatori 1591 Scipione Pulzone's *Lamentation* for Il Gesù 1587-89 *Circumcision of Christ* by Girolamo Muziano (1532-92) for the high altar of Il Gesù commissioned by Cardinal Alessandro Farnese

Renaissance Popes

Martin V (Colonna), 1417-31
Eugenius IV (Condulmer), 1431-47
Nicholas V (Parentucelli), 1447-55
Calixtus III (Borgia), 1455-58
Pius II (Piccolomini), 1458-64
Paul II (Barbo), 1464-71
Sixtus IV (Della Rovere), 1471-84
Innocent VIII (Cibo), 1484-92
Alexander VI (Borgia), 1492-1503
Pius III (Piccolomini), 1503
Julius II (Della Rovere), 1503-13

Leo X (Medici), 1513-21
Adrian VI (Dedel), 1522-23
Clement VII (Medici), 1523-34
Paul III (Farnese), 1534-49
Julius III (Ciocchi del Monte), 1550-55
Marcello II (Cervini), 1555
Paul IV (Carafa), 1555-59
Pius IV (Medici), 1560-65
Pius V (Ghislieri), 1566-72
Gregory XIII (Boncompagni), 1572-85
Sixtus V (Peretti), 1585-90

Bibliography

ACKERMAN, J. S., "The Belvedere as a Classical Villa," *Journal of the Warburg and Courtauld Institutes*, 14 (1951), 70–91

— *The Cortile del Belvedere*, Studi e documenti per la storia del Palazzo Apostolico Vaticano, 3 (Vatican, 1954)

— *The Architecture of Michelangelo* (Harmondsworth: Penguin, 1971)

— "The Planning of Renaissance Rome, 1450–1580," in *Rome in the Renaissance: The City and The Myth,* ed. P.A. Ramsey, Medieval and Renaissance Texts and Studies, 18 (Center for Medieval and Early Renaissance Studies,Binghamton, N.Y., 1982), 3–18

AIKIN, R., "Christian Soldiers in the Sala dei Capitani," *Sixteenth Century Journal*, 16 (1985), 206–27

ANTONOVICS, A.V., "Counter-Reformation Cardinals: 1534–90," *European Studies Review*, 2 (1972), 301–27

ALBERTI, L.B., *On the Art of Building in Ten Books*, trans. J. Rykwert et al (Cambridge, Mass.: MIT Press, 1988)

BAROLSKY, P., *Daniele da Volterra: A Catalogue Raisonné* (New York and London: Garland, 1979)

BAUMGARTEN, P. M., *Von den Kardinälen des sechszehnten Jahrhunderts* (Krumbach: F. Aker, 1926)

BENEDETTI, S. et al, *L'Arte in Roma nel Secolo XVI,* 2 vols, Istituto Nazionale di Studi Romani (Bologna: Cappelli, 1990–92)

BENTIVOGLIO, E., and S. VALTIERI, *Santa Maria del Popolo a Roma* (Rome: Bardi Editore, 1976)

BOBER, P. P., and R.O. RUBINSTEIN, *Renaissance Artists and Antique Sculpture: A Handbook of Sources* (Harvey Miller and Oxford University Press: London and New York, 1986)

BOSEL, R., *Jesuitarchitektur in Italien, 1540–1773. Die Baudenkmaler der Römischen und Neapolitischen Ordensprovinz,* 2 vols (Vienna, 1985)

BOSSY, J., *Christianity in the West, 1400–1700* (Oxford: Oxford University Press, 1985)

BRADY, T.A., H.A. OBERMAN, and J.D. TRACY (eds), *Handbook of European History 1400–1600. Late Middle Ages, Renaissance and Reformation,* 2 vols (Leiden and New York: E.J. Brill, 1994)

BRODRICK, J., *The Origin of the Jesuits* (New York: Longmans Green, 1940)

BRUMMER, H.H., *The Statue Court in the Vatican Belvedere*, Stockholm Studies in the History of Art, 20 (Stockholm: Almquist and Wiksell, 1970)

BRUSCHI, A., *Bramante architetto* (Bari: Laterza, 1969); shorter, revised English edn. *Bramante* (London: Thames and Hudson, 1977)

BUDDENSIEG, T., "Zum Statuenprogramm im Kapitolsplan Pauls III," *Zeitschrift für Kunstgeschichte* 32 (1969), 177–228

BURROUGHS, C., "Below the Angel: An Urbanistic Project in the Rome of Pope Nicholas V," *Journal of the Warburg and Courtauld Institutes* 45 (1982), 94–124

— *From Signs to Design. Environmental Process and Reform in Early Renaissance Rome* (Cambridge, Mass., and London: MIT Press, 1990)

CEEN, A., "The Quartiere de'Banchi: Urban Planning in Rome in the First Half of the Cinquecento" (Ph.D. dissertation, University of Pennsylvania, 1977)

CELLINI, BENVENUTO, *The Autobiography of Benvenuto Cellini* (trans. G. Bull; Harmondsworth: Penguin, 1956)

CHASTEL, A., *The Sack of Rome, 1527*, trans. B. Archer, A.W. Mellon Lectures in the Fine Arts, 26; Bollingen Series XXXV, 26 (Princeton: Princeton University Press, 1983)

CIERI VIA, C., "Characteres et figuras in opere magico. Pinturicchio et la décoration de la camera segreta de l'appartement Borgia," Revue de l'art 94 (1991), 11–26

COCHRANE, E., Italy, 1530–1630 (London and New York: Longman, 1988)

COFFIN, D.R., The Villa d'Este at Tivoli (Princeton: Princeton University Press, 1960)

— The Villa in the Life of Renaissance Rome (Princeton: Princeton University Press, 1979)

— Gardens and Gardening in Papal Rome (Princeton: Princeton University Press, 1991)

COHN, N., The Pursuit of the Millennium (New York: Oxford University Press, 1970)

DACOS, N., La Découverte de la Domus Aurea et la formation des grotesques à la Renaissance, Studies of the Warburg Institute, 31 (London and Leiden, 1969)

D'AMICO, J.F., Renaissance Humanism in Papal Rome: Humanists and Churchmen on the Eve of Reformation (Baltimore and London: Johns Hopkins University Press, 1983)

DAVIDSON, B.F., Raphael's Bible: A Study of the Vatican Logge, College Art Association Monographs on the Fine Arts, 39 (University Park: Pennsylvania State University Press, 1985)

DELUMEAU, J., Vie économique et sociale de Rome dans la seconde moitié du XVIe siècle, 2 vols (Paris: E. de Boccard, 1957–59)

— "Rome: Political and Administrative Centralization in the Papal State in the Sixteenth Century," The Late Italian Renaissance, 1525–1630, ed. E. Cochrane (New York: Harper and Row, 1970), 287–304

DEMPSEY, C., "Mythic Inventions in Counter-Reformation Painting," Rome in the Renaissance: The City and the Myth, ed. P.A. Ramsey, Medieval and Renaissance Texts and Studies, 18 (Center for Medieval and Early Renaissance Studies, Binghamton, N. Y., 1982), 55–75

DICKENS, A.G., The Counter Reformation (Norwich: Harcourt, Brace & World, 1970)

DUSSLER, L., Raphael. A Critical Catalogue of his Pictures, Wall-Paintings and Tapestries (trans. S. Cruft; New York and London: Phaidon, 1971)

EBERT–SCHIFFERER, S., "Ripandas kapitolinescher Freskenzyklus und die Selbstdarstellung der Konservatoren um 1500," Römisches Jahrbuch für Kunstgeschichte, 23/24 (1988), 75–218

EINEM, H. VON, Michelangelo (London: Methuen, 1973)

ERASMUS, DESIDERIUS, The 'Julius Exclusus' of Erasmus, trans. P. Pascal, intro. and critical notes by J.K. Sowards (Bloomington: Indiana University Press, 1968)

ETTLINGER, L. D., The Sistine Chapel before Michelangelo: Religious Imagery and Papal Primacy (Oxford: Clarendon Press, 1965)

EVENNETT, H. O., The Spirit of the Counter-Reformation (Notre Dame: University of Notre Dame Press, 1970)

FAGIOLO, M. and M.L. MADONNA, "La Roma di Pio IV: la Civitas Pia, la Salus Medica, la Custodia Angelica," Arte Illustrata 5 (1972), 383–402

FALDI, I., Il Palazzo Farnese di Caprarola (Turin: Edizioni Seat, 1981)

FIRPO, M, "The Cardinal," in Renaissance Characters, ed. E. Garin, trans. L.G. Cochrane, (Chicago and London: University of Chicago Press, 1991), 46–97

FREEDBERG, S. J., Painting of the High Renaissance in Rome and Florence, 2 vols (Cambridge, Mass.: Harvard University Press, 1961)

FROMMEL, C. L., Der Römische Palastbau der Hochrenaissance, 3 vols, Römische Forschungen der Bibliotheca Hertziana, 21 (Tübingen: Wasmuth, 1973)

— "Die Peterskirche unter Papst Julius II. im Licht neuer Dokumente," Römisches Jahrbuch für Kunstgeschichte 16 (1976), 57–136

— "Francesco del Borgo: Architekt Pius' II. und Pauls II.," Römisches Jahrbuch für Kunstgeschichte 20 (1983), 107–54, and 21 (1984), 71–164

— "Il Palazzo Vaticano sotto Giulio II e Leone X: Strutture e funzione," Raffaello in Vaticano (Milan: Electa, 1984), 118–35

— "Papal Policy: The Planning of Rome during the Renaissance," in Art and History: Images and Their Meaning, eds. R.I. Rotberg and T.K. Rabb, (Cambridge: Cambridge University Press, 1986), 39–65

— "Il Cardinal Raffaele Riario ed il Palazzo della Cancelleria," in Sisto IV e Giulio II mecenati e promotori di cultura, eds S. Bottaro et al, Atti del Convegno Internazionale di Studi, Savona, 1985 (Savona: Coop Tipograf, 1989), 73–85

— "Il Palazzo della Cancelleria," in Il Palazzo dal Rinascimento a oggi in Italia nel regno di Napoli in Calabria: Storia e attualità, ed. S. Valtieri, Atti del Convegno Internazionale Reggio Calabria, 20–22 Ottobre 1988; (Rome: Gangemi editore, 1989), 29–54

— "St. Peter's: The Early History," in The Renaissance from Brunelleschi to Michelangelo, H.A. Millon et al (Milan, 1994)

FROMMEL, C. L. et al, Raffaello architetto (Milan: Electa, 1984)

GAMRATH, H., Roma Sancta Renovata: Studi sull'urbanistica di Roma nella seconda metà del sec. XVI con particolare referimento al ponificato di Sisto V (1585–1590), Analecta Romana Instituti Danici, 12 (Rome: L'"Erma" di Bretschneider, 1987)

GEIGER, G.L., Filippino Lippi's Carafa Chapel: Renaissance Art in Rome, Sixteenth-Century Essays and Studies, 5 (Ann Arbor: 1986)

GERE, J., Taddeo Zuccaro: His Development Studied in his Drawings (Chicago and London: University of Chicago Press, 1969)

GILBERT, F., The Pope, his Banker, and Venice (Cambridge, Mass.: Harvard University Press, 1980)

GLEASON, E.G., Reform Thought in Sixteenth-Century Italy, American Academy of Religion, Texts and Translations Series, 4 (Chico, Calif.: Scholars Press, 1981)

Gli affreschi di Paolo III a Castel Sant'Angelo: Progetti ed esecuzione 1543–1548 (Rome: de Luca, 1981)

HALLMAN, B. McC., Italian Cardinals, Reform and the Church as Property, 1492–1563 (Berkeley and Los Angeles: University of California Press, 1985)

HARPRATH, R., Papst Paul III. al Alexander der Grosse. Das Freskenprogramm der Sala Paolina in der Engelsburg (Berlin and New York: de Gruyter, 1978)

HAY, D., "The Renaissance Cardinals: Church, State, Culture," Synthesis 3 (1976), 35–46

— The Church in Italy in the Fifteenth Century: The Birkbeck Lectures, 1971 (Cambridge and New York: Cambridge University Press, 1977)

HEYDENREICH, L. and W. LOTZ, Architecture in Italy, 1400–1600, trans. M. Hottinger, Pelican History of Art, (Harmondsworth: Penguin, London: 1974)

Hibbard, H., "Ut picturae sermones: The First Painted Decorations of the Gesù," in Baroque Art: The Jesuit Contribution, eds R. Wittkower and I.B. Jaffe (New York: Fordham University Press, 1972), 29–49

— Michelangelo (New York: McGraw-Hill, 1974)

HIRST, M., Sebastiano del Piombo (Oxford: Clarendon Press, 1981)

JACKS, P., The Antiquarian and the Myth of Antiquity. The Origins of Rome in Renaissance Thought (New York and Cambridge: Cambridge University Press, 1993)

JEDEN, H., A History of the Council of Trent, trans. D.E. Graf, 2 vols, (St. Louis: B. Herder, 1957)

JONES, M.D.W., The Counter Reformation: Religion and Society in Early Modern Europe (Cambridge: Cambridge University Press, 1995)

JONES, R. and N. PENNY, Raphael (New Haven and London: Yale University Press, 1983)

JUNGMANN, J.A., The Mass of the Roman Rite: Its Origins and Development, 2 vols (New York: Benziger Brothers, 1951)

KELLER, R.E., Das Oratorium von San Giovanni Decollato in Rom: Eine Studie seiner Fresken (Neuchâtel: Institut Suisse de Rome, 1976)

KLIEMANN, J., Gesta Dipinte: La grande decorazione nelle dimore italiane dal Quattrocento al Seicento (Milan: Silvana, 1993)

LEE, E., Sixtus IV and Men of Letters, Temi e Testi, 26 (Rome: Edizioni di storia e letteratura, 1978)

LEWINE, C. F., The Sistine Chapel Walls and the Roman Liturgy (University Park: Pennsylvania State University Press, 1993)

LEWINE, M.J., "The Roman Church Interior, 1527–1580" (Ph.D. dissertation, Columbia University, 1960)

— "Roman Architectural Practice During Michelangelo's Maturity," in Stil und Überlieferung in der Kunst des Abendlandes, 2 vols, Akten des 21. Internationalen Kongress. Kunst. Bonn 1964 (1967), II, 20–26

MADONNA, M.L. (ed.), Roma di Sisto V: Le arti e la cultura (Rome: de Luca, 1993)

MAGNUSON, T., Studies in Roman Quattrocento Architecture (Stockholm: Almquist and Wiksell, 1958)

Michelangelo e la Sistina. La tecnica, il restauro, il mito (Rome: Fratelli Palombi, 1990)

MITCHELL, B., Rome in the High Renaissance: The Age of Leo X (Norman: University of Oklahoma Press, 1973)

MORTARI, L., Francesco Salviati (Rome: de Luca, 1992)

MURRAY, P., Bramante's Tempietto, Charlton Lecture on Art, Univ. of Newcastle upon Tyne (London: McLean, 1972)

O'MALLEY, J., Giles of Viterbo on Church and Reform: A Study in Renaissance Thought (Leiden: E.J. Brill, 1968)

— Praise and Blame in Renaissance Rome: Rhetoric, Doctrine, and Reform in the Sacred Orators of the Papal Court, c. 1450–1521, Duke Monographs in Medieval and Renaissance Studies, 3 (Durham, N.C.: Duke University Press, 1979)

— The First Jesuits (Cambridge, Mass.: Harvard University Press, 1993)

Le Palais Farnèse: École française de Rome, 3 vols (Rome: L'"Erma" di Bretschneider, 1980–81)

PARKS, N.R., "On the Meaning of Pinturicchio's Sala dei Santi," Art History 2 (1979), 291–317

PARTNER, P., Renaissance Rome, 1500–1559: A Portrait of a Society (Berkeley and Los Angeles: University of California Press, 1976)

— The Pope's Men: The Papal Civil Service in the Renaissance (Oxford: Clarendon Press, 1990)

PARTRIDGE, L., "Triumphalism and the Sala Regia in the Vatican," 'All the world's a stage...': Art and Pageantry in the Renaissance and Baroque, eds B. Wisch and S.S. Munshower, 2 vols, Papers in Art History from The Pennsylvania State University, 6 (University Park, Pa., 1990), 22–81

PARTRIDGE, L. and STARN, R., A Renaissance Likeness. Art and Culture in Raphael's "Julius II" (Berkeley and Los Angeles: University of California Press, 1980)

PASTOR, L. VON, The History of the Popes from the Close of the Middle Ages, eds F.I. Antrobus et al, 40 vols, (St. Louis: Herder, 1912–52)

PIETRANGELI, C., et al, The Sistine Chapel. The Art, the History, and the Restoration (New York, 1986)

QUEDNAU, R., Die Sala di Costantino im Vatikanischen Palast: zur Dekoration der beiden Medici-Päpste Leo X. und Clemens VII., Studien zur Kunstgeschichte, 13 (Hildesheim: Georg Olms, 1979)

Raffaello nell'Appartamento di Giulio II e Leone X (Milan: ENEL, Electa, and Edizioni Musei Vaticani, 1993)

REDIG DE CAMPOS, D., I Palazzi Vaticani, Roma Cristiana, 18 (Bologna: Cappelli, 1967)

REINHARD, W., "Nepotismus. Der Funktionswandel einer päpstgeschichtlichen Konstanten," Zeitschrift für Kirchengeschichte 86 (1975), 145–85

ROBERTS, P.L., Masolino da Panicale (Oxford: Oxford University Press, 1993)

ROBERTSON, C., *"Il Gran Cardinale": Alessandro Farnese, Patron of the Arts* (New Haven and London: Yale University Press, 1992)

ROSENTHAL, E., "The Antecedents of Bramante's Tempietto," *Journal of the Society of Architectural Historians* 23 (1964), 55–74

SALERNO, L., L. SPEZZAFERRO, AND M. TAFURI, *Via Giulia: Una utopia urbanistica del '500* (Rome: Aristide Staderini, 1975)

SANDSTRÖM, SVEN, *Levels of Unreality. Studies in Structure and Construction in Italian Mural Painting During the Renaissance*, Acta Universitatis Upsaliensis; Figura, N.S.4 (Uppsala: Almquist and Wiksell, 1963)

SCHIFFMANN, R., *Roma felix: Aspekte der städtebaulichen Gestaltung Roms unter Papst Sixtus V.* (Bern and Frankfurt am Main: Peter Lang, 1985)

SCHROEDER, H.J. (ed.), *The Canons and Decrees of the Council of Trent* (St. Louis and London: Herder, 1941)

SETTON, K.M., *The Papacy and the Levant (1204–1571)*, 2 vols (Philadelphia: American Philosophical Society, 1976–78)

SHAW, C., *Julius II: the Warrior Pope* (Oxford: Blackwell, 1988)

SHEARMAN, J., *Mannerism* (Harmondsworth, 1967)

— "The Vatican Stanze: Functions and Decoration," *Proceedings of the British Academy* 57 (1971), 369–424

— *Raphael's Cartoons in the Collection of Her Majesty the Queen and the Tapestries for the Sistine Chapel* (London and New York: Phaidon, 1972)

SMITH, G., *The Casino of Pius IV* (Princeton: Princeton University Press, 1977)

SPEZZAFERRO, L., and M.E. TITTONI, *Il Campidoglio e Sisto V* (Rome: Carte Segrete, 1991)

STEINBERG, L., *Michelangelo's Last Paintings: The Conversion of St. Paul and the Crucifixion of St. Peter in the Cappella Paolina, Vatican Palace* (New York: Oxford University Press, 1975)

STINGER, C.L., *The Renaissance in Rome* (Bloomington: Indiana University Press, 1985)

THOMSON, J.A.F., *Popes and Princes, 1417–1517: Politics and Polity in the Late Medieval Church* (London: Allen and Unwin, 1980)

TOMEI, P., *L'architettura a Roma nel Quattrocento* (Rome: Multigrafica, 1977)

URBAN, G., "Die Kirchenbaukunst des Quattrocento in Rom," *Römisches Jahrbuch für Kunstgeschichte* 9–10 (1961–62), 75–287

— "Zum Neubau-Projekt von St. Peter unter Nikolaus V.," *Festschrift für Harald Keller* (Darmstadt: Eduard Roether, 1963), 131–73

WEIL-GARRIS, K., and J.F. D'AMICO, "The Renaissance Cardinal's Ideal Palace: A Chapter from Cortesi's *De Cardinalatu*," in *Studies in Italian Art and Architecture 15th through 18th Centuries*, ed. H.A. Millon, Memoirs of the American Academy in Rome, 35 (Rome: Elefante, 1980), 45–123

WEISS, ROBERTO, *The Renaissance Discovery of Classical Antiquity* (Oxford: Blackwell, 1963)

WEISZ, J.S., *Pittura e Misericordia: The Oratory of S. Giovanni Decollato in Rome* (Ann Arbor: UMI Research Press, 1984)

WESTFALL, C.W., *In this Most Perfect Paradise: Alberti, Nicholas V, and the Invention of Conscious Urban Planning in Rome, 1447–55* (University Park: Pennsylvania State University Press, 1974)

— "Alberti and the Vatican Palace Type," *Journal of the Society of Architectural Historians* 33 (1974), 101–21

WISCH, B.L., "The Archiconfraternità del Gonfalone and its Oratory in Rome: Art and Counter-Reformation Spiritual Values" (Ph.D. dissertation, University of California at Berkeley, 1985)

WURM, H.W., *Der Palazzo Massimo alle Colonne in Rom* (Berlin: de Gruyter, 1965)

ZERI, F., *Pittura e controriforma: L'arte senza tempo di Scipione da Gaeta* (Turin: Einaudi, 1957)

ZUCCARI, A., *I Pittori di Sisto V* (Rome: Fratelli Palombi, 1992)

Picture Credits

Unless otherwise stated, museums have supplied their own photographic material. Supplementary and copyright information is given below. Numbers to the left refer to figure numbers unless otherwise indicated.

Title pages: see page 34
1 Bayerische Staatsbibliothek Munich
3 Scala, Florence
5 Reproduced by courtesy of the Trustees, The National Gallery, London
6 Araldo De Luca, Rome
7 © James Morris, London
page 19, detail of figure 16
10 The Fotomas Index, Kent
12 © British Museum, London
13 Araldo De Luca, Rome
15 Monumenti Musei e Gallerie Pontificie, Città del Vaticano
16 © James Morris, London
17, 18, 19 Biblioteca Apostolica Vaticana
20, 21 © James Morris, London
page 43, detail of figure 23
23 © James Morris, London
24 Scala, Florence
25 © James Morris, London
27, 28 © James Morris, London
31 The Metropolitan Museum of Art, Harris Brisbane Dick Fund, 1941. [41.72 (3.29)]

32 Alinari, Florence
33 © James Morris, London
34, 35 © British Museum, London
37 Scala, Florence
38 © James Morris, London
page 61, detail of figure 45
42 Scala, Florence
43 © Loren Partridge
45 Scala, Florence
46 © Loren Partridge
48 © British Museum, London
50, 51 James Morris, London
54 Fotografica Foglia, Naples
page 79, detail of figure 65
57, 58 Scala, Florence
59 © James Morris, London
61 Scala, Florence
62, 63 Reproduced by courtesy of the Trustees, The National Gallery, London
64, 65 © James Morris, London
66 The Metropolitan Museum of Art, Purchase, Anonymous Gift, in memory of Terence Cardinal Cooke, 1984 J (1984.74)
67 © James Morris, London
68, 69 Scala, Florence
70 © James Morris, London
page 109, detail of figure 88
72, 73, 74, 75 Scala, Florence
76 Ernst Steinmann, *Die Sixtinische Kapelle*, (Tafeln, Erster Teil, Munich, 1901), folio volume I, pl. VII

77, 78 Scala, Florence
79, 80 James Morris, London
81, 82, 83, 84 Nippon Television Network Corporation Tokyo 1991
85 Scala, Florence
86 © Nippon Television Network Corporation Tokyo 1991
87 Scala, Florence
88 By courtesy of the Board of Trustees of the Victoria & Albert Museum
89 © James Morris, London
90 Original drawing by Peter Schmitt
91 © Nippon Television Network Corporation Tokyo 1991
92, 93 Araldo De Luca, Rome
94, 95, 96, 97 © James Morris, London
page 145, detail of figure 103
98 Monumenti Musei e Gallerie Pontificie, Città del Vaticano
99, 100, 101, 102, 103, 104 Scala, Florence
105 Monumenti Musei e Gallerie Pontificie, Città del Vaticano
106, 107, 108 Scala, Florence
109, 110 © James Morris, London
112, 113, 114 Scala, Florence
115, 116, 117, 118 Araldo De Luca, Rome

Index